To Wendy

Secret Samurai Trilogy

Book Three Shifting Sands

With thanks for looking
after Naoko san so well
over the years.

Best wishes

Jill Rutherford

18/6/2017

OTHER BOOKS BY JILL RUTHERFORD

SECRET SAMURAI
Trilogy

Book Three
Shifting Sands

Jill Rutherford

Little Wren Press

Published in paperback in 2016 by Little Wren Press
Text © Gillian Rutherford 2016
Cover design by Jill Rutherford and Mike Olley
© Gillian Rutherford 2015

This novel is a work of fiction. The names, characters
and incidents portrayed in it are the work of the author's
imagination. Any resemblance to actual persons, living or
dead is entirely coincidental.

ISBN 978-0-9569679-4-7

A CIP catalogue record for this book is available from the
British Library

Set in Garamond

Little Wren Press, 27 Old Gloucester Street,
London WC1N 3AX

For Miki

Japanese names are written in the traditional style with the family name first followed by the given name.

Foreign words are in italics only when first written and thereafter in normal script.

CHAPTER ONE

BEBE

June 1865

The threat of imminent death enhanced my senses as I felt the stark coldness of Masako's sword against Kai's neck contrasting with the stifling, humid heat. I hoped it was the temperature making Kai sweat and not panic.

I was trapped inside Kai's mind, powerless and despairing but despite that, or because of it, the colours around me were vivid and dazzling. The wild flowers looked psychedelic, the greenness of the leaves luminous, and I could even see the complex bark patterns of the trees that surrounded us. The breeze that caressed Kai's face caused sensual vibrations on his skin sending shivers of pleasure through me and I almost forgot that my life was about to be extinguished.

I noticed that Masako's breath was sweet, with a hint of peppermint. Kai had described her face as being like a flat plate and, although cruel, it was true, but she had the clear skin of a new petal, and although her eyes were small and too far apart, they were clear and bright – and full of hate.

Time had slowed to a virtual stop as my worst fear was being realised and I knew Kai's death meant mine too. His heart was pumping blood so furiously I was terrified that it would inflate his jugular and cause Masako's sword to pierce his skin. All it needed was the slightest increase in pressure to cut through the thin membrane and artery and release Kai's blood and certain

death. I had to keep him calm. Stave off his anger at Masako for ruining his relationship with Yoshi and her insistence that bloodshed was the answer to everything.

She was the woman he'd rejected in marriage and was now taking her revenge by killing him. I had to get him to focus on getting away from her, not being angry with her.

'Think man,' I said to him, 'think of a way out of this. Keep calm, don't let your thoughts wonder. She'll kill you if you allow your anger against her to dominate you. Control yourself. Stay calm … nothing good happens if you don't stay calm.'

Kai and Masako's faces were only inches apart. She had to look up to him, an awkward position for her to maintain at such close quarters and that was to our advantage. Her eyes still showed enough hate for an army to fight on and told us she was not afraid of killing. He looked fleetingly over her left shoulder, as if a movement had caught his attention. It was almost no look at all.

'You don't fool me,' she snarled. 'I know there's no one there: you're trying to trick me.'

Kai's gaze didn't waver. I felt him grow stronger as doubt crept into hers – a fatal mistake in a stand-off. Kai had seen it too because he allowed himself to blink as his gaze flicked almost imperceptibly over her left shoulder again. This time her doubt increased and proved too much as she swung around fast expecting to defend herself from an attacker. But there was no one there.

Kai quickly took a step to the side and brought his hand down on her sword arm in a karate style chop. She dropped the sword crying out in pain and anguish at having been fooled.

He grabbed the sword and held it against her neck in a mirror image of what we had just been through.

'Kill me Kai,' she said in a soft and pleading voice. 'Finish the job Yoshi didn't have the courage to do.' She stopped speaking, giving him the chance to push the sword into her jugular. When he hesitated she begged, 'Please Kai, I have nothing to live for.'

I felt his resolve to kill her lessen. Maybe it was because he had looked into her eyes and seen her soul laid bare. Her pain

at his refusal to marry her, the killing of her family including her father, Kai's best friend, and the realisation that Kai, the man she still loved, hated her.

He lifted the sword away from her neck in an arc and I thought he was going to behead her and prepared myself for a sight I never wanted to see but, to my astonishment, he threw it into the trees.

She looked at him, despair now filling her eyes. 'Why?' she asked harshly.

I felt his inner turmoil as he wanted more than anything to kill her, but believed that if he did so, he'd send her off to the after-life to be re-born into a new life. That was too good for her. She was not interested in helping others or her country. She was living a bad life and Kai wanted her to continue to live it. That was far more torment to her than a simple death.

I felt the tension in him, the hate he was succeeding in controlling as he made his voice, soft and low. 'Go … go from here and never let me see you again. You don't deserve the sanctity of death. I cannot forgive you for what you've done to Yoshi and me. You wanted to ruin our plans for your own selfish desires: you have no sense of values or decency. You belong to the past and have no place in the world that is to come … you must suffer in this world until you find it in your heart to do something decent.'

'My heart is dead,' she spat, 'shrivelled in vinegar and you may as well kill me now because if you do not, I'll make sure I get my vengeance on you and that pompous, self-satisfied … *Makino Yoshi.*'

Kai surprised me by relaxing as if he'd just had confirmation he was seeking and he said, in that same calm, low voice, 'Your words prove you do not deserve to die. Suffer in this life and poison yourself with hate. Live with that. I'll take my chances. I believe the gods will be on mine – and Yoshi's – side.'

He undid her long obi sash and used it to tie her arms to her body and then used the rest of it to bind her feet tightly together. Without a second glance he walked swiftly away leaving her to her fate. His thoughts tumbled and jostled as he

tried to make sense of the events. Yoshi was gone, and I could feel his desire to find him and make up with him somehow. He was running now, and I had enough sense to put a distance between my mind and his. I'd discovered that I could switch myself off, take a back seat, until I was needed by Kai or at least, I felt I was needed by him. I wanted to give him his privacy in this most intimate and upsetting time. I hoped he'd give me the same courtesy if the roles were reversed.

My thoughts were interrupted by a wail of anguish from Kai. We'd come to a crossroads. Two roads going in opposite directions branched off ours, and there was no way of telling which one Yoshi had taken.

He fell to his knees in the middle of the crossroads as huge sobs engulfed him.

Kenji had said I should impress Kai with my intelligence and knowledge so that he would see the benefits of accepting me, but right then, all I could do was to stay silent and wait for him to recover his senses. This pain was something Kai would have to deal with himself.

CHAPTER TWO

KAI

Sobs came from a dark and private place inside me. My heart was breaking. I never thought such emotion would come from me. I'm a samurai. I felt ashamed.

It was her again. That Bebe. She's doing this to me. She's making me weak. I hate her. *Hate her.*

I needed to get her out of my mind. She was turning me into someone I didn't recognise. I couldn't take much more of her.

I was broken.

I stayed sitting at the crossroads for a long time. The roads were just narrow dirt tracks without signage and no one passed by.

I'd never thought about roads before – they were just there and I used them. But now they would decide my future for which one would lead to Yoshi?

Some roads lead to disaster, some to happiness. People use them to do business, to run away from life – or the law. Others use them to make a living; robbing, selling, preaching. Even the great lords, must use them. Roads have no allegiance or conscience. They treat every traveller with equal indifference. They simply lead to the future. Choose wisely: be vigilant. Every road will lead you somewhere: it is you who has to choose the right one.

But how? How to choose the road Yoshi took? For me, that was the right road as I admitted to myself that nothing mattered anymore but Yoshi and his good opinion of me. I'd been stupid.

Now he had gone away from me thinking I was a callous monster while I thought he was so caring he should be a priest not a samurai. But then, none of us can choose what we want to be right now. The country is in such turmoil and doesn't know itself which road it wants to travel. Which one will be for the best?

I needed to analyse what Yoshi would be thinking when he got to this crossroads? Which road would tempt him? Where did he want to go? What did he want to achieve?

The same as I do. We have our beliefs in common and determination to change things. So why aren't we still together, fighting for it?

Masako's image flashed into my mind. She'd come between us: driven us apart. Curse her. And curse that Bebe; she'd put a wedge between us too. I didn't know who I hated more, but I knew you can never trust a woman. They don't have the same values as men: the same strength of mind and body. They are weak and cause trouble and are best left at home: the world was not meant for women. Yoshi, come back. I need you. We men must stick together.

Then I remembered the teapot. I took it out of the pocket in my sleeve and examined it. It was pretty in its own way. A quality teapot – where did he get such a thing in the middle of nowhere? There was something about it that drew me to it besides it being a gift from Yoshi. I needed to take great care of it, maybe it would be my good luck talisman. I wrapped it carefully in my small towel and tucked it securely in my sleeve again realising I was rambling, doing myself no good. I closed my eyes in concentration to analyse which road Yoshi would take. Would he want to get to Edo as fast as possible? Or would he prefer to take a road leading another way, far from me?

I decided to let fate lead me. I drew a line in the dirt halfway between the two roads and gathered up a couple of handfuls of small pebbles, intending to throw them into the air and whichever side of the line had the most pebbles on would be the road I would take. My hands shook; everything depended on this. With a pounding heart I threw the pebbles high into

the air praying the spirits would chose the right way.

I looked down as the pebbles scattered and couldn't tell from looking at them which side had won. I knelt down and started counting, twelve, thirteen, fourteen for the right and twelve, thirteen, fourteen, fifteen for the left. So, the left hand road became my destiny and I said a silent prayer to the spirits of the road to help me find Yoshi.

CHAPTER THREE

YOSHI

When I left Kai I walked away quickly, resisting the temptation to look behind. I was so full of emotion; the fight with Masako, the falling out with Kai, the old woman and the teapot. My thoughts were in chaos. I couldn't understand Kai. He'd changed so much. What was he thinking? I was angry he wouldn't trust me with his problems. He'd shut me out and become unpredictable, morose and irritable. But the business with Masako had left me traumatised, as if I'd never known him. The Kai I knew and loved had changed into a stranger.

"Do it Yoshi," he'd said, "kill her." Those words imbedded themselves into my mind and I don't think I'll ever forget them or the venom with which he spoke. The gods tell me why this has all gone so wrong. We started out with such high hopes and ambitions. What had changed him? Brought him to this? It was as if a demon had entered his soul and was taking him over.

I stopped in mid stride, looking down at the earth. Could a demon have entered his mind?

I began walking again, trying to remember when everything started to go wrong, when a crossroads halted my progress. Two roads met mine and ran in opposite directions. Roads twist and wind and one could never be sure where one would end up.

So many thoughts were crowding me I didn't give much consideration to which road to take and just followed Lucky as he trotted up the right hand one, nose to the ground following

a scent.

But I'd been travelling on it for a day now and had seen no one. I was beginning to think I should have used my brain instead of relying on Lucky. I couldn't blame him though, it was my own fault.

But then, when I rounded a bend, the road linked up with a larger one and several people were walking along it. I asked someone which road it was and when he said it was the Tōkaidō my heart leapt for joy.

I looked down at Lucky and said, 'We'll soon be in Edo. The gods are on our side after all.'

CHAPTER FOUR

BEBE

June 2013

I started to come round, feeling uneasy. I was back in my own life, my own thoughts, and as my senses grew, I knew I was in my own bed. But I couldn't remember anything that had happened this time except I had been pulled away from Kai when he needed me. Something was very wrong and I felt I'd abandoned him.

What was the reason Kai and I entered each other's lives? Was there a pattern? Was someone … something, controlling this? A thought was hovering in my subconscious, something I'd seen in Kai's time that I knew I was familiar with in my own time, but I couldn't quite grasp it. I knew with certainty that it was important but it wouldn't formulate. It was infuriating.

My thoughts were interrupted as I saw Kenji sitting on the side of the bed holding my hand and a movement made me turn my head and Fumi was standing the other side fanning me with an uchiwa. The cool breeze from the fan was refreshing and brought me back to full consciousness.

Kenji caressed my hand and kissed it. 'Oh, Bebe, I've been so worried. Thank the gods you are back safe.'

I couldn't see him clearly as my vision was still a little blurred, but I could hear the worry and tension in his voice.

'What happened?' asked Fumi, trying to hide her anxiety as

she continued fanning me.

'I don't know. One minute I was there with Kai and the next I was waking up here.'

'But you usually remember … don't you?'

'I do Fumi, recently I do, but this time … there is nothing … I can't remember …'

'I'm just overjoyed to see you back,' Kenji interrupted as he kissed my hand again, this time more passionately, even though Fumi was watching.

I smiled at him, 'And I'm overjoyed to see you too Kenji.' We looked into each other's eyes and forgot about Fumi. Then, without any forethought, I said, 'There's something that's not right. I can sense it … but I don't know what it is.'

Sensible Fumi said, 'But are you alright? Is your health okay?'

I thought about myself for a moment, 'Yes, I'm fine, just tired … and confused.'

'Well, it is my experience that everything looks much better after a good night's sleep. We are all tired so I will leave you two lovers alone,' she looked at Kenji and winked, 'look after her,' she said as she put her hand on his arm, a very unusual thing for her to do, and I could see the concern and worry in her eyes. She was trying to keep things light, but only partially succeeding.

Kenji and I smiled at her, both glad for her consideration. She was a good friend.

'Please call me when you are rested,' she added as she closed the door behind her.

'How long have I been away?'

'About a couple of hours,' Kenji answered as we looked into each other's eyes and moved as one into a hug that went on and on. We couldn't let each other go and I felt Kenji's tears wet my face. We both cried then, in each other's arms. I sensed Kenji's fear and realised just how much I loved and wanted to keep my real life. I had to face the fact that what was happening to me threatened Kenji too and I was grateful for the fact that I had no control over it for that took all responsibility from me.

'Can you really remember nothing?' he asked.

'Not a thing. It's like a black hole I can't see through.' I hugged him harder and kissed him passionately. He responded and we lay together and made love for a long time; the merest touch inflaming our nerve endings. I never wanted it to end.

CHAPTER FIVE

KENJI

I lost myself in Bebe that night. It was a night of exquisite sensations, worry and anxiety. They all got mixed up in our lovemaking. I'd never felt so alive, so much in love and so fearful that I would lose it all in the dangerous game Bebe was being dragged into. I was aware I was being unfair. She had no control over it but I was annoyed that she took so much pleasure in it. If she loved me as much as she said, then surely she would hate this thing that was happening to her. I could not make up my mind how I should feel about it all. I wanted to support her and get her out of this, but how do I do it? How could anyone do it?

It's as if the gods are punishing me for something I don't understand. My family's history left me with no expectation of being able to love someone, then, like a miracle, Bebe enters my life, but is taken from me in this incredible way.

And then, in the mix of my confusion and self-pity, something happened that changed everything.

A few days later, while I was taking my English lesson with Bebe and my classmates, Hiroko and Rie, we were grappling with the concept of phrasal verbs and how ridiculous they are. The meanings bear no connection to the words that are used. For example, *show you the ropes*, is nothing to do with ropes but just means we will teach you how something works in a procedure. My friend, Hiro's favourite saying, *keep your hair on*, has nothing to do with hair, it means, don't lose your temper.

See what I mean? It's a big problem for us Japanese who want to learn English. So it was while we were all laughing about these strange sayings that my mobile phone rang. I always turn it off before the lesson, but I'd forgotten that day. Apologising profusely, I took it out of my bag to turn it off and glanced at the screen. When I saw my mother's name my heart almost stopped. She never phoned me unless it was an emergency.

I had to take it, so I excused myself and went outside into the street and took the call. That was when everything changed and there was no going back.

CHAPTER SIX

BEBE

Kenji's mobile started ringing deep in his briefcase. I watched him as he apologised and glanced at the screen. His face lost all colour as he rushed out of the room saying he had to take this call.

When he came back several minutes later his face was white and he'd aged years. 'What's wrong?' I asked taking his arm as he passed me.

'I'm sorry; I can't stop to explain, please believe me I have to go.' And with that he picked up his things, shoved them into his briefcase, and tore out of the classroom. I went out after him to see him running across the road towards the train station.

How dare he just run out on me like that with no explanation: did our relationship mean so little to him? I swallowed it all down as I went back into the lesson deciding that I would not call him. This was all his doing and he was the one to apologise.

After two weeks, I was beside myself with worry. I'd called him of course but his phone was always turned off and although I'd left messages, he never returned them.

CHAPTER SEVEN

KAI

I could hardly breathe I'd run so far and fast to try and catch up with Yoshi. The pain in my side finally brought me to a stop. I'd been running on and off for a day and was beginning to have doubts that fate had been kind to me. Maybe Yoshi had taken the other way. This road ran through a forest, undulating with the terrain, making travelling difficult. As I reached a hilltop I saw a village sitting below, looking small and inviting in the distance. I bought some food there and rested a while but when I enquired about Yoshi no one had seen him. I bought some more food for later and continued on, alternating walking with running.

After a couple of days, it became clear that I had taken the wrong road for I would have certainly caught up with Yoshi even if he'd been running. I was disheartened and walked slowly, exhausted now. I knew I'd lost him. I could feel it inside, I could always feel his presence when he was nearby. I'd taken the wrong road.

As I continued my journey, desperate to find a town, I heard men shouting in the woodland and although I couldn't see them, I knew they were ruffians by their coarse language and voice. They were arguing and I tried to pass without them seeing me but luck was not my friend that day.

The next thing I knew I was waking up in a small, clean room, lying on a sweet smelling futon, and the aroma of cooking was so appetising my mouth watered even though it had been as dry

as a river bed in a drought only seconds before. Horses were thundering through my head and when I tried to raise myself up nausea overwhelmed me and I was glad I had nothing in my stomach.

I lay back down and darkness enveloped me. I don't know how long it was before I felt someone shake me gently and a woman's voice kept saying, 'Are you awake yet? Young sir, I can see your eyelids fluttering, can you wake up?'

I forced myself up from a pit of nothing and into a bright world of pain. Those horses were still galloping in my head as I opened my eyes and gradually focused on the woman. She was in her final years and wearing an expensive kimono: obviously a woman of wealth. Her past beauty was still evident and she had a smile so sweet and kind I said in my stupor, 'Are you a goddess?'

She laughed softly, 'That knock on your head has affected your brains young sir, for I am no goddess.' She laughed that same soft laugh again, obviously amused, as she put a cold cloth over my forehead and it was as cooling and welcome as the touch of a goddess.

'What happened? Why am I here?' I asked, my voice rasping in my dry throat.

'We don't know what happened to you. My son found you on the side of a country road and thought you were dead, but you groaned when he touched you. You are lucky my son is a kind man and he put you over his horse and brought you here. You have a large lump on the back of your head, a broken leg and many bruises. The doctor says it looked like you'd been hit very hard on the head and leg with something, maybe a heavy stick. I'm sorry to say the leg has a bad break. It will take a long time to heal.'

My head was so painful I hadn't realised my leg was also throbbing and when I put my hand down and felt it, it was encased in bandages and splints.

'Forgive me kind lady, for my head hurts so much I can hardly think.'

'Take your time young sir; you are welcome to stay here for

17

a long as you want.'

'That is kind of you madam,' I managed to say between the throbs in my head, 'but I do not want to burden you.'

'It is no burden,' she said in her soft, soothing voice, 'I am alone most of the time as my only son lost his wife in childbirth recently and he travels much for business so I would welcome some company. And you cannot go anywhere in your condition. Unless you are the emperor's man sir, I will be most comfortable looking after you as you so need.'

'I am the shōgun's man madam. I'm pleased to meet you and you have my undying thanks.' I paused to ease my throbbing head, 'I am Matsuda Kai of Takarazuka: a small village of no consequence, in one of our western provinces.'

'I am pleased to meet you, I am Kawamoto Yaeko,' she said as she helped me to raise my head to take a sip of tea from the cup she held to my lips. It tasted like nectar but the pain increased so much that I had to lie back down.

'You need to rest young sir, but you also need to drink. I will fetch the sickness cup so that you can drink lying down.'

Ignoring the pain I tried to remember what had happened, but I had no memory after hearing the ruffians arguing in the woodland. I assumed they must have come up behind me, attacked me, robbed me and left me for dead.

Kawamoto san came back and put the spout of the sickness cup to my lips and I supped the nectar. The cold tea soothed my raging throat and I was able to say, 'I met some ruffians on the road, I think they must have attacked me.'

'You were unconscious Matsuda san, when my son brought you here.'

'How long have I been here?'

'A couple of days. I think the men must have robbed you as you had no money on you when my son and I undressed you. The only thing you were carrying was that little teapot.' She nodded her head towards a small table in a corner and on it stood the little teapot. I felt stupidly overwhelmed with relief. It was the only thing I had to remember Yoshi by and his last words to take care of it echoed around in my head. 'Is

18

it damaged?' I asked, my voice betraying my anxiety.

'No sir, unbelievably, it is not. We found it tucked into your sleeve and the ruffians must have missed it, although I am at a loss to know how it survived unscathed.'

'Indeed,' was all I managed to say thinking it was a miracle and wondering what sort of thing Yoshi had bequeathed to me.

I pulled myself back to the present, 'Madam, you said your son brought me here. Where is here?'

'Why Nagoya sir,' she said in all innocence as the name hit me as hard as those ruffians had. She saw the shock on my face. 'What ails you sir? You look like you've seen a past ancestor come to life. Does Nagoya have bad memories for you?'

Nagoya.

A place I never wanted to enter again.

AUTUMN 1865

The heat of summer had cooled to the chill of autumn as my leg healed and I was able to get about for the first time without the aid of sticks. The doctor had done a good job and Kawamoto san had skills in healing and had looked after me well. My headaches were now a thing of the past and I was fit enough to go out on my own. Kawamoto san and I had been out together for walks near her home but that day, I strode out alone for the first time.

I needed to start looking for Yoshi again and this walk would be my final test that my strength and stamina had sufficiently recovered. I was full of optimism. I'd missed Yoshi like the absence of a limb and knew for sure I was nothing without him. I just had to find him again. I'd been stupid and never stopped berating myself for behaving in a way that drove him away. It was that damned woman in my head. She was the cause of everything. The only good thing to have come out of all this was that she was no longer in my mind – she must

have been killed, or dislodged, by the blow to my head. I was overjoyed, I felt whole again. I'd come back to myself.

Nagoya is a large sophisticated town full of life and activity and under different circumstances I could have embraced it and taken it to my heart, but Sato's menace hung over it. I kept to the closely packed, narrow residential streets of a poor area, confident they would keep me safe. There was no reason for Sato to be in such a place.

Some of the alleys were so narrow only one person could walk along them and roof edge touched roof edge but whenever I came to a wide, prosperous street, I turned away and strode down the same alleyways, doubling back into the smaller streets. I was feeling pretty pleased with myself – always a dangerous sign – and as my confidence grew and I walked more and more rapidly, I committed the worst sin of all – I got lost in my thoughts. I was too pleased with my progress and my certainty that I was now fit enough to start my hunt for Yoshi when, to my annoyance I found myself walking along a wide, busy road. I turned to retrace my steps when someone came out of one of the buildings. We both stopped in mid stride and I know my face mirrored the disbelief of Sato's as we both gasped.

He recovered first saying, 'Well, well. I didn't expect to see *you* again. What a pleasure s-i-r,' he said sarcastically, bowing in mock respect. I remained silent trying to recover when I heard people saying goodbye in the doorway of the same building. He turned towards them and said to me, in a condescending voice wrapped in a malicious grin, 'Please meet my wife.'

My shock at meeting Sato was but a ripple on a pond as Masako appeared and my blood turned cold. In those first few seconds neither of us moved and her image seared itself into my brain like one of those photographs I'd seen in Edo. Her hair was immaculate and as black as her character as it hung down her back in the style of a great lady. The sun shone on it in the sunlight and her kimono was of the best silk which enhanced its autumn colours. She'd gasped and raised her hands to her face on seeing me, shock making her unmindful

of decorum. The wide sleeves of her kimono fell back giving me a good view of her lower arms which were covered in severe bruising: some old and yellowing, others purple and vibrant. Had she been in an accident – or worse? She noticed my stare and put her arms down quickly, her expression dissolving into one of satisfaction.

Fear gripped me hard as I looked into Sato's malevolent smile. His eyes, lost in the depth of their sockets, examined me closely and that enormous chin jutted out with the arrogance of a sword.

'I cannot say it is a pleasure to meet you again,' I said, keeping my voice hard and strong.

'Now, now,' he said quietly, in that same condescending voice, 'let's be nice. Where are you staying? My wife and I will escort you home.'

I certainly didn't want Sato to know anything about the kind lady who had taken such care of me; he would surely get his own back on her somehow so I said I had just arrived in Nagoya.

'Excellent,' he boomed, 'you have no where to stay, then let me offer you salubrious accommodation sir.' He turned towards four guards who had arrived with Masako – rōnin protection on hire to Sato I assumed. 'Help us escort this excellent man to my home.' Without a word two of them positioned themselves closely in front of me and the other two, equally closely, behind me. I had no way of escaping them so I did as I was bid as we walked through the streets with Sato and Masako following.

Sato's house was large for a merchant's as they were not allowed, by law, to express their wealth in property or personal adornment – a source of great resentment from the merchants. As I had deduced on first meeting him, he was not a man to be restrained by the law.

Sato's pleasant demeanour altered as soon as we entered his house: as I knew it must.

'Lock him in the empty outhouse and keep two guards posted outside day and night,' he barked. Turning to me he

said in a sweet voice, 'I'll see you tomorrow s-i-r,' as he bowed his head briskly at me. Another insult I would not forget.

Two of the rōnin had drawn their long swords and held them against me so I had no option but to meekly allow them to take my swords and enter where I was bid. The door slammed shut and the bolt thrown with such force the noise echoed around the room. I looked about me and saw I was in a storeroom. It had thick walls made of clay and straw with a couple of small windows set high for light. But they were of little use once the door was closed. I sat down on the earthen floor and leaned my back onto the cold wall until the chill became cruel and my body lost its warmth and day turned into night. As dawn broke, thirst began to plague me. I didn't care about the hunger, I was used to that, but thirst was a different thing. I knew the dangers of dehydration. I walked slowly up and down the small room to help me think, and I cursed my stupidity at being captured. All this was my own fault. There was no way I could escape from this room. I was trapped.

Then I thought of that woman: that Bebe, and surprised myself by thinking where was she when I needed her? The shock of that thought stopped me in my tracks. Did I need her? I'd been cursing her, resenting her, and now I wanted her to appear?

I shook my head, dog-like, to try and clear it as my thoughts tumbled and churned. I calmed myself and continued pacing, my predicament enabling me to see things in a different perspective: going over and over events until I realised that I had to face the truth – she *had* helped me and I *did* need her.

I'd been so angry about it all, I hadn't realised the potential of such a wondrous thing. I'd been a fool: too wrapped up in myself and my own pride to let a woman help me. What did it matter now? I was going to die so I could afford to be magnanimous. But the more I thought the more I realised that she'd put ideas into my head, helped me to develop them and see into an unknowable future. I saw it all now. How she had influenced me and how much I had changed under that influence. What a fool I'd been. She'd lifted me up from being

a lowly samurai to someone who had vision and confidence to take on the changes my country desperately needed. I wouldn't have been able to do this without her; I had enough sense to realise this. Enough intelligence to know my limitations of the past were now no longer an impediment to what I could achieve in the future.

I knew I couldn't get out of this without her help.

Where was she? Why had she deserted me?

Had I succeeded in throwing her out of my mind?

A feeling of even deeper despair crept up on me but was cut dead by the bolt being thrown and the door kicked open, crashing it against the wall. It swung back on its hinges blocking the blinding light that was hurting my eyes. Then it opened again, slowly and I saw the outline of Sato standing in the doorway.

I blinked a few times and saw the silhouette of Masako standing behind him and behind her, the four rōnin.

Sato told them to wait outside as he left the door open and walked towards me smiling his malevolent smile.

'Well, my friend, how are you this morning?'

'Thirsty,' I replied.

'Good,' he said, 'you will learn the value of water.'

I said nothing.

He walked slowly up to me and punched me hard in the stomach, once, twice, three times. I doubled over and fell to the ground. He kicked me many times until Masako said, 'Husband dearest; do not kill him. I still have my pleasure to come. I'd like him alive for it.'

Sato stopped kicking me and said, 'Of course, your way will far outdo mine. Excuse my selfishness. I will leave you two alone for I have pressing business.'

After he'd left, I heard the rustle of Masako's kimono as she slowly approached: it sounded like the rustle of death.

She knelt down beside me and to my dismay I could see her love for me shining from her eyes. It was still there, after all that had happened, she still loved me, and in that moment, she couldn't hide it. I felt sorry for her. I knew what she was going

through. I felt the same about Yoshi. He could do anything, be anything, and it wouldn't change my love for him. I was cursed with having Masako feel that way about me. And then a terrible crossed my mind – did Yoshi feel my love was a curse?

'Kai, you are a foolish man,' she said softly. 'Why do you always go against me? I have to teach you that it is not a good idea to do that.' As she was saying this she started to undo my clothing. First my obi, then she opened my jacket and my kimono until my chest was bare. She ran her fingertips over my skin and I saw the pleasure touching me in such an intimate way gave her. Curse her love.

And curse me for I couldn't stop a shiver of disgust – and she noticed. She clapped her hands suddenly and the four rōnin ran in. 'Strip him of his upper clothing,' she spat.

They manhandled me out of them, threw them against the wall, and left me lying on my back useless and despairing. The punches and kicks from Sato had begun to throb and joined the dehydration pain that was developing in my head. I was furious at my inability to help myself. Unbidden, I thought again of Bebe and couldn't stop thinking, help me … please.

Masako knelt beside me holding a large, shiny knife. She ran the smooth blunt edge down my face and caressed my body with it. Circling my nipples, making her way further down my body until my trousers halted the knife's progress. And this time the love in her eyes had been replaced by malevolent pleasure.

'You are a stupid man sometimes Kai. I cannot understand you. But I will show you what happens when you go against me. I'm going to give you a pleasant death Kai. One you can savour over the coming days. Death by a thousand cuts is a Chinese torture, but there is no reason why we Japanese cannot take our example from them.'

She moved the knife up my body and nicked the skin on my chest. I felt a trickle of hot blood over my cold skin. She caressed me with the knife again and its threat ignited each nerve it crossed over in an agony of anticipation.

I used all my strength to keep my face impassive and not

make a sound. I would not give her the pleasure of seeing me defeated.

'Dearest Kai,' she murmured as she cut again, just deep enough to draw blood before continuing her knife caress. She traced a wavy line down to the middle of my body, nicking here and there as she did so until finally, she stopped at my navel and said, 'We'll save the best bits for last.'

She got up in one smooth motion and looked down on me. My heart was beating almost as hard as the pain in my head. My thirst was raging. I knew if I was to live I had to ask.

'Water,' I said, annoyed my voice cracked because of its dryness.

'Tomorrow,' she laughed. 'We'll continue tomorrow, and then if you are a good boy, I will give you water.'

The door closed with a bang, the bolt thundering home and despair flooded through me. My skin crawled with the feel of her still lingering on it. Would I die here?

I needed help. My health wasn't as good as I thought it was, although my leg was holding up well. I was still weak from my forced inactivity and my physical weakness had affected my mental state. How could I get out of this? The rōnin were guarding the door which was bolted from the outside and the windows were too high to reach. I was beginning to welcome death. Then I thought of Bebe again and made a vow that if she ever came back I would apologise profusely and accept her advice and presence in my life with great joy. I knew now how lucky I had been to have had her support in the past.

I was cold and shivering as I struggled to put my clothes back on. I needed to keep warm if I was to live.

The next morning Masako appeared at the door with the four rōnin. There was no sign of Sato. 'Good morning, Kai. I hope you are well this morning?'

I didn't answer but her lack of respect at calling me Kai and not Kai san was rankling more and more. Her arrogance was smarting almost as much as my thirst.

Her voice was harsh as she repeated, 'I said, I hope you are

well this morning?'

'I am as well as can be expected,' I answered and my voice was now almost inaudible as the air rasped against my tinder dry throat. 'I think I will be dead soon if I do not drink.'

I heard her issue an order to one of the rōnin and then kneel down beside me. Let's take a look at how your cuts are healing,' she said in a soft, sweet voice as she started to undo my jacket. She took her time and opened my kimono top examining her handiwork of yesterday. As I suspected, the tiny cuts stung like biting ants as the cold air hit them and she ran her fingers lightly over the lesions. I tried not to show my disgust.

The rōnin reappeared with a water flask and gave it to Masako. She smiled her devil's smile again and her image blurred as she slowly poured some of the water over my mouth. I tried to suck it in but it dribbled down my chin onto my chest. She stopped pouring and I couldn't stop my eyes betraying my anger. I should have killed her when I had the chance.

She laughed, as if she could read my thoughts, 'Take the clothes off his upper body,' she instructed the rōnin. And again they manhandled me out of them and pushed me onto my back.

I kept my silence. I would not give her the satisfaction of thinking she was breaking me.

She ran the knife around my body again, nicking my skin whenever she felt like it. I'd counted twenty cuts yesterday and decided not to count any more. She kept talking to me as she cut, but by now I was going in and out of consciousness. Finally, I heard her say, 'Here you are Kai, here's your precious water, drink it slowly now or you'll be sick.'

She left as suddenly as she had entered and as the door and bolt banged into place I could barely see in the semi-darkness as I searched with my hands, desperate to find the flask. My hands were scouring the earth in increasing desperation. Where was it? Had she done the cruel trick of taking it with her? If so, then I would die.

With a relief that sent surges of hope through me, I found it and clutched it to me with the reverence that water deserved. I

slid myself across the floor to lean against the wall ignoring the coldness of it and carefully, focused on the flask. Everything was blurred now. I was so weak it was difficult to move, and I didn't want to spill any of it. With difficulty, I pulled out the stopper and moved the flask slowly to my cracked lips. The dryness of my mouth was now agony and my tongue had stuck to the roof of my mouth. Despite my care, the water came out in a rush and ran down my chin onto my chest. I didn't even have the energy to swear. I recovered myself enough to control my shaking and get a drizzle of water into my mouth. The membrane cried out in pain as the water hit it but I continued to swill it around slowly to try and hydrate my mouth enough to enable me to swallow. My throat was so dry it had closed up and I had to let the water dribble out onto my chest three times before it responded and I managed to swallow a little. I continued like that, tiny swallow by tiny swallow, until my throat opened up more. Once I could drink, I knew I had to take my time in case my body rejected it. I spent the rest of the day drinking in small sips and by the end I felt a little better and hope surged through me again. I hadn't died. But hope for what? Had I just prolonged my death agony?

CHAPTER EIGHT

BEBE

AUGUST 2013

After Kenji left my lesson so suddenly I felt abandoned and betrayed, but it soon turned into worry. His phone was always switched off and my increasingly frantic messages went unanswered. Was he dead? Fumi had checked and there was no record of anyone with his name having died recently.

How can someone you love just disappear from your life without explanation? And if he wasn't dead, why had he done this to me? I thought he loved me. You don't do that to someone you love.

A few days after he'd run from his lesson, I called his bank even though he had told me never to call him there. He hadn't been into work they told me, and he had taken extended leave from his job but they refused to tell me why, although they did confirm that they were in touch with him. About a week later I got a phone call from him. He said, "This is Kenji. Do not try to contact me. It's over between us. We cannot meet again. Goodbye." That's all he said and hung up. Those words are imprinted on my brain: so cold, as if we had never been together and shared so much.

To add to my worries, I hadn't been into Kai's mind for over a month. Had he abandoned me too? Was *he* dead? I was grieving for the two most important people in my life and was exhausted.

~~~

I'd been meeting Fumi regularly, she was my rock of certainty and commonsense, and I clung to her like a mollusc gripping a rock in a storm.

One momentous day, I got a call from her saying she wanted to see me urgently. I could tell by her voice that something important had happened. We agreed to meet that evening.

She came to my apartment after dinner and looked dour. She sat down on her knees at my table and refused refreshments. I sat on my knees opposite her and looked into her eyes. She was not looking into mine. I knew then that this was seriously bad news and I tried to keep control of myself. 'Please Fumi, please tell me. Whatever it is, please just tell me.'

She looked at me and said, 'It's Kenji.'

My heart missed several beats as I gasped, thinking the worse. She didn't say anything else for a few seconds and I couldn't bear not knowing.

'Is he dead?'

Again she paused.

'Please Fumi,' I begged.

'I saw him at his bank this morning.'

I gasped. 'You saw him?'

She nodded, 'Yes, and I'm so sorry Bebe, but there is more.' She paused again and the wait was terrible, but I knew I couldn't rush her. She took a deep breath and said, 'I found out by asking one of his colleagues – he has been back at work for the past two weeks.'

The shock hit me so hard I couldn't speak – couldn't take this in. All I could think of was that she had made a mistake.

She took my hand squeezing it gently saying, 'I'm so sorry, so very sorry.'

As I looked into her troubled eyes I could see it was the truth, there was no mistake; Fumi didn't make those sorts of mistakes.

My breath started to come in short bursts until I felt I couldn't breathe.

Still holding my hand she said, 'Can you cry Bebe? It would

be better if you could. Let it out, don't hold all that emotion in, you must let it out.'

I knew she was right, but I couldn't. I whispered, 'I can't. I feel like I can never move again. I'm frozen.'

'It is the shock. Let me make you some soothing tea.'

'Make it wine.'

'Tea will do you more good than wine.'

'I don't care,' I shouted like a child in a tantrum. And then something broke in me, the emotion bubbled up and sobs jumped from deep inside me. Tears took away my vision and I sobbed with the abandonment of a child.

Fumi stayed close by but had the sense not to interrupt or say useless platitudes and left me to cry out my anguish.

When I'd recovered a little she said, 'Would you like me to leave you alone? I can come back tomorrow.'

'The bastard,' I shouted at her. Fumi's shocked look stopped me from swearing more in her presence. I respected her and didn't want to alienate her, so I took a grip of myself. 'I'm sorry, Fumi, I didn't mean to swear like that, but he is a bastard,' I couldn't resist saying.

I got up and started to walk up and down the room and felt an overpowering desire to smash something; to scream my frustration, my stupidity: his betrayal.

I said as softly as I could, 'Yes, please leave me Fumi. I'd like to be alone. I'm sorry, I'm just so upset.'

'Yes, of course, I understand. I will come round tomorrow evening.'

'Thank you. And thank you for having the courage to tell me.'

'I'm sorry it was me who had to tell you. Take care. Cry and get it out of your system. I'll see you tomorrow.' And with that she left quietly and I was alone.

I continued to walk up and down, thinking thoughts of betrayal. How love can make a fool of you. Full of anger and self-pity, I went into the bedroom and threw myself onto the bed and sobbed the night away.

~~~

The next day I went to work as I had too. I had many lessons that day and couldn't let my students down. Fortunately, none of them was rude enough to say anything about my puffy eyes or distracted lessons and for that I was grateful. If someone had shown me sympathy I would have lost my self control all over again. Fortunately, I had no more lessons after five 'o clock and I was, thankfully, alone again. I opened a cupboard and took out a bottle of red wine – a present from a student – and poured it into a water glass and gulped it down. The only effect it had on me was to make me burp and I realised that this was no answer to problems. I was not that stupid. I tipped the rest of the bottle down the sink.

I went out onto the balcony and stared at the wall of my neighbouring apartment block a few feet away and welcomed the closeness of it: its permanence reassuring. I'd stop noticing the claustrophobia around me. Although I don't think I would have noticed if the building had fallen down in front of me; my thoughts were full of Kenji and his betrayal.

A knot of fury raged inside me and built until I thought I would explode. The question - why had he done this to me – changed to – how dare he do this to me.

With anger driving me, I stormed out of my school and took the train to Nishinomiya Kitaguchi and Kenji's bank. I assumed he would be leaving at his usual time so I stood hidden in a nearby doorway until he appeared. Sure enough, he came out just after seven and I waited until the electronic door had closed after him. I didn't want him to take refuge back inside.

I walked quickly out of my hiding place and approached him quietly. He had his back to me and jumped when I said, 'How dare you do this to me.'

He turned around looking scared, like an animal in a trap.

I said it again. 'How dare you do this to me. You cannot treat people this way. Do you know how you've betrayed me? I could kill you for this,' I hissed in final fury.

He looked stricken.

I had to stop speaking then as I felt I really could have killed him. I had to get control of myself. Bring me – the modern

Bebe back – with less of the violence that dominated Kai's life and was now coming more often into mine.

He looked everywhere but at me. 'I'm so sorry Bebe. I didn't want to hurt you,' He sounded defeated.

'Well, you made a bloody good job of it, you bastard.' I gripped his arm tightly. 'I need some answers,' I said trying to keep my voice strong when all the time I just wanted to cry.

He looked down at the ground and nodded, 'Yes,' he said quietly, 'I see how angry you are. Let's go to my apartment.'

He walked off quickly and I followed him through the narrow, busy streets as we jostled with people going in and out of the many bars and restaurants. Although this was a family area, there was always a buzz of excitement in the air as people made for their favourite places, but that evening it was an irritant, a hindrance to our progress. All I wanted was privacy and Kenji's explanation.

As we walked into his apartment, he said in an uncertain tone, as if he wasn't sure how he should be behaving, 'Would you like a drink?'

'No I bloody would not.' I shouted, losing my control. 'All I want is an explanation. You owe me that much.'

He poured himself a glass of water and drank it down in one. His hand went up to his hair and rubbed it back and forth as he paced his living room a few times. He turned to me, 'You are a foreigner, I forget that sometimes, and foreign women do not behave like Japanese women. You behave more like a Japanese man. I would be angry if it happened to me.' He stopped speaking, and sweat broke out on this forehead.

'I owe you the truth and I cannot lie anymore. I'm defeated Bebe. I just wanted to spare you. Maybe I made the wrong decision, but it was the easiest one for me and I am not proud of it.'

He walked to the window and looked out onto the street below. I kept silent, letting him gather his thoughts. He said he was going to tell me the truth, but would he? Was he trying to think up lies to cover his behaviour? I stayed patient and stood unmoving, watching him. I knew my expression was hard, but

inside my love for him was fighting its way through my anger and feelings of betrayal. No, I shouted to myself. No. You mustn't make excuses for him. Don't be soft.

Still looking out of the window, his voice pitched low, he said, 'I apologise very much for my behaviour. It has been unforgivable, I can see that now. You are owed an explanation.'

He rubbed his hand over his hair again in that way of his when he was confused or uncomfortable. 'It all started when I got that call during our lesson. I saw on my screen that it was my parents' number. They never called me unless it was an emergency. When I answered it, it wasn't them but a policeman. He told me that the Sunday before there had been a great tragedy and that my family's house had burned down and all my family burned to death inside it.'

I gasped but Kenji put his hand up and said, 'Please, let me finish.'

My heart went out to him but I stayed silent.

'When I got to my parents home I was taken in for questioning. The police suspected I had done it.'

'*What* ? But why? That's impossible.'

'You know that, but they did not. All they knew was that I had moved away from home and not become a farmer: that made them suspicious of me. I was a man of the city with city values. Bad values they think. The simple life of the country is often ridiculed by city people and the local police had a … chip on their shoulder, I think you say.'

I nodded, thinking hard. 'But we are always together on Sundays, why didn't you tell them that?'

'That was the problem. I could not tell them.'

'But why? I don't understand.'

'Look, sit down and I'll explain.'

He went to the fridge and brought out a bottle of cold tea and two small cups and poured them, both of us ignoring them.

He took a few deep breaths, 'I left home when I went to university at eighteen and I never went back to live there again. Now I have a good job in a bank and the police knew I gave

money to support my parents – I suppose they checked their bank account – anyway, they knew about it. I had to keep you out of this because if they knew I had a foreigner as a girl friend they would have suspected you too.'

'But why? I've never even met your family.'

He sighed and counted on his fingers. 'One: because my family were troublesome. Two: because I had to help support them and they were costing me a lot of money. Three: because you are a foreigner and foreigners do not behave like Japanese people. Four: you might have persuaded me to kill them so that I could keep all my money, inherit the farm and then sell it off.'

'But … that's unbelievable. How could anybody think that?' I tried to keep control of myself.

'That's how some people think. This inspector really disliked my family and he wanted to get me; that much was clear. I had to keep you out of this. They could have put you in jail: charged you with murder. Or at the very least, got you deported and never allowed back into Japan. I could not do that to you. So I decided I had to keep you out of this and the best way to do that was to cut off all contact. I was ashamed, confused, I didn't know what was happening to me. How I could get out of it. I was in despair but I knew I would feel worse if you were dragged into it. Maybe I did wrong, but I did the best I could at the time. And …'

'And what?' I asked softly, my heart going out to him.

'And … I'm sorry … but I knew that you would become very foreign and demand this and demand that and make everything worse. I am sorry, but that is not our way.'

I put my hand on his but he didn't move or look at me. 'I'm so sorry Kenji, you're right; I can understand your thinking. We westerners are often too forthright for Japanese tastes and we all pay the price for previous generations of misunderstandings. It's hard sometimes for Japanese people to tell the difference between good foreigners and bad ones.'

He nodded and smiled a weak smile. 'Thank you for understanding Bebe.'

I smiled back, 'But wait a minute, let me think … you said

that your family's house was burned down?'

He nodded.

'And you said that when your phone rang at our lesson you looked at the screen and saw your mother's number – but how could they have found her phone undamaged? Surely it would have melted in the fire?'

'Good point, I asked that too. They told me they found it a few days later in a poly tunnel at the edge of the farm. My mother must have been working in there and it fell out of her pocket without her noticing.'

'Yes, I see. I'm so sorry.'

He sighed again, as if everything was just too much for him. 'They put me in prison Bebe … I was scared.'

'Oh Kenji, that must have been awful … but why? Surely they can't do that without evidence or charging you with a crime?'

He shrugged and said, 'This is Japan.'

I kept my voice soft and low, 'There's something you're not telling me isn't there?'

He jumped up. 'No. No, there is nothing more. That's all I can tell you, that's what happened and if you don't believe me, then I'm sorry.'

'Okay … please calm down. I do believe you … but what happened to make them let you go?'

He sat down opposite me again, looking upset and breathed deeply. I could see it was difficult for him to keep control of his emotions.

'Two things: the first one was that Hiro came to find me. My phone was switched off and I had disappeared and he was worried about me … he's a good friend. I'd told him the area I came from one time when we were discussing our childhoods – but I didn't say specifically where in that area but once he had arrived he found me easily as everyone was talking about it. He came to the police station and told them I was with him on the date of the fire.'

'But that's wrong surely, we are together on Sundays. How would you have met Hiro?'

'Yes, that's true, but I had forgotten on that day I went to Nishinomiya Kitaguchi to buy you your favourite cake as a surprise. You were working on some lesson plans and I had nothing to do, so it seemed like a good idea. I just told you I was going out for a walk. On the way back to the station I bumped into Hiro. He asked me to go for a quick coffee with him. He was so excited. He had met a waitress at a coffee shop and wanted to ask her out. There was something different about his attitude to her – he seemed serious and uncertain, he really wanted me to meet her and tell him what I thought. I was in no hurry so I went. While we were there, he took a selfie of the three of us and you could see the name of the coffee shop clearly on the wall and the date and time of the photo was on his phone. There was no doubt that I was in Nishinomiya Kitaguchi and could not have done it.'

I tried to disguise the relief I was feeling as I didn't want him to think I'd thought he was guilty. 'I see … thank goodness for Hiro … but you said there were two reasons.'

He nodded, and his voice wavered as he said in a fast, clipped and business-like way, 'The autopsy results came in and showed that my brother's body had been more badly burned than the rest of my family. The police report showed that his body was next to an overturned paraffin heater in the middle of the living room. The rest of my family were in bed, so they think he had knocked it over and was either too drunk or drugged to know, or maybe hurt himself and could not get up. Either way, the result was the same. And then they let me go.'

'But you didn't come home then?'

He shook his head and was silent for a few moments and wiped away a few tears as his voice wavered even more. 'No, I had to sort out my family's affairs … their funerals … the farm … there was just so much to do … and … I was in shock Bebe … I still am.'

I tried to keep the hurt out of my voice. 'But why didn't you contact me after your release? I could have helped you.'

He looked into my eyes and let me see his pain. 'Truth is Bebe; it is because I love you so much that I have tried to

keep you out of this. No contact at all. It was all I could think of doing and I had no one but Hiro to talk to about this. He helped me and between us we decided to break all contact with you. It was best we thought.'

He got up and walked to the window and looked out again. He spoke so quietly that I had trouble hearing him. 'There is something else.' He rubbed his hand over his hair again. 'Since I've been back, someone has been following me.' He turned and looked at me and I could see the hurt and apology in his eyes. 'I can't prove it, but I feel it. The police are still following me, those bastards are still following me. I am not a good liar, you know that. The police knew I was hiding something, they just did not know it was you. I am sure they still suspect me.'

My breath caught in my throat, 'But why? Why should they be following you?'

'I don't know,' he shouted and then gained control ... I cannot take much more.'

I knew this was the truth and I felt ashamed at my lack of faith in him. 'I'm so very sorry Kenji. I had no idea ... I realise now that I only thought of myself and my feelings. I didn't have faith in you ... I feel ashamed.'

His voice was soft, 'No need to feel ashamed Bebe. We come from different cultures and we think differently about things. Our values are different. The way we cope with problems and protect people are different. I can see that now. I didn't know what to do and I was alone. All I could think of was to keep you out of this. If I was wrong, then I'm sorry.'

I wanted to take him in my arms and hug him forever. My shame increased. I hadn't trusted him. I'd been a fool.

I made to come to him, 'No, please Bebe, don't touch me. I need to stay strong and if you touch me I'll give way to grief. I cannot afford to do that. I must stay strong and stop all this. But the gods help me I don't know how.'

He turned back to the window and said, 'We must part. Take a month for you to sort out your feelings about all this and for me too. I need time. I must stop whatever is happening to me. I must keep you out of this. I would never forgive myself if

anything happened to you because of me. Can you understand that?'

A month? How could I last out another month? The blow of his last statement hit me hard. But I knew I didn't want to leave Japan even though my life was in such turmoil. And I was in danger of losing Kenji. What if he didn't want me after all this? Decided I was too much trouble – that I wasn't worth it?

He interrupted my thoughts. 'I think you should go home now and think carefully about what I've told you. Remember that someone is following me and I do not know why. If I lead them to you, it could be the end of your life in Japan ... and with Kai.'

My heart was aching, but I needed to stay strong for him. 'I can take care of myself, you know that, especially with Kai – '

'You can't rely on Kai,' he interrupted, 'you are a woman Bebe. You are strong, but we do not know for certain who is following me. The police here cannot be trusted. We cannot know what is in their minds. No Bebe. Being with me is no place for you right now. We must part for a month. After that, I'll phone you and let you know what has happened.'

He looked at me and I'd never seen such steel in his eyes before, I knew he was not to be swayed. 'Yes, I agree. I can see talk will not change your mind. But Kenji ...'

He looked at me, waiting.

'You will call me if you need me won't you?'

He nodded as he opened the door for me and I found myself outside his door, outside his life.

CHAPTER NINE

KENJI

When I heard Bebe's voice as I left work it froze me to the spot. It was the voice I dreamed about every night since all this happened. The one I wanted more than anything to hear. But everything had changed. I'd changed.

When I got that call from the police I went into shock. I couldn't think straight. I couldn't tell anyone about this until I knew what had happened. In a panic I rushed home and threw some things into my sports bag and took the next train to my hometown.

My family lived in an isolated country area in Saga on the island of Kyūshū, and it was early next morning before I found myself getting out at Hakata station. I have no memory of the journey. I couldn't believe what had happened and was in denial.

I hired a car and drove in the same frame of mind the few hours it took to get to my village and it was only then the reality of it hit me as I saw what was left of my family's home - a charred lump roped off by police tape. No one was allowed over the tape, but there was no point as everything had been destroyed.

I didn't know what to do. I couldn't take it in. So, in a very Japanese way I suppose, I became practical, thinking the fields around the house had crops growing and the rice fields were showing a good season so I'd have to get someone to take care of them for me. I couldn't let all that food go to waste.

The police had asked me to report to the police station

in our nearest large town as soon as I arrived. It was about twenty miles from my parents' farm. I went straight there as I knew there was no point staying in my village as no one wanted to talk to me. There were people walking around, sightseers come to look at the bad end of the bad people who lived there. I recognised them all. People I'd gone to school with, their parents, local traders or neighbours. When they saw me, they looked straight through me as if I didn't exist although I knew they recognised me as I stood looking at the devastation. They wanted nothing to do with my family, even in tragedy.

When I got to the police station I couldn't help thinking how old fashioned and small it looked and I knew the attitudes of the police would be equally old fashioned. It sent a shiver of fear through me, but I had no choice and gave my name and told them I'd been told to report there. I was shown into a bare room on the second floor and left alone. The only furniture was a table and three chairs, two on one side of the table and one on the other. I sat down on the single chair and waited. A few minutes later an inspector came into the room with a sergeant and was immediately hostile and offensive.

His questions never stopped. The same ones over and over; the same answers over and over.

We stopped for meals – sometimes. We stopped for a drink – sometimes. We had a toilet break – sometimes. Honesty compels me so say that if I had done it I would have confessed by the end of day two. I'm not a hero. I'm just an ordinary guy and we ordinary guys in Japan respect authority.

'Why did you kill your family?'

'I did not.'

'How could a fire like that start on its own?'

'I don't know.'

'Did you support your family with money?'

'Yes.'

'How much money?'

'A hundred thousand yen a month.'

'How much do you earn?'

'Three hundred thousand yen a month.'

'That's a lot of your pay.'

'Yes.'

'Did you resent it?'

'No.'

'Why not?'

I paused. I'd have to be careful here. 'Because they were my family and needed the money.'

'But that left you quite poor.'

'I manage. I live a simple life. I don't need much.'

He changed direction. 'Do you have a girlfriend?'

I think he caught the slight hesitation I couldn't suppress as I saw Bebe's beautiful face in my mind. Felt my love for her.

'No.'

'Why not?'

'I can't afford one.'

'Does this make you angry?'

'No.'

'Why not?'

'I'm happy without a girlfriend.'

'Do you like men?'

'No,' I said instantly and then thought I should have said yes, maybe that would deflect them from Bebe. Fool!

'Why did you support your family?'

'Because they needed me to.'

'Why couldn't they support themselves.'

My silence lengthened. Should I tell him my family's secret? Could I keep it a secret? So many people knew about it; doctors, neighbours, schools. No, I had to tell him – he knew anyway I felt sure. He was trying to trick me so it was better for me to tell him than be confronted by the truth.

I told him all. Answered all his questions and then he locked me up in a cell again.

It was hell. And I didn't know how to get myself out of it. I should have asked for a lawyer, but I didn't trust lawyers,

especially country ones. I felt sure he would find out about Bebe somehow. Trick me. I couldn't be sure whose side he'd be on. So I struggled alone and felt wretched.

CHAPTER TEN

YOSHI

AUTUMN 1865

'Why won't you come Yoshi san? It'll be fun, I guarantee.'

'Leave him be Jun, he likes boys better, it's obvious.'

'Is that right young Yoshi? You like the boys – well, it is time to grow up and get yourself a real woman. I can take you to a woman who is so skilled in the art of lovemaking she will change you overnight. You will never look at a woman in the same way again and you will certainly never want the inferior charms of a man.'

He put his arm around my shoulders and tried to steer me in the direction of the tea house with the worst reputation in Edo. I was finding his insistence harder to oppose as he took my continued refusals as a personal insult. I shrugged him off saying that I had more important things to attend to.

'What you?' he laughed. 'More important things to attend to? Oh, by the gods, this youth, this important man of the world, has more important things to attend to.'

He laughed even more as he put his arm around me again and tightened his grip forcing me to walk with him.

I had been afraid something like this would happen; that there would be a day of reckoning.

I'd been in Edo for the past three months and had discovered the streets more dangerous than I imagined. The turmoil that was affecting other parts of the country was well established

here too. Rōnin who were loyal to the shōgun searched out people who didn't support them and street fights were common.

Fear had also caused many people who lived in areas outside the city to move to Edo for "safety", while others saw an opportunity to make a living from the unrest: craftsmen were needed, cooks, inn-keepers and farmers were necessary to cater for the increased population. Merchants soon followed them, looking for a quick profit – and the courtesans came in their droves – or I suspected, many a decent woman had lost her husband or family and was made destitute. The only course of survival open to her was prostitution.

I eventually found like-minded radicals, but they gathered in the poorer areas, in the quickly expanding shanty towns on the edges of the city. Coarse, uneducated people, a mixed bag of peasants, farmers or poor artisans who'd come looking for that better life. Hastily erected buildings were cheap and fragile, the streets narrow and claustrophobic. The vile, odious smells of inadequate drains and latrines dominated and complaints from more prosperous areas were common. The residents of Edo did not want these people and distrust was everywhere. And those who were distrusted in turn distrusted me and I found it difficult to keep them at bay. They wanted friendship in the normal way of things with men: visits to bath houses and disreputable tea houses full of courtesans. It was getting more difficult to extricate myself from their expectations of me. One of the boys I was not – and that made them suspicious of me.

Edo had been a disappointment. It was over-crowded and lacked the elegance of Kyōto. There was no history here, just the rag-tag of the desperate, the greedy and the power hungry.

Also, I was missing Kai much more than I thought. My feelings for him were far stronger than I had admitted to myself. I was but a shadow without him as I realised how much he influenced me and how I relied on his support. I always thought it was the other way around, but now, I had to admit that it wasn't like that. I needed him as well as loved him. I

couldn't deny the truth of it.

I pulled my churning thoughts back to the present and turned towards my tormenter hissing, 'If you do not let go of me I will be forced to make you.'

He turned his head and looked at me laughing as if I'd just made the best joke he'd ever heard. His foul breath hit my face and I turned my head away. As I did so I dropped quickly down into a crouching position that caught him unawares and he lost his grip on my shoulder. I moved quickly out of arms length and drew my long sword.

'Leave me be, or I will have no choice but to fight you,' I said in my most arrogant voice. These men were not skilled at fighting and my samurai status had kept a lot of them away from me; fearful of that status and the power that came with it. But with this man, that power was waning.

He laughed again and infuriated me more. I must keep my temper. Fights are lost if tempers rule. But I'd had enough of him, and with a speed that rocked him, I swished my sword across the top of his head and cut off his top-knot without injuring his scalp. He looked down at it lying at his feet with incredulity.

'Now, do you still want to fight me?' I said in a soft voice, which made it sound more menacing. He picked up his hair still looking at it with his mouth open and shook his head saying, 'What do I care what you do, but I won't forget this humiliation. You stay out of my way in future.' He walked quickly away from me, followed by his friend who was looking at me with a mixture of awe and fear.

Kai and I had been preaching to poor people like these and most of them were good, honest people. I had to put ruffians like this out of my mind and remember all the good people we had met. Men such as these were not worth thinking about.

But I needed to think carefully about Edo. The shōgun's government was based here and there was a growing state of fear that if the Southern clans could not be stopped then major battles would erupt here too: their support of the emperor was a direct threat to the shōgun. It was emperor or shōgun; there

could be no other winner.

Rumour was rife and it was difficult to know who to believe. Fear and excitement were close partners and the disorder that was destroying my country was here in abundance.

As I put my sword in its scabbard I was reminded of Kai and his family. Of when his father presented me with the sword and how much I treasured it and the confidence he had shown in me. It was one of the best moments of my life. I looked after it with great care, honing and polishing it in the late evenings before retiring, relaxing with the good memories his family brought me … and … it was my link with Kai.

I'd made a mistake in leaving Kai. I knew that now with absolute certainty. I'd abandoned him to his fate and now I was sorry. I'd reacted hastily, without due thought to what would happen if we separated. I'd been rash and emotional – my womanly ways again no doubt – but now I'd had time to reflect and experience life without him and realised I needed him probably more than he needed me.

When I first arrived in Edo it had taken me a while to understand the machinations of what was going on around me and to acquire some acceptance into a few groups. But I wasn't the same Yoshi who had travelled and preached with Kai. My spark had gone. My passion was subdued and I felt a hollowness inside me. I wasn't sure what it was about him but I knew I needed it. Whatever happened to me, I wanted it to be with Kai.

The next morning was crisp with an autumn chill in the air as I left my cheap lodgings and looked down at Lucky who was walking beside me like the faithful dog he was. 'Shall we go and find Kai?' I asked him.

He looked up as I spoke and barked and wagged his tail as if he understood me. It was all the confirmation I needed and we walked out of Edo.

But I didn't know where Kai was or what he would be doing. Would he be preaching without me? If so, where had he gone? I was as sure as I could be that he hadn't come to Edo. No

one had heard of him and I knew he would be frequenting the same groups as I was. I resolved to go back to his family in Takarazuka, and hope they had heard from him, or if not, I could leave a message for him if he did return.

Lucky and I took the most direct route along the Tōkaidō road. I estimated it would take us about three weeks to walk. Unfortunately, we would have to pass the city of Nagoya, there was no way to avoid it unless I took a long way around and I didn't have time for that. A gut instinct told me I had to find Kai quickly.

We made good progress but when we were a few miles from Nagoya my anxiety rose. I kept telling myself that Sato was probably dead, that I had killed him that night of the rape, but even if he wasn't then he would be doing business in the city centre, not travelling around its edges. I pushed myself on as fast as possible, eager to leave Nagoya behind.

As I came to a bend in the road, I heard the distant, but unmistakable sound of a battle. The sharp clank of swords, interspersed with shouts, grunts and yells. I didn't want to get mixed up in it so I ran off the road and into the woods with Lucky at my heels. As we rounded the bend unseen from the road, I saw scores of samurai fighting each other. Some were already dead but many more were still involved in a vicious fight. I noticed a lavishly decorated palanquin sitting on the ground in the middle of the battle and a tall, richly dressed man standing next to it, sword in hand, fighting skilfully. My curiosity overcame me and I looked around, making as sure as I could that no one was observing me, and ran to the trees on the other side of the road. As I approached nearer I saw the shōgun's crest on the door of the palanquin and the man was wearing the dress of the shōgun's court. He was a man of immense importance.

The fight was taking place around the palanquin and judging by the number of dead, it was a serious assault, and it looked like his guards were struggling to protect him. As I crept nearer, the man was fighting and surrounded by ten or so of his men. Many bodies lay around them and by the time I'd reached him

his foe had drawn him slightly away from his protectors. I could see the badge of the emperor on the attacking forces uniforms and the fact that this man was still alive told me they wanted to take him alive.

He was not young and looked exhausted. I had to make a choice: help him or not. I don't know what made me make the decision I did. Fate?

Telling Lucky to stay, I ran towards him just as he killed another of the emperor's men and he turned at my movement and looked at me. He saw immediately that I was not one of the emperor's samurai and he raised his eyebrows at me in question as if we were passing the time of day. A man cool and unruffled by such danger was a man to be respected – and afraid of.

I saw two of the enemy running towards him from behind and he followed my eyes and swung around, and in the seconds left to him before they attacked, he swung the other way to check his flank – a skilled fighter indeed. Three more of the emperor's samurai were running just as fast towards him from the side. By this time, I had reached him and we stood back to back. 'Concentrate on your assailants, not mine,' I had time to say before the first of the three reached me. I slashed at his middle and made contact, dispatching him without effort. The other two were more of a problem, but I was more accomplished in fighting techniques and far more agile. The second tried to slice at my neck but I ducked and took off both his feet in one slice and I thanked Kai's family's sword yet again. The last one was more careful and almost got my arm with a quick, disguised slash, but I just managed to move out of his way. I retaliated with an upward slash as his arm was reaching the end of its downward arch and took it off with a single slice. Avoiding the gushing blood, I turned towards the important man only to find him on his back with his one surviving attacker pointing a sword at him and telling him to get up. This was all the confirmation I needed to understand that this was an abduction attempt. Only the gods knew what awful fate awaited this man if he was caught, and what affect

that would have on the shōgun and his policy. His men were outnumbered and still fighting valiantly, but unable to help him.

'Move and I will kill him,' the attacker said. 'Drop your sword *boy*,' he snarled. I hesitated, calling his bluff. If he had been instructed to capture this man alive, he wouldn't risk killing him … although he would have no such compunction towards me. But I couldn't see how I could kill him without the risk of him killing the man. Something told me that this man needed to be saved. I dropped my sword at my feet so that I could dive down and pick it up quickly if the opportunity arose. As I did so, I whistled to Lucky. It was short and sharp and he knew it as our signal he was to rescue me. In an instant, he was running from the woods and before the attacker had chance to realise what was happening, he had locked his teeth around the man's ankle. He screamed in agony as Lucky tore into it and I picked up my sword and lopped the man's head off.

I glanced around. Everyone was busy fighting and the man's samurai were struggling to cope. I offered him my hand and pulled him up roughly.

'Quickly, follow me and run hard, like you've never run before.' I took hold of the man's sleeve and pulled him along as best I could. He was hampered by his voluminous hakama trousers, but, still holding on to his sword, he picked up their ends and pulled them upwards, exposing his legs and ran disjointedly towards the wood. It was a distance of ten or so paces but lasted a lifetime as time slowed and I expected an arrow in the back at any moment.

Finally, the denseness of the trees hid us and I stopped for a moment to make sure the man was fit to go on. Lucky wagged his tail furiously with his tongue lolling out: his face a picture of pleasure. 'Good dog, Lucky,' I said and patted his head.

The man, gasping for breath, stopped and leaned against a tree. 'We cannot stop here sir,' I said, 'we have to put a greater distance between us and the others. Your side is losing the battle.'

'Yes, young sir, you are right. I apologise for my slow speed,

I am not as fit as I was and old age has caught up with me, but lead on, I will follow as best I can.' He thrust his sword into its scabbard, picked up the ends of his hakama again and said, 'Run my new friend, it is vital that I am not captured. I am an important man of the shōgun's court. Help me and there will be great rewards for you.'

I believed him. I was used to such men when I lived in the emperor's court, and they were indeed vital, important men. And this man had an integrity about him I trusted. I wanted to save him.

I followed Lucky as we ran on with the man trailing us as best he could. Even though we had travelled at his slow speed, he finally called out, 'I'm winded my friend, can we not stop. Surely we are safe now.'

'Not quite sir, I think we should put a greater distance between us. But let's take a few minutes to rest. Breathe deeply and relax your body, it will help.'

'I'd like to thank you,' he said his breathing laboured. 'I had come to the end of my strength and could not fight much longer. You saved me.'

'Don't thank me yet sir, we have a way to go before safety comes to us. Don't speak now, save your breath.'

After a few minutes we started our escape again when we both heard a noise that shouldn't be there. Suddenly, one of the emperor's samurai ran full pelt into us. Fortunately, for us, he seemed surprised to see us and had trouble stopping. I used this against him and slashed at his back while the man lopped at his legs. He went down screaming. Another noise alerted us but then all went quiet. I told the man and Lucky to stay where they were as I carefully made my way, in a circuitous route, to the area I thought the noise came from. The emperor's samurai and I saw each other at the same time and he jumped up wielding his sword, intending to bring it down on upon me, but I leaped away and he embedded it into a tree instead of me. As he frantically tried to pull it out, I sliced off his arm which sent his blood soaring into the air. This is a common sight in battle but nothing prepares you for the shock of finding

your own arm flying through the air and your life's blood pumping out of you. High level samurai are trained to fight on as best they can, but the foot soldier is of a lower order and his training is not so extreme. They always scream in anger that it has happened to them and collapse quickly as they allow themselves to be traumatised. It's the natural reaction after all. This man was a foot soldier and he screamed his frustration, his eyes unbelieving as he watched his arm settle on the ground. I couldn't let him continue screaming and attract more samurai so I had no choice but to lop off his head.

I felt sickened. I didn't want to be doing this, I wasn't made for such viciousness, but I had no choice. I ran back towards the man but found him nearby. 'I was prepared to come to your aid young sir, but I see you didn't need it. That is twice you have saved my life.'

'And I do not want to do it for a third time sir,' I said brusquely, 'Let us depart.'

I ran on in the same northwards direction we'd followed but changed my mind and swerved towards the west. 'We will walk fast now sir, this terrain will be more difficult for us to travel but equally difficult to track us.

'Go ahead sir, I have confidence in your ability, I will follow your lead.'

We remained silent after that, saving our breath for our exertions as we kept a steady pace. I helped the man as we scrambled over large rocks and through small streams, following animal tracks as much as possible so that we did not leave a trail. Lucky was always ahead, his nose to the ground. I felt it was just as well to follow Lucky as he had more knowledge from his nose and ears of what was around us than I did from my inferior ones. He didn't let me down and finally, we came to a high spot that led to a deep valley, completely wild and uncultivated.

'We need to rest sir,' I said ignoring decorum and sitting against a tree, even though, as my obvious superior, he had not given me permission to do so. He ignored my rudeness and chose a tree facing me and sat down with obvious relief, saying,

51

'I think you mean, *I* need to rest,' and smiled.

I looked at him closely for the first time. He was not as old as I'd originally thought now his face was more relaxed. He had a few good years left and was still handsome with good bone structure. He wore a pleasant expression, but one I guessed hid a mind of steel. The confidence of power shone from him like a bright star outshines its neighbours in the night sky. He wore his hair shaved with a topknot and it was thick and lustrous. His clothes were of the best quality silk and made for show not for practicality: they had hindered him when fighting and escaping and would continue to do so. But he didn't complain. I felt he was a man of resource and intellect.

He looked at me closely and asked, 'Who *are* you?'

I was afraid of this man's power and I wasn't sure I wanted him to know anything about me.

'I'm no one sir; just a travelling rōnin,' I replied dismissively.

'You are more than that I think, you have saved my life against great odds and led me to safety.'

'Don't speak too soon sir,' I replied. 'We have a long way to go before we get to civilisation.'

'True, but you have a name surely.' His voice had taken on an air of authority.

I stood up and bowed as I said, 'Makino Yoshi of Kyōto at your service sir.'

He didn't stand up, he was not required to, and said, 'I am Nakamura Tomomi. I am one of the shōgun's advisors.'

I bowed to him again, very low.

'Sit down young sir, you need to rest too.'

'Thank you sir,' I said as I sat down gratefully and leaned against the tree.

'Kyōto is a bad place to be right now,' he said, 'why are you not with your family helping to protect them?'

I paused momentarily, 'Alas, all my family are dead sir: killed in the service of the shōgun. As you say, Kyōto is a dangerous place which is why I left.'

'Is that why you have that scar down your cheek? It is not old I can see, did you get it fighting in Kyōto?'

I was grateful to him for giving me a way out of explaining it and immediately said, 'Yes, that is correct sir. I was injured and left Kyōto soon afterwards.'

'Someone has sewn it up well for you. It must have been painful. I see here more evidence of your bravery. It takes courage to withstand the sewing of something like that.'

'Thank you sir,' was all I said. I didn't want to talk about my scar.

'And what are you doing now? Apart from saving my life of course.' He gave me a little bow of his head and had a twinkle in his eye. He'd recovered fast from almost certain death: he was resourceful; I'd have to be careful around him.

I picked up a small stone next to me and moved it from hand to hand while I pondered on whether I should tell him the truth. Or say I was a nothing, a stupid rōnin wandering aimlessly. Instinct told me this was a crucial moment in my life. This man could be of great importance to my future – or destroy me easily. I didn't know which.

The man was perceptive and said, 'You seem unsure of what to say to me. Do you have secrets you are not willing to share? For if you have, then that is to your advantage. We all carry secrets in our hearts. They either enrich us or we hide them away hoping they will not resurface to haunt us later in life. I am a man of secrets, I have to be in my position, but I will tell you something, I find you interesting, intriguing even, and would like to know the real you.' He paused, looking at me closely, 'Is the Makino Yoshi on the inside as handsome as Makino Yoshi is on the outside? Or are you all show and no substance?'

If he had wanted to goad me he couldn't have found a more sensitive spot. I was still prickly about my good looks even though my scar spoilt them; I still had doubts deep inside me as to how seriously people took my views. I made my decision: one I could never go back on.

'Sir, you are correct and an excellent judge. I do indeed have secrets that I keep close but I will tell you truthfully what passions I have inside me; what drives me on.'

Of course, I didn't tell him the whole truth, I kept my true sex from him and my love for Kai.

'I have a history as we all do. As I told you, my family is of no importance, they were just ordinary farmers in Kyōto but all are now dead. As you know sir, the shōgun's decision to open up small areas of our country to allow foreigners to trade is a contentious issue, but I will tell you honestly my position and why I believe in it so strongly.'

I paused for dramatic effect, something I'd learned during my talks, and looked him straight in the eye. 'I believe we must open up and modernise our country, cooperate with the foreigners in trade. If we do not, we will go the way of China, who, as I'm sure you know, refused to cooperate until the foreigners lost patience and invaded the country. Then they took what they wanted without respect or recourse to the Chinese people. It was a disaster that will happen to us if we are not careful. We must keep the power we have over our land and people. We must learn from China's mistakes.'

I paused wondering whether I had insulted him for he was a man who knew much more than I did, it was one thing saying these things to peasants, but completely another to say them to a man such as this. But his face hadn't changed expression and he was obviously listening closely so I had no option but to continue.

'I want our country to modernise, to accept the ways of the foreigners and welcome their knowledge and adapt it to ourselves, to our culture. We must trade with the foreigners, open up our land to them and learn the modern ways of thinking, of farming and production, give education to the masses – including women,' I risked saying. 'Change our feudal system of government and our feudal culture. Give more power to ordinary people and improve their lives. I travel around the countryside sir and preach this doctrine to the farmers, the peasants, the merchants, to all people who will listen to me. That sir is how I spend my days.'

He looked at me hard and finally said, 'You speak with great passion young man, you have a gift of oratory and an aura

about you that is attractive and intriguing. A trustworthiness that is rare in one so young.'

His eyes softened as they continued to look into mine, 'You are a conundrum: a young man who is indeed full of substance – extraordinarily so. You have grasped areas of our politics that are hard to define and explain. A place where we must see ourselves in years to come. The present day will stay the same for a while whatever we do, but the future is ours to decide now. Many people cannot make that leap of faith – to understand that change will bring benefits – and to stay as we are will bring destruction. Indeed, you are someone with perception, intelligence and courage: a boy to watch.'

He'd stopped talking and I didn't interrupt his thoughts lowering my eyes so that he could not see the uncertainty in mine.

Then he said, 'You are a true samurai and fought better than my bodyguards and are not afraid to kill. You take chances and risk your life. That doesn't seem to go with the words you speak. Shouldn't you renounce your samurai status to preach such views?'

I was shaken. I had never thought of that before. Renounce my samurai status? This man was trouble. I had to be very careful but directness was called for.

'Excuse me for my bluntness sir; I have nowhere else to go but to be direct. So please excuse me when I say it is easy for you to say such a thing when you travel around in a palanquin with many bodyguards to protect you. You do not walk alone among the people. You do not gather them around you and speak of things they have never heard of before. Of things that many do not want to hear because they have power now and want to keep it. No sir. The answer is no, I cannot renounce my samurai status – yet. I must protect myself and the only way I can do that is by keeping myself samurai. People are afraid of and respect samurai. I am but a boy, I have no other status. I have to cloak my youth in the aura of samurai power.' I bowed to him again, adding, 'Please excuse my bluntness.'

His eyes met mine and bored into me. I felt he was stripping

me bare. I wanted to look away but dared not. He wanted to see my soul. I kept my thoughts focused on thinking about my passion for the future and all other thoughts of my insecurities, my fear of discovery, out of my mind.

Time stood still and lingered and his gaze felt like a torture. I was beginning to wear down and doubt was creeping in as to how much he could see into me. I felt he could discover everything about me with that gaze. It was bruising and raw, I'd never felt anything like it. I resolved once more to keep him out of my deepest secrets.

His words, when they came, were like the sweetest music to me. 'I can see that you are pure. Your thoughts and ideas are radical but I have no doubt that you believe in them absolutely.'

He looked deep into my eyes. 'You are just a boy, but a boy of insight; a boy of the future; a boy to be watched; a boy I could respect and cherish.' Those last few words hit me as hard as a champion's sword. What did he mean, "a boy he could respect and cherish?" It was that word cherish that sent the shivers of fear through me. Did he mean what I thought he did? I kept my face expressionless but my eyes had moved involuntarily from side to side and I knew I had given myself away. He knew the meaning of those words were not lost on me. And he saw the fear there.

He moved forwards and kneeled in front of me, putting his arm out towards me lowering his voice as if he didn't want anyone to hear, but there was no one else here, except Lucky, who'd been sat next to me throughout this and now growled deep and low in his throat. The man took his arm back but kept on talking, 'I can open doors for you; give you status – if you give me what I desire – and need.'

There is was, out in the open. He was a man used to getting his own way; he probably had many such conquests around the country. I was nothing to him, just another one that took his fancy. But it would be a disaster for me. Not only would I lose all my power once my true sex was known but I would be in the control of this man forever afterwards. He could do with me what he wanted.

I despised the system of nepotism that dominated our society and kept everyone as slaves to their benefactor. It was one of the things I was fighting to change. No, I couldn't let this man gain power over me. But how to stop him?

I took a chance that I would not insult him too much by standing up quickly and saying, 'Come sir, we must take advantage of what light we have left and make as much progress as we can. It's not impossible that we are still being pursued.' I didn't wait for him to answer and started walking briskly downhill, Lucky again in front with his nose to the ground.

I made sure I kept a distance between us: I didn't want any more casual conversations with this man.

CHAPTER ELEVEN

BEBE

September 2013

I was frantic. I had to meet Kenji again. I'd done as he asked and not contacted him for a month but when I called him he still wanted me to take more time. There was still someone following him he said. It was safer we didn't meet. It didn't matter what I said to him, he was adamant and there wasn't much I could do. I couldn't force him.

After we'd hung up, I realised he still hadn't told me his secret. Was it so bad? Why was he still keeping me at bay? Did he really still love me? My mind flittered around like a hungry bee looking for pollen. Any pollen would do, any speck of hope would turn to honey inside me. But there were no flowers, not even a bud on the horizon.

And what about Kai? What had happened to him? Why had I slipped out of his mind at such a vital moment and why wasn't I going back into it? I was worried about him and whether I'd lost him forever.

It was a Sunday and I had nothing to do, so without any conscious thought, I walked to my cupboard and took out the little teapot. I looked at it closely and rubbed it with my fingers. It was cold and smooth under my touch and as I ran my hand over the chip on the handle and lid I wondered how and when they had happened.

I boiled some water and warmed the pot and put in some

green tea and covered it with the water just off the boil so as not to damage the leaves as Fumi had taught me and left it to brew. I took out my tiny porcelain cup and sat down on the sofa and poured the tea. As I sipped it, I remembered my times with Kai. He was a good man overtaken by strange events. I'm not sure I would have coped so well if the positions had been reversed. Poor Kai …

Suddenly, those thousand needles I'd so longed for, pierced my skin and my head swam around and around and then I heard him speaking to me.

'Bebe, is that you? Are you back?'

I thought I was dreaming and tried to wake up. 'Bebe,' the voice said again, 'come back to me, please I need you.'

I realised then that I was back inside his mind, looking out of his eyes onto a bare, cold room.

'Yes, it's me,' I answered, astonished that he was talking to me directly. He'd always sworn at me or talked at me but never communicated in a civilised and normal way before. It threw me and then I realised what he was saying. He needed me? He wanted me back? I couldn't believe it. What had changed him?

Then I felt the force of his pain and realised that agony is just a word when you have not experienced it, but when it happens to you, the full meaning of it becomes clear. It was almost unbearable and I knew I had to help him quickly. I steeled myself to overcome the pain I was sharing with him. I was fit and well and would use my strength to help him.

I could talk to him directly now, he wasn't fighting me, 'Kai, I can feel your pain, I will try to help you, but before I can do that, I must know what is going on.'

He was weak and his thoughts were disjointed but his weakness meant he couldn't block me and I delved into his memories without resistance. How he'd gone after Yoshi but couldn't find him. How he'd been hit over the head by the ruffians – that must have been when I was knocked out of you I thought – about Kawamoto san and her son who

had helped him, and of meeting Masako and Sato on the street and how they brought him here and were torturing him.

'What about Yoshi?' I asked.

'I have no idea what has happened to Yoshi. I pray to the Goddess every night to keep him safe, but he may be lost to me forever. How will I ever find him now? I don't even know if he's still alive.' Tears came to his eyes and I realised I would have to be gentle with him.

I advised him to go to sleep if he could. He needed to rest and give his body time to absorb the water he'd just drunk. He didn't need any encouragement and was asleep in moments. I used the time to think and try and find solutions. The first one was to get Kai out of this situation. He was so weak he was in danger of not surviving and I had to push thoughts of – if he dies so do I – from my mind. Our survival was up to me.

I wasn't sure whether Masako wanted him dead of not. Or did she want him broken and useless so she could use him as her slave? How far did her depravity go?

Masako: I pondered on her. Was she the way out of this mess? What did she want? How did she meet Sato? They were birds of a feather that much was clear and now they were together they were a powerful source of evil. Was that a solution? Put a wedge between them so that they couldn't encourage each other? Kai had seen bruises on her arms when he first saw her. Did Sato cause them?

He was a strange man. One not to be underestimated, but a man the world would be better without.

I thought of Nobu. Could Nobu be a descendent of Sato? Could Masako and Sato be Nobu's ancestors? That thought sent a violent shiver through me that made Kai jump in his sleep.

Then I dismissed the thought, it would do me no good. It was Masako that was coming to see Kai. She was the one torturing him, not Sato. The key to this had to be Masako.

How could we use her to help us?

It was then that the door bolt was violently thrown and the

door flew open with a bang and there she was, standing in the doorway, silhouetted by the sun shining behind her. I could just make out the four rōnin at the rear, standing with their arms crossed. It was like a tableaux of Hollywood movies: Ben-Hur, Gladiators ... Romans ... Jesus ... Judas.

Those thoughts went through my mind in the seconds that Masako stood in the doorway looking at Kai. He was rubbing his eyes and sitting up, pushing his back against the wall as if he wanted to get as far away from her as he could.

One of those thoughts stayed with me.

Judas.

Judas Iscariot.

The Judas who betrayed Christ ...

Masako walked into the room and looked down at Kai. 'How are you this morning?' she asked with a sneer, 'I suppose you want another drink?'

Kai looked up at her and I felt a hopeless feeling flooding through him. Had he forgotten I was there? I decided now was not the time to remind him. He had to concentrate on Masako.

His reserve of strength was almost zero and all he managed to do was nod. I saw her look at him closely and I think she realised then that if he didn't drink and rest, he would die quite soon 'Kai, you are not well I can see. I don't want you to die just yet. I want to have my fun with you.' She called out to the rōnin, 'Bring casks of water and some food.'

Masako bent down and opened the front of Kai's clothes and examined the cuts on his torso. 'Mmm, you've scratched these,' she said in a voice devoured of emotion. You'll only make it worse.' He didn't reply. Her face was very close to his as she looked into his eyes. Kai's eyes were unfocused but I could see enough through them to look into her chilled, unfeeling eyes and wondered where the human being in her had gone. But then, something else appeared in them. Was it compassion? Love? Could she still be in love with him?

'I think we'll give you this day as a day of rest. Drink and eat well, we'll start our fun again tomorrow.' She turned and walked quickly through the open door and said to one of the

rōnin, 'Leave the door open today, let the warmth come into the room. Stand guard and don't let him escape or upon your head it will be.' Then she was gone.

One of the rōnin came in with flasks of water and plates of food. He put them down beside Kai and left without a word. Kai looked at the food and I felt his stomach lurch. He needed water more than food. Water first. When he didn't respond I reminded him that I was there.

'Kai,' I said softly, 'I'm here, had you forgotten?' He jumped and his heart pumped faster.

'Bebe? Is it really you? Am I dreaming?'

'No Kai, it's me. I've come back.'

He took a deep breath and his whole body shuddered with the effort.

'Drink Kai: you need the water more than the food at the moment.' He put his hand out and dragged one of the flasks towards him. He had to use two hands to pick it up and struggled to take out the stopper and I could feel him slipping back into sleep. I had to keep him awake, sleep now would kill him.

'Drink, Kai.' I didn't know much about people with dehydration but I did know that water should be given slowly and in small quantities. 'Drink Kai,' I repeated slowly, 'you have plenty of water now so tip some onto you cracked lips and over your face. Then drink a mouthful – but only a mouthful every few minutes. You must drink slowly and regularly otherwise your body will reject it. Then, when your mouth and throat start to feel more comfortable you can eat some of the food.'

He did as I bid and I felt his agony as the water found the cracks in his lips and mouth. 'Steady, not too much. Rest for a while now. I'll tell you when to drink again.'

The stinging in his mouth was like a hive of bees gone berserk but I followed Kai's example and didn't think about it; pushed it out of my mind and concentrated on other things.

Every few minutes I instructed Kai to drink and told him when to stop. His mind was not working properly; he was too

dehydrated and was hallucinating and unable to focus. I kept him awake by talking to him about Yoshi and Masako and Sato and anything else I could think that would keep his mind alert.

After several hours of this he was beginning to think more clearly. I advised him to eat some of the food now, 'But slowly Kai, very slowly.'

By the time night fell he was stronger but still exhausted and I felt it was safe for him to let the power of sleep do its magic.

And that's what happened that first day we were together as one.

The next day I was expecting Masako to return but she didn't. The rōnin came and gave Kai more water and food and left the door open again standing guard outside.

By the middle of that afternoon Kai was feeling much better; his mind was alert and his body recovering although his muscles were still weak. He walked around the room, steadying himself by keeping his hand on the wall, and little by little the strength started to return to his shaking legs but it was slow progress. We both knew we didn't have a lot of time before Masako came back.

As evening came on and the rōnin closed and locked the door, Kai sat down and said, 'Thank you. Thank you for saving my life. I think I would have died if it hadn't been for your guiding hand. I will forever be grateful to you.'

'It was my pleasure. but let's leave that behind us now; let's think how we can get out of here.'

'I've been trying to think of a way but how can we escape with the rōnin always on guard at the door?'

'While you've been recovering, I've been thinking and I may have come up with a plan.'

I felt hope stir inside him. He was learning to trust me and that was great progress.

'I think Masako is the key to this. Sato wants you dead, there's no doubt about that, but what about Masako? She says she wants you dead, but does she really? She may be saying it to pacify Sato.'

'Mmm, I don't know about that. After her fight with Yoshi, she looked at me with hatred when I stopped her from killing me.'

'But would she have actually killed you? She was hesitating if I remember correctly.'

He thought for a moment. 'That's true, but the look in her eyes was pure hatred.'

'But she did hesitate.'

'Yes, she did. I cannot deny that.'

'Then I think that's our salvation: our only way out of this.'

'Do you think she'll hesitate again?'

'Maybe, it's up to us to find the chink in her armour.' I paused to let my thoughts form, 'Okay, let's think why she hesitated. She wanted to kill Yoshi. She almost did, it was only his fighting skills that stopped her. So why did she want to kill him? I think it was because she saw the love you had for Yoshi and she felt he was standing in the way of you loving her. If Yoshi was out of the way, then you would turn to her.'

'But that's impossible. I would never turn to her.'

'But she doesn't know that. When you love someone, there is always hope. We delude ourselves because our love is so strong we can't believe the other person doesn't feel the same – or could do – in the right circumstances. Just think Kai, what would you do for Yoshi?'

A jolt went through him as he realised he would do anything for Yoshi … anything. 'I see,' he said pondering, 'yes, I do see what you mean.'

'Now do you understand how this could work?'

His nodded, 'Yes, indeed I do.'

He was silent for a while. 'So you think that she did want to kill Yoshi but was out fought, but because she hesitated at killing me, she didn't really want to.'

'I do. Look how she has given you water and food and time to recover. She doesn't want you to die. I saw something in her eyes when she looked at you … and I think it was love. I think she still loves you Kai, even after all you've done to her.'

'That's interesting because I too thought I saw love in her

eyes before she started torturing me.'

'But why would she torture you if she loves you?'

'Because I showed revulsion at her touch … I couldn't help it Bebe. She saw how much I hated her.'

'And yet she's still giving you the chance to live … I think she hates her love for you. She's trying to squash it down, but as much as she tries, she cannot let you go and she cannot stop her love rising up even through her pain. I think she has a plan for you but she has to get around Sato. He wants you dead. And that, I think is our way out.'

'What do you mean Bebe?' (I loved the way he'd started to call me Bebe.) 'How does that matter? I'm sorry I don't understand.'

'Let me explain. We don't know how Sato and Masako met or why they got married – and so quickly. I don't think it was a love match.'

'Again, that may be true but how does that help us.'

'You told me you saw bruises on Masako's arms when you first met her in Nagoya. How did she get them?'

He shrugged.

'I think Sato is to blame. I think Masako has discovered she's married a sadist.'

He thought for a moment, 'Yes, I see – he did try to rape Yoshi. And I think he took great delight in slashing his cheek and taking away his good looks.'

'Yes, that's the nub of it. I think Sato enjoys taking from people things he doesn't have. In Yoshi's case his good looks, in Masako's case her youth and … well … what else would Sato see in her?'

'I don't know,' Kai said, 'Maybe he could see her underlying cruelty. He could see it in her because it is in him too.'

'Mmm … but if that's true then he'll want to prove to her – and maybe to himself – that he can outdo her in anything and that's why he married her. She couldn't complain if she was like that too.'

He was silent for a while. 'You may be right Bebe. Things changed for her when her family were killed and she was

forced into the real world. But even before that I always felt uncomfortable in her company. There was something about her, even then, that I didn't like. Maybe I could feel there was another side to her. One she hid from her family ... from everyone ... maybe even herself.'

'Interesting ... I'm wondering whether deep down she still thinks of marriage as a young girl would – one who hasn't had the realities of life forced upon her.'

'What do you mean?'

'Well, I know that love plays no part in marriage in your time Kai, and –'

'Wait a minute, are you saying marriage is not a business proposition in your time?'

'That's right, in my part of the world anyway, we usually marry for love.'

He laughed. 'You're making a joke. That's so funny.'

'I'm serious Kai, we usually marry for love.'

'But ... how can that work? How can you improve your family's status? Find the best person for your family's circumstances? It doesn't make sense ... why ... just anyone could become your wife or husband.'

It was my turn to laugh but I realised he was right. 'Yes, that's true ... it often causes trouble ... but let's concentrate on the time we are in now. The point I'm trying to make is that she was in love with you and hoped to have an arranged marriage with you.'

'More than hoped.' he answered. 'I think she *expected* to marry me. Her parents, my good friend Rintarō and his wife, expected it too. When Rintarō proposed the match he thought it was just a formality. I owed him my life. There was no way I could refuse. But I did ... and I now realise that was because you were in my mind Bebe. You were influencing me.'

'Really? Was I? I was struggling so much with the idea that I was now Matsuda Kai, a samurai, I didn't think I was influencing you at all.'

'It wasn't anything I could identify. I was just aware of something different inside me, I felt different and I was

thinking differently. I wouldn't have had the strength to refuse my good friend if it hadn't been for you. I feel sure about that now.'

'So, we can assume that when you refused it was a massive blow to her.'

'And to her parents, although they hid it well.'

'So this has been festering inside her ever since. I think she still has those same feelings for you. Her anger and humiliation at you refusing her – but her love for you is still there – as much as she wants to be rid of it, she cannot … and that is our way out.'

'But how can we turn that against her?'

'We don't turn it against her – we use it to influence her. Look, I think she's not happy with Sato. They haven't been married long but already she has bruises on her arms, goodness knows what else he's done to her. If we could persuade her to think there is hope for a future with you … that you can love her … she may do the unthinkable.'

Kai's mouth opened in astonishment. 'Do the unthinkable? What kind of unthinkable?'

'If we can persuade her you have had a change of heart, and if she can get you out of this prison and back into the world, then you will marry her.'

'Unthinkable !' he yelled.

'Shhh, not so loud; it will only be a ploy, you don't really do it.'

'But even if I did persuade her, what about Sato, she cannot marry me if she's already married to Sato.'

'Exactly. That is the crux of the matter. We'll persuade her to kill Sato and to let you free. She'll think she's coming with you but when the time comes you kill Masako.'

'Kill Sato? Are you seriously suggesting that I can persuade her to kill Sato? And me kill Masako !'

There was a long silence. 'I hate her, but to kill her in cold blood, not in the heat of battle … to *murder* her.'

'No, you are not listening carefully enough Kai, *you* do not persuade her – *we* will persuade her. I'll be right beside you

during all this, guiding and helping you.' I felt Kai's anxiety to murdering Masako. I hadn't thought of it like that, but I suppose he was right, it would be murder.

I had to persuade him, it was our only chance. 'Look Kai, I can feel your reluctance to commit murder, but don't forget that Masako wanted to kill Yoshi, it was only his superior fighting skills that stopped her, if he hadn't she would be the murderer of Yoshi and getting her just punishment.'

Kai leaned his back against the wall and let out a long sigh. 'I have to hand it to you Bebe; you are an extraordinary woman with an extraordinary mind. What a plan. But could it work? Could we really do it do you think?' How would she kill him? Have you thought that far?'

'That would be for Masako to work out. We could suggest poison so that people would think he had food poisoning. Maybe she could give him blow fish that wasn't properly prepared, that would kill him for sure and there would be no suspicion on her.'

'But you forget that winter is the Fugu season, and anyway, some poor chef would be blamed and probably killed for carelessness or at the very least his reputation would be ruined. No. I don't want to inflict misery on some innocent person.'

I thought for a moment. 'You're right; it was irresponsible of me to suggest that. We don't want someone else to suffer. You see, sometimes you have the better ideas.'

'Well, maybe … but if we have to think of murder – I suppose she could come up behind him and stab him in the back one night when he walked home from a restaurant. I remember, he always drank a lot so it may be possible. She could say she was at home in bed and no one could prove she wasn't.'

'By the Goddess Bebe, I think you are brilliant. I think you've done it.'

'She sells Sato for her thirty pieces of silver and pays the price of it forever afterwards.' I said quietly.

'What? What thirty pieces of silver?'

'Oh, it's just a saying Kai, one we say in the Christian religion.

Where Judas betrayed Jesus for thirty pieces of silver and was stricken with remorse and hanged himself. But the end result was the same. Jesus was hung on the cross and died through betrayal and that is what will happen to Sato.'

CHAPTER TWELVE

YOSHI

Nakamura and I had been travelling at a steady pace, but night was falling and we had to stop, eat and sleep. But how was I going to keep this man away from me during the night?

I saw an area suitable for our camp on the edge of a small river. The trees and bushes gave us cover while the flat land around the river was comfortable for sleeping. Nakamura san was obviously tired and I insisted he sit and rest while I went with Lucky to catch some fish. We went upstream and I sharpened the end of a stick to pierce the fish as they swam past. It was a skill I had learned through necessity during my travels and I was expert at it. It wasn't long before I had six reasonably sized fish, one each for us now and the rest for breakfast. It was enough.

I decided to cook the fish although the man said he would eat his raw as it would save time. I had no interest in saving time and I made a fire and built it up carefully until it was an even glow with no flames. I'd found some thin sticks and had soaked them in the river. I pushed them through the fishes' mouths and out of their tails, two fish per stick, and laid them across the top of two stones over the fire. They would cook there very quickly in the heat and not burn as long as I turned them regularly.

Fortunately, the man was of an age where tiredness made him sleepy. He had trouble keeping awake. I gave him the first of the cooked fish and he devoured it neatly and with decorum. I gave Lucky his and he took it behind a tree to

eat in peace. I ate the third and wrapped the others in leaves to protect them from insects. By this time the man had lain down and was snoring. Thank the Goddess I thought as I took myself away from him and lay down behind the tree and cuddled up to Lucky. He would wake me if the man came near.

The morning sun awoke me. Lucky stirred, opened his eyes and seeing me awake, wagged his tail and licked my face. I put my arm around him and kissed his head. We lay together for a few more minutes, enjoying our closeness and then I checked on Nakamura san. He was still asleep thankfully, so I went to the stream to splash water over my face to wake myself up. When I came back he was wiping the sleep from his eyes and looking around in a puzzled way. When he saw me he smiled and said, 'Ah, the young samurai. I remember all now.'

'How are you this morning sir?'

'Rested: thank you.'

'We must make our way as quickly as we can, we may still have the emperor's forces looking for you. Let's eat breakfast and go.'

'True young man. Give me five minutes for personal preparation.' He walked away into the woodland and disappeared from view. After we had eaten the last of the fish, we walked to the river to drink some water and I encouraged Lucky to do the same. We needed our hydration for I didn't know when we would see water again. I filled up my water bottle and was thankful the river ran so clear.

I had no idea where we were or in which direction to go. I asked Nakamura san if he had any preference. 'I don't care,' he said, 'as long as we reach some sort of civilisation where we can hire transport.'

We set off at a good pace with Lucky leading again. He kept us to animal tracks which made the travelling easier. We made good progress and I kept myself a good distance in front to discourage talking.

Lucky heard it first, the distant banging of wood on wood. We moved towards the sound carefully until we came to a

small village where workmen were repairing a house. They stopped and stared at us as if they had not seen strangers before. I smiled and bowed to them to show them that I was not dangerous and asked Nakamura san to leave negotiations to me as his grand ways would probably frighten them.

It was not long before I had ascertained that transport was possible to take us wherever we wanted to go.

'Splendid,' Nakamura san interrupted, 'then we start for Nagoya in the morning.'

I couldn't breathe. *Nagoya* !

Nagoya, I repeated to myself stupidly, trying to keep my despair from showing. I had to stay calm. I couldn't get out of this now without making Nakamura san suspicious. He was an influential man and I wanted to keep on the right side of him. I also felt an obligation to see him to safety. I liked and respected him as much as feared him.

'I have friends there that can help me,' he continued, 'how long will it take?' he asked the man who had introduced himself as the village leader.

'As you say you do not want to use the main roads that means we have to travel over country roads, many of them are just tracks, so I'd say a couple of days, but the way is not easy, you will need to travel by horse and use a guide if you don't want to get lost.'

'Splendid,' Nakamura san repeated, 'we will pay your fee with pleasure if you can get us to Nagoya safely.'

It was agreed and I felt like a insect trapped in a spider's web. There was no way out for me, and now I had to spend another night with Nakamura san. The head man offered us his house for the night. 'My family will stay with relatives tonight, please take our house and my wife will look after you and cook dinner. We are only poor people sirs,' he added, 'my wife cooks poor people's food and it will be unworthy of your great selves. I apologise for it.'

'Thank you,' Nakamura san said, 'I am so hungry that I could eat your house let alone the food that your wife will so diligently prepare. Lead the way man.'

~~~

The headman's house was basic. As we entered we waited for our eyes to adjust to the gloom inside and the smoke from the fire in the middle of its one room made us cough. As my eyes adjusted I could see that the years of smoke from the open fire had blackened the room right up to the high rafters of the steeply sloping roof. It was a different world to the one I had been brought up in and by Nakamura san's reaction, his too.

The headman's wife rushed over to put clean straw mats around the fire for us to sit on and threw water around the earthen floor to keep down any dust. She looked after us well and gave us plain but well cooked and delicious food of miso soup, rice, fish, various vegetables and tofu that tasted like nectar, 'It's a secret recipe known only to our area sirs,' she told us. She left us alone with hot tea and some sweet bean cakes for desert.

It wasn't long before Nakamura san sat closer to me and put his arm around my shoulders and his head close to mine. 'You are a handsome young man,' he said, as I tried to control of shiver of distaste. 'I can offer you a lot of help if you want to advance in the world. You are interested in politics I can see and I could help you there too. We need young men like you to hold power in the future. If you give me what I want, stay true to me, I can bring you to the shōgun's court and find you important work to do. I can offer you education and explain the ways of politics; I can groom you to be a man of importance with me as your mentor.'

A cold shiver went through me. I was sure this was just a trick to have sex with me. I needed to put him off and did it by audacity, hoping my big opinion of myself and my views would discourage him. I kept things formal.

'Yes sir, I understand what you are saying and appreciate your position in the world as it is now. But that is the reason why I am trying to change things. We should not have to rely on devious means to get ourselves into positions of power. We need all men – and women –' I added rashly, 'to become leaders of our country by honest means, for their intelligence

and vision, not for their family's position or sexual favours. The system we have now is stagnant, new blood and ideas are not allowed to grow. It is a flawed system. Our country has languished for too long in our traditional ways. They are the ways of the past, we must modernise if we are to survive in this new world.'

He surprised me by taking his arm away and sitting back a little, looking at me intently and then he confused me by laughing loud and long. I tried to keep my dignity under the blows of his laughter.

Then he surprised me again. 'By the good Sun Goddess young sir, I was right about you. You have the gift of talk and the courage to think different thoughts and are not afraid to say them.'

He laughed once more. 'I like you young man. Tell me what plans you have, both for our country and for yourself. What part do you want to play?'

I was pleased my ploy was working; he no longer had his arm around me and seemed genuinely interested in my opinions. Was I being naïve? Was it a trick to make me feel important and let my guard down?

I'd given the question he'd asked a lot of thought in the past. Today, I was Makino Yoshi, samurai boy. What would I be in the future? Could I have a future? I'd started to believe in the old man's prophesy that I had greatness in me. That our country needed people like me: that I should save myself and devote myself to my country.

Could I ever become a person of influence? Whenever that tantalising thought entered my mind I had always come to the same conclusion – it was impossible. I'd had that confirmed in Edo – life there was too enclosed and I met the same people over and over and that encouraged intimacy of friendship that would have exposed me if I had not been so forceful. I was a woman, with a woman's feelings and sensibilities. I didn't like all this killing and hated it when I had to get into fights, but that was the way our society was: I had no option. But conversely, I loved the power being a 'male' gave me, loved the influence I

74

could bring to ordinary people. This man could open doors for me, could make me an important person, he didn't object to my views. But he would object very strongly once he found out I was a woman. No, it was all impossible. When I looked deep into the future, when our country was peaceful again, which it must be as war couldn't last forever, I could only see a return to womanhood for me, I knew I couldn't keep up this disguise under close scrutiny. I couldn't see any other future for me, even though the old man's prophesy wouldn't leave me alone.

I would continue to look like a boy for a few more years but I would never develop into a man. Then a flash of memory sent me back to the old man in Kyōto and his prophesy. He had addressed me as sir, but he did not say that our country needed men like me, as I would have expected him to say, he said, "our country needs *people* like you". Did he know I was a woman in disguise? But was too polite, or too ill, to expand on it?

That thought had not occurred to me before and it came to me like a thunderbolt.

Could I be someone of importance in our country's future like the old man prophesied? He was a soothsayer; a mystic, could he really see a future of importance and influence for me – even though I was a woman?

And if so, how?

But I wasn't about to tell this man of my history or my insecurities. I needed to bluff my way out of this somehow.

I kept my voice confident, 'I haven't given my future plans much thought sir,' I lied, 'It's all I can do to keep myself alive now.'

'But you should think about it. Talking to you has given me an insight into your mind and I like it. You have the courage to think beyond what you see, to imagine a better place with more equality and the need for change in our power structure. That is a rare gift and you are not afraid to preach your views to others. That is another rare gift. Also, you have the personality to take people with you and believe in what you say.' He laughed, 'Need I say it – another rare gift.'

I was surprised, but again, needed to hide my real feelings

from this man. 'It's very kind of you sir, but you do me too much honour.'

'I don't think so young man. I regard myself as a good judge of character, let's be friends. Let's find joy in each other. I will enjoy looking after you in the years to come.' He put his arm around me again, pulling me to him and turned my face to his and kissed me hard on the lips. I struggled but his strength was much more than mine. He pulled me tighter into his embrace and kissed me passionately. I couldn't move and decided to bluff my way out of this. I let myself go limp and he gained confidence and thought I was aroused as he was. When he moved his grip from my face and moved his hands to my clothing, I jumped up fast and knocked him over.

My voice cracked, betraying my distress. 'I'm sorry, I cannot do this. It's not in my nature and I would rather find importance my own way, not yours.' I kept control of my rage as I moved quickly to the front door and opened it with Lucky rushing after me, aware of my distress. He turned to the man and growled as I said, 'I'll sleep elsewhere tonight and go my own way tomorrow. You'll be safe with the guide from the village.'

Again, he surprised me by laughing loudly. 'Before you go Yoshi, I have a confession to make. I had set you a test and you have passed it well.'

'*Test?*' I spat.

He was smiling broadly, looking self-satisfied and that angered me more.

'Please be assured that you are safe from my advances. I wanted to give you the impression that I wanted you amorously. It's not true; I only wanted to see how far you would go to get improvement in your life. What your values were. Whether I could trust you. Other young men fall into this trap and succumb to my advances. I know then that they are not suitable candidates for our country's future. We need honourable young men who will not sell their souls for the price of advancement.'

I was astounded. What was he saying? His attention to me was all a ruse? He saw the confusion on my face.

'It's true young Yoshi. I was testing you.'

I didn't know what to say, or whether to be angry or relieved. 'But why?' I asked. 'What difference would it make if I sold my body for advancement? People do this all the time, especially if you are a person with no power or influence and have ambitions.'

'That is precisely why I did it. Many things happen in the shōgun's court and a lot of it is done in secret as people manoeuvre for position and favour. Contacts are often made and business discussed in the casual atmosphere of the bath houses and accommodating tea rooms of Edo. I needed to know that you would not be tempted by the things on offer there.'

I must have looked confused because he went on to clarify it. 'Sexual favours can put you into the power of unscrupulous men, who use this ploy as a way of controlling men of influence – or by young men who think they will gain influence.' He looked at me inquiringly.

'I'm sorry sir,' I said, 'I still don't understand what this has to do with you and your attitude to me.'

'You are young yet, and innocent in the ways of influence. Look at it this way, most men fall in love at some point in their lives whether they want to or not. Or at the very least, they get a sexual passion over someone, whether it is caused by a man or a woman. If it's a woman then all is well because women do not matter and they can separate their private and public lives. But if that person should be a man, the one who is enamoured may very well respect his paramour and listen to him; take action on his suggestions or even advance him into positions of influence, but that man may not be a good man for our country.'

He looked down at the dying fire and carefully chose a short, thin log and with the grace of a dancer, placed it cautiously onto the embers. I had a feeling that he did most things with such care and forethought. He made me feel that his action was for my benefit, that he had been debating with himself, for when he looked up his eyes locked with mine and his fierce

intelligence bore into me.

'I have a privileged position with a lot of power and I respect and honour it. I do not take it lightly. My thoughts about our country mirror your own and whatever happens we need good, honest men with high principles to guide us. Our government is corrupt, and when such a government cannot accept the people's reasonable demands, only violence changes things. Our leaders are not being realistic and the people will continue to rise in ever more brutality and desperation. It will be the end of such leaders who are so entrenched they cannot bend with progress. We cannot live in the past. Everything has changed with the coming of the foreigners. They cannot be sent back – and I for one, wouldn't want them to be. It is a chance for our country to become involved with the world outside. And it's a fascinating world that I have only been able to glimpse through the voices of others. We must take this chance or be defeated – and defeat would be a disaster for our country.

Enlightenment struck me and I finally understood his position. 'I see sir,' I said slowly, still digesting the concept of influence through sex – or love. 'Yes, I do see how that could happen, Of course, I have been well aware that older men mentor younger ones, it is part of our tradition. I had just not thought about it being related to sexual passion before … maybe I've been naive.'

'Of course, not all of it is, you must understand that too. The point I am making is that it does happen, and more than I would like. If I am going to help anyone to succeed in their life, I want to be sure they cannot be tempted by sexual favours, that their values are above that. I need to ensure they will not betray me once they have got what they want. You have proved that you are a person of worth and high morals. I like that. I like you young man. I can help you.'

Two things happened then. The first one was I knew with certainty that whatever happened I could never let myself come under the power of this man. It was too risky and he spoke of making sure men didn't betray him once they'd got what they wanted. When he found out I was a woman, as he

surely would one day, he would look upon that as the ultimate betrayal and the Goddess knows what he would do to me. I cursed being born a woman again, for I wanted this chance so much, but I mustn't make an enemy of him, one never knew when paths crossed again. I needed him to feel good about me and sad he had lost me. I had to lie to him convincingly.

The second thing was the confirmation that my life was nothing if Kai wasn't in it too. Whatever happened to me or to our country, I wanted it to be with Kai.

I closed the door and sat down opposite the man, out of reach, and bowed my body so that my head was touching the earthen floor. I only stayed in that position for a few seconds as I didn't want him to get the wrong impression. I just wanted to bow to his superior wisdom and position, then, I sat up and said, 'Sir, you do me too much honour to think I could be a man of influence in our great country. But I appreciate your thoughts and intentions with all my heart. I know I am not able to be such a person as you think I may become. It is not what I want from my life,' I lied, 'I saved your life and for that I am grateful for you are a good man, a man of vision for our country, but I would have done the same for anyone in your perilous position. I did not know who you were at the time. Please believe me when I say I am honoured but it is unnecessary. I would like to go back to my own life now and continue my journey in my own way.'

He was silent for a while. 'That's a pity, I would have liked to have seen how you developed but I respect your request and there is no point in forcing you. This is something you must do of your own accord. Just remember you can approach me anytime for any favour you want. You saved my life – twice – and I will be forever in your debt.' He bowed low to me and I felt emotion raise its ugly head again. I must not get emotional, I said over and over to myself.

I bowed back to him. 'Thank you sir, I am grateful for your understanding. I will leave you tomorrow and go my own way.'

He looked shocked. 'But surely you can accompany me to Nagoya. It is a big city and you will find all sorts of people there

to talk to about your views. It would be a great opportunity for you.'

Yes, opportunity to get myself killed if Sato is still alive I thought. No, I really didn't want to go there and I knew that Kai would most certainly never go there again. It would be a pointless and dangerous.

'I thank you for your consideration sir, but I have already been to Nagoya and spoken there, it would not be productive to go back again.'

He wasn't a man to be discouraged, as I was finding out. 'I would like to introduce you to a good friend of mine. He is a man of influence in Nagoya and he may be able to help you, either now or in the future. It is an offer that you should not refuse. It may make all the difference to you one day. Please allow me to repay some of the debt I have to you.'

I was afraid of making him suspicious of me if I was to protest too much. I would accompany him and be introduced to his friend and leave very quickly. I deduced the chances of me meeting Sato, if he was still alive, would be small. He didn't move in the same society as this man.

'Very well sir, I will come with you to Nagoya,' I said with misgivings.

# CHAPTER THIRTEEN

# KENJI

It had been a month since I'd seen Bebe. We'd had no contact since I told her to go home and think about what I'd told her about my family and what happened to them – and to me – and the ramifications of it all.

She'd called me yesterday morning as arranged, saying her feelings were just the same, she still loved me. I had to hide my delight, squash it down hard, because I couldn't see her. I had to tell her I was still being followed. I couldn't risk leading him, for some reason I knew it was a man, to her.

I had to be strong and insist we stayed apart, no contact by any means, not yet. Truth was, I felt ashamed of my inability to catch this man. I couldn't bring myself to tell her of my inadequacies. My stupid pride wouldn't let me and I can't tell you how much I regret that.

I tried to analyse why someone would want to follow me. He hadn't attacked me, so I assumed he wanted me to lead him somewhere, to confirm something. Bebe?

But why would he be interested in her? Was he a policeman from my hometown trying to catch me out and prove I'd had an accomplice in murdering my family? That Chief Inspector hadn't believed me and it was obvious that he wanted to get me somehow. I knew I had to keep him from Bebe at all costs.

Since I'd spoken to Bebe something had been worrying me. In my anxiety to reassure her that I was coping well, I'd been too unemotional, too unfeeling, too cold. She would have been hurt. I'd overdone it. I wanted to phone and apologise, say I

still loved her. This was all for her.

When I told Hiro I couldn't have lunch with him as I was going to the phone box at the station to call Bebe, it was he who had the brilliant idea of buying a pay-as-you-go throw away phone. Hiro would buy it for me under his name. Untraceable unless someone got hold of the number – and I wouldn't tell anyone. Stupid – why didn't I – why didn't Bebe – think of this? But we hadn't and that was that.

I called her intermittently through the afternoon and then through the evening but there no answer. I tried again and again but it always went to voicemail. Sleep was impossible and I called her every hour through the night. I knew she turned her phone off during her lessons, so had she just forgotten to turn it on again? The next morning, when my calls were still going to voicemail, I'd had enough.

I called my office and asked for the day off work to attend to a personal matter. They'd been so worried about me and what had happened to my family they didn't query it.

As it was after 9.00 am I decided to go to Bebe's school. If she wasn't there I could wait for her but I didn't want our trains to pass each other with me going one way and she the other. As I couldn't be absolutely sure no one followed me during the day I took elaborate precautions. I took the train to Sakasegawa, three stations passed Kōtōen, and when I was sure no one was following me, I took a taxi to the supermarket near her school. I walked the rest of the way, looking around me all the time and when I got to her school I rang the bell. There was no answer. I waited. When two of her students arrived for their lesson and still no Bebe, I told them she was very sorry, but there were no lessons today. Then I started to panic. I kept ringing her bell in a desperate hope that she was inside and unconscious. Stupidly thinking the bell would wake her. I wasn't thinking straight. And then I thought of Fumi.

She lived nearby, so in desperation I rang her and within five minutes she was running towards me.

'What's happened?' She asked, breathing hard.

'I can't find Bebe. She's not at her school, she's not answering

any of her phones.'

'Have you been to her home?'

'No, I haven't.' I had to tell Fumi then about someone following me and how I didn't want to lead them to her.

She nodded and thought for a short while. 'Look,' she said, 'we should split up. I'll go to Bebe's apartment and check it out. You have a key don't you?'

'Yes,' I thought about someone following Fumi to Bebe's place, but then thought this unlikely, so gave her the key,

'And you Kenji, go to the real estate agents who handle the contract for her school, it's the one in Kōtōen, and tell them you think she may be ill inside, get them to come with their key and open the school. At least then we will know whether she is inside or not.'

'You're brilliant Fumi,' I said swallowing my annoyance that I hadn't thought of it. 'I'll go right now. We call each other as soon as we have any news.'

'Yes. I'll go in my car, it'll be quicker. I'll see you later,'

And with that she was running back to her home and I ran towards the agents' office.

As soon as we got the front door open, the agent stepped back so that I went in first, I wasn't sure if he was being polite or scared, but the place was empty. It was at that moment my phone rang and Fumi said, 'She's here, but don't get too relieved, her body's here but she's gone back into Kai.'

'I'll be right over,' I said clicking off.

When I got there fifteen minutes later, Bebe was sitting on her sofa with her head bent forwards. She looked relaxed and comfortable. Her little teapot, the one she treasured, was on the table with her best porcelain cup, the tea was cold.

'This doesn't look good,' Fumi said.

I sat next to Bebe and touched her hand. It was cold – and her pulse was weak. 'She's cold,' Fumi said, 'I put a blanket over her.'

Then I saw her phone beside her. I picked it up and checked it – it was switched on. 'The power is on Fumi. She must have

been like this since yesterday afternoon ... she's so cold.'

'Yes, we must act fast,' she said. 'Let's put her to bed and warm her up. Being cold like that is dangerous.'

I ran into the bedroom and took the quilt and sheet off Bebe's bed and took her electric blanket out of its summer storage and put in on the mattress switching it on high and covering it with the sheet. I went back into the living room and Fumi and I lifted Bebe up carefully. Fumi was stronger than she looked as she lifted Bebe's legs easily while I took her shoulders, and between us, we laid her down gently on the bed and covered her with the quilt and I put an extra blanket over her.

'Do you think we should get a doctor Kenji?'

My stricken look was reflected back to me in her face. 'You think it's that serious?'

'I don't know.'

'Well, let's leave it a little longer. Bebe would be angry if we sent for a doctor and her secret came out.'

Fumi nodded. 'I suppose you're right. But am I right in thinking she's never away more than a few hours at most?'

I nodded. 'Yes, sometimes less. The time she's in Kai's life doesn't equate to the time away from this life.'

'So, this is different ... I don't like to say this Kenji, but this is worrying.'

'You don't need to tell me that,' I snapped, and apologised straight away.

'Don't worry, no problem. Let's think.'

I had to decide then whether to tell Fumi that I had been under suspicion of killing my family. I knew that Bebe trusted her completely and I although I had told Hiro, he had not been much use in solving my problems. I decided Fumi was much more intelligent than Hiro, so with hope that she could help, I told her.

She remained silent throughout, nodding sometimes, raising her eyebrows at other times but she gave me the space to tell it as I saw it.

'The Goddess look after you Kenji, ne. I'm so very sorry.

Bebe had told me about it but not in great detail, except to say that of course you were innocent of all charges.'

'Yes, totally innocent. These people had it in for me and were determined to try and charge me.'

'But why?' Why should they have it in for you?'

I looked down at the table, unable to tell her. If I hadn't told Bebe my secret then there was no way I was going to tell Fumi before her. 'I'm sorry, I can't tell you that. Not now, but please remember I am innocent. Please trust me.'

She nodded, 'Yes, I trust you Kenji, and I respect your privacy. Whatever your secret is, it's a major part of your life, but you should tell Bebe. Take her into your confidence. It may make all the difference to how you feel about it.'

She put her hand over mine and said, 'Let's leave it there shall we. You can think about it. But in the meantime we have the problem of Bebe and the man following you.'

'I don't know what to do Fumi. I'm only an ordinary man. I'm not used to such things. I'm not a fighter – I work in a bank. I'm not Mr Macho Man. Sometimes I think I've failed Bebe.'

'You're too hard on yourself. Not many men could have coped with what you have. I think you've done brilliantly. And I know Bebe does too because she's told me. She's told me how much she relies on you, that she couldn't cope with what is happening to her without you. She loves her time with Kai, but she loves you more. I know that for a fact.'

I smiled and felt I wanted to kiss her, but resisted the urge. She might get the wrong idea. Instead, I smiled and said, 'Thank you Fumi. You are too kind and I am unworthy of such praise.'

Fumi ignored my Japanese platitudes and was all business again. 'We need to make a plan. We can't do anything about Bebe for the moment, but we can make a plan about the man who is following you. You say you are most sure that he follows you when you leave work, so what if we arrange one evening for you to leave as usual but I will be walking casually nearby. Then I could see if anyone follows you and if so, I follow him.'

'Mmm … but it could be dangerous; I don't want to put you in any danger.'

'I'd thought of that, but I don't think it would be dangerous as I will be very careful. I'll dress down and wear a shapeless hat. Men never notice women like that. I'll be fine.'

'Well then, what about your husband and kids, you have to look after them.'

'That's true, but you leave my husband and kids to me, that is not your worry.' She looked at me with a mischievous grin. 'This is exciting Kenji – very exciting. I can't wait.'

# CHAPTER FOURTEEN

# KAI

I'd stopped caring whether I lived or died. Death was beckoning me and I had no resistance.

And then Bebe came and shocked my mind into a volcano of hope.

The nearness of death made me realise her true worth. She could help, not hinder, and I understood the stupidity of my past attitude. She offered me another chance at life. I was not going to make the same mistakes again.

We'd made a plan. I wasn't sure if it could succeed, I was not a good liar I knew that much. Yoshi always saw through my little ruses. Yoshi, there he was again. Everything went back to Yoshi. I had to get out of here, had to find him.

We put our plan into action when Masako came back the next morning. I was feeling much stronger and I let her know it.

'Kai,' she said, 'you are looking much better. How do you feel today?'

I had to convince her that I'd changed; that events had altered my way of thinking.

'Thanks to you Masako, I feel much better. I offer you my thanks. I owe you my life; I will forever be in your debt.'

She looked at me with curiosity, 'Well, well, a little mistreatment goes a long way with you.'

My life depended on my acting ability. I thought of Yoshi and surprised myself at the sincerity I managed to conjure up. 'I almost died, it was your kindness in giving me water

and food and time to recover that I am alive now. My brain is clearer today and I can think properly. I now realise how much I admire you. What you've achieved since your family were killed. You've survived and prospered in the most difficult, almost impossible, circumstances and I respect you for it. You have hidden depths I hadn't seen before. I misjudged you,' I bowed my head to her, 'I apologise.'

As she looked at me I saw hope in her eyes for a second or two before she blinked and disguised it. 'I did what I had to do to survive,' she said with a stony face, but I could see she was affected by my words.

I wanted to get off the subject of our past just in case my true feelings won the battle to get out. 'You are now a lady of substance, you have an important husband, you can live your life in peace.'

She looked wistful, 'Ah, that is where you are wrong,' she looked down and I saw tears in her eyes.

'What's the matter,' I asked forcing tenderness into my voice as Bebe urged me forwards, advising me on my reactions. 'Problems can be lessened once they are talked about.' I forced myself to say the unthinkable. 'Masako, can I be honest with you?'

She nodded, 'Please, I welcome it.'

'Over these past few days I've had plenty of time to think. Things are different now, we, you and I, are different too. Yoshi is no longer here and is probably dead.' Her eyes widened and I saw a flash of pleasure show itself, but I ignored it. 'I almost died but for your kindness and I now need to start a new life. The thing I regret more than anything is that I didn't see your worth before you married Sato. Now you are a married woman and are no longer free.'

That hope in her eyes surged again. 'What do you mean Kai?'

I took hold of her hand as Bebe urged me to, and said with as much remorse as I could, 'I mean I am sorry I didn't marry you when I had the chance. I see now that I was stupid and let my ideas gain more importance than they merited. The most vital thing for a man is to have a wife beside him to help him

through life. If you'd been my wife, I would not have made such a mess of things. Not met Yoshi, who I now regard as one of the worst things that could have happened to me. You and I would have succeeded where Yoshi and I failed.'

I looked down at her hand, which I was still holding, and stoked the back of it tenderly. When I looked up she had tears in her eyes.

'Well done, very convincing,' Bebe whispered. 'Stroke her face, you can do it. Say you are sorry for her pain and wish you could help her.'

When I looked into her eyes, there was so much hurt there I almost felt sorry for her until I remembered her cruel ways and her attempted murder of Yoshi.

'Forget that,' said Bebe urgently, 'forget it all except what is happening now. Keep your concentration. You've got her. She believes you. I can see it in her eyes. Don't ruin it now with wayward thoughts. Our lives depend on this Kai.'

I forced compassion into my eyes as I put my hand up and stroked away her tears. 'Why are you crying?'

Her breath shuddered. 'Don't you know Kai? Don't you know how much I have loved you … still love you?'

'Oh, Masako,' I said quietly, 'poor, poor Masako. It's all been a mess hasn't it? But it's all been my fault. Can you ever forgive me?'

'Oh, Kai, I can forgive you anything.'

She put her hand up to my face and stroked my cheek. She leaned towards me and I knew she wanted me to kiss her. I held back, revulsion surfacing, '*Do it*,' Bebe hissed at me. 'You have to kiss her; everything depends on her believing you love her. For us Kai, kiss her for our lives.'

I pretended this was a dream and it was Yoshi I was kissing. I leaned closer to her and put my lips onto hers.

'That's right,' Bebe whispered, 'it's Yoshi you are kissing. Yoshi's mouth … Yoshi's lips …'

I was inflamed with his image and really thought I was kissing him as I put my hand at the back of Masako's head and pulled her closer as my lips opened and passions flew. We kissed like

starved lovers for a long time and Bebe kept up her mantra of; 'It's Yoshi ... Yoshi's mouth ... Yoshi's lips ...'

When we broke apart both of us were breathless, our chests heaving deeply as we searched each other's eyes for love and confirmation of that love. I was still thinking of Yoshi as I looked at Masako. I could see that she had opened her inner self to me. I'd got her.

'Would you really marry me if you could Kai?' she asked.

'You need ask me after *that* kiss? Yes, yes, a thousand times yes.'

Bebe whispered to me, 'Now is the time to secure the plan. Do it Kai. Push on. It will soon end if you do it right.'

I looked into her eyes, 'If only I could marry you I would look forward to a life of love and passion. But your husband holds me prisoner. He hates me so much I shall probably die here.' A genuine sob crept into my voice.

Masako kissed me passionately again and I responded. She pulled away a little and said in her softest voice, 'Kai, I would marry you too if I didn't have my husband.' She looked down. 'He's a bad husband, cruel and hateful. I wish I'd never met him.'

'What do you mean? Does he hurt you?'

She paused and seemed uncertain, Bebe told me to wait and not say anything; to give her space to incriminate herself. I did as she bid.

'He doesn't just hurt me ... he tortures me.'

'Tortures you?'

Again, she looked down as if she was ashamed. She blinked several times and finally whispered, 'He can only enjoy intimacy if he is hurting someone. It's the pain he inflicts that arouses him.'

'I saw bruises on your arms when we first met, did he do that?'

She nodded and again and whispered, as if she didn't want to speak these things out loud. 'But that is nothing compared to the burning.'

'*The burning?*' I hadn't expected that.

She nodded again.

'How does he burn you?' I asked softly.

Reluctantly she said, 'He lights a spill from the lamps and uses it to burn off my body hair ... all of it.'

'He burns off your body hair?'

She nodded again, 'A little more every night: arms, legs ... everywhere.'

'The Goddess help us, I cannot believe this.'

'He likes to grip me hard during our ...' she paused, embarrassed.

'Go on,' I said softly, 'you don't have to be specific, I can imagine easily enough.'

She blinked back tears. 'He hits me ... afterwards, but always where it won't show. He says it is my fault that he is weak for the flesh and because I tempt him so he must punish me.'

'How long have you been married?'

'Six weeks. Six weeks of misery and agony and I don't think I can take much more of it. I can hardly move I hurt so much.'

'The bastard,' I exploded and meant it too. Even Masako didn't deserve that. I had to ask the next question even though I knew she would not welcome it. 'But why did you want to inflict pain on me too? Why do that?'

She looked into my eyes and took my hand, 'Because if I didn't, he would. And it would have been many times worse if he had tortured you. He will soon. He has given me a week with you and then he will finish you off in the worst way he can think of.'

I felt sick. 'The gods help me.'

'Yes, Kai, they are the only ones now who can help you.'

'Now, Kai,' Bebe said, 'we've got her. Come on, you can do it.'

I took her hand again, this time with more sympathy. 'Masako, listen to me. I think I've thought of a way out of this for both of us – and it may just work.'

I saw hope fill her eyes. 'What do you mean? How?'

'Well ... this is not thought out – it will need to be planned – but what if you killed Sato ... and set me free ... and then we

could run away together and start a new life.'

I saw hope and pleasure in her eyes. Maybe this would work after all.

'But how?' How could I kill him?'

'You and I are skilled fighters, we can think of a way.' I paused pretending to think, 'His food could be poisoned? Someone could stab him as he walked at night? Or when he was in bed?'

'Wives are always suspected of poisoning their husbands, that would be too dangerous I think.' She thought for a moment, 'but someone stabbing him in the street – that could work as he has many enemies. Everyone knows that.'

'Then that's our plan.' I said enthusiastically before she could change her mind.

'Let me think … I remember he entertains his customers and suppliers in restaurants. Maybe you could be waiting for him in a dark street and stab him as he passes.'

She thought for a minute. 'Yes, it could work.'

'Could you do it do you think – kill him?'

She looked into my eyes, 'For you Kai, I could kill a whole town.'

I pushed down my repulsion and somehow managed a smile. 'Then you rush back here and release me … and then we disappear.'

'But wait, if I disappear straight afterwards, it will be suspicious and people will come looking for me.'

'I hadn't thought of that … then you would have to stay here and we meet up later. I'll stay in Nagoya until you are free to leave. No one will expect you to stay once the enquiries are finished … another thing I've just thought of … he's a rich man, does he have children?'

'No, that's one thing he wants but cannot get. He's so angry and says the stupidest peasant can get children, but he, educated and successful, someone who needs children, cannot find a wife who can produce them.'

'He's been married before?'

She nodded. 'Twice: both of them died.' She closed her eyes, as if trying to block it out. 'That's why he married me. He said

I was good child-bearing material.'

I could see she was upset, but I had to know. 'Excuse my impertinence, but why did you marry him?'

'More fool me. The day I met him was the worst of my life. I didn't know about his former wives until it was too late. I was a fool.'

She took several deep breaths, 'When you left me tied up, some of the nearby villagers rescued me. They were kind so I remained with them. A few weeks later, Sato came by with some of his friends. He was on one of his business trips, don't ask me what because he never discusses his business with me, but he took a fancy to me, so stayed on for a week or so. He was rich and charming – ' she gave an ironic laugh at my expression – 'oh yes, Kai, he can be quite charming when he wants to be … and he was kind to me.'

She sniffed and looked down, as if remembering and her voice quavered, 'He asked me to marry him. I thought my dreams had come true: he'd rescued me from poverty and shame and I didn't need much persuading.'

She got up and walked the few steps to the other side of the room, turned and leaned against the rough, cold wall as if the distance between us helped her to say what she had to. 'He insisted we marry as soon as we got to Nagoya and although I thought it strange, I was so eager to be his wife, I pushed it to the back of my mind: fool that I was. I realise now that he wanted to marry before anyone could warn me against him. He … he has a reputation. It started on our wedding night: the pain, the burning … and his pleasure at my distress. I've spent the last weeks trying to think of a way out. You have come just at the right time Kai.'

'Then you'll do it? You'll do it for us?'

'I'd do anything for you Kai, you know that. I'd kill myself if that made you happy.'

'No, just killing Sato is enough.' I said while thinking, how can I kill her once she's killed Sato?

'Stop that.' Bebe shouted at me. 'You mustn't think like that. Not now, keep your mind pure or she could see through you.'

93

I knew she was right.

'When will you do it?'

'Tonight.' she answered firmly. 'I know he is out at his favourite restaurant with some businessmen and I cannot take another night of his torture. Not now I have you.' She looked at me and love shone out of her eyes and I had to remind myself that Masako was as cruel as Sato in her own way. She deserved what she was going to get.

'Then, if it's tonight, what's your plan?'

'The restaurant is on a quiet street, very expensive and there are a lot of places to hide. I'll wait for him to leave and take my chance when it comes.'

'But wait, where will you get the knife? You cannot use anything from your house.'

'No, but I'll find a way to get one, let me worry about that.'

She walked purposefully back and sat down on her knees in front of me, looking deeply into my eyes. 'I can do this. I *will* kill him tonight. Then, after it's done, I'll rush back here and release you and you escape via the southern gate which I'll leave unlocked. I'll go straight to my bed, making sure no one sees me.'

'That's a good plan. It will work.'

'Yes, I think it will, but you forget one thing Kai.' Her look had turned hard.

'What?' I asked in alarm.

'Where will we meet afterwards? You do want to meet me afterwards don't you?' Again, that hard look: I'd been careless and alerted her. Damn. Damn. Damn.

'Stay calm,' Bebe said softly, 'she's testing you. Stand up and take her into your arms. Kiss her passionately. Ask her then if she doubts that you want to meet her afterwards. Make this convincing – our lives depend on it.'

I did as she suggested and Masako melted into my embrace. I felt proud of myself and my ability to deceive. 'Don't get too confident; that way leads to disaster,' Bebe reminded me.

She was right; I'd have to watch myself.

There was a knock on the door that made Masako and I

jump like frightened rabbits, we threw ourselves apart and I sat on the floor with my back to the wall and Masako went to the door and opened it. One of the rōnin stood there holding a tray of food and drink.

'I'll take it,' she said, 'we're finished here anyway.'

She left the door open and put the tray down beside me. 'Tomorrow Kai, we start our sessions in earnest, up to now it has all be just practice,' she said for the benefit of the guards but smiled at me as she said it. As she left I heard her say to the rōnin that they should lock the door but there was no need to stand guard.

The door slammed shut behind her and the bolt was thrown. I set out a huge sigh of relief as Bebe said, 'We did it. We fooled her. Well done Kai. You were brilliant.'

'I can't claim all the glory; I couldn't have done it without you. You kept me focused and warned me when I was straying.'

'Well, we both did it then, but now it is time for us to rest. Eat and drink as much as you can, you'll need your strength for tonight.'

# CHAPTER FIFTEEN

# YOSHI

AUTUMN 1865

We rode into Nagoya three days later. My dread that Sato might still be alive made me swear to myself that I would finish him off if he was. My common sense meanwhile, told me to stay out of sight and avoid that situation, especially with Nakamura san around, he was too curious about me already. He insisted on Lucky and I staying with him at the same expensive inn. He had so much influence that I was allowed to keep Lucky in my room. I hadn't had such luxury for a long time and I was enjoying it. I had to keep reminding myself that this was not real life – not anymore.

The next day, Nakamura san went to visit his important friend.

'I'll introduce you another time Young Yoshi,' he said. 'I have pressing business to take care of so please entertain yourself as you so desire. Everything will be charged to me, so don't worry about that.' He smiled his knowing smile and left. I had to wonder if this was another test to see if I would spend his money lavishly or not. Of course, I had no such intention and decided to go and see the old woman who had stitched up my scar. It was safer to take Lucky with me rather than leaving him at the hotel and run the risk he would escape to try and find me. He was an added danger as we walked the streets together for people may not notice me as I walked along alone, but

they would certainly remember the young man with the fierce looking dog if they had attended any of my talks. But I had to take the chance. Lucky held my heart and I would never put him in danger if I could avoid it. We were together for life now.

I'd got directions from the hotel and kept to the back streets and walked quickly with my head held down whilst keeping a sharp look out. Within thirty minutes I was knocking on her door. My heart was beating fast and I felt nervous for I was returning to a life that had now gone, but it was the one I wanted back.

When she answered her eyes widened and she beamed her black toothed smile, 'Young Yoshi san! Oh, thanks to the Goddess for keeping you safe. I've been worrying about you and Kai san.' She looked around me into the street, 'But where is he?'

'I don't know good lady.' I didn't want to tell her that we had had a great fight and falling out so just said that circumstances parted us and I was looking for him.

'Then come in good sir, my poor accommodation is at your disposal. Bring your dog out to the back. I called Lucky to me and we went quickly through the house and I told him to stay outside in the tiny yard and the old lady gave him a bowl of water. She made me tea and examined my scar. 'It's healed well,' she said, gently pulling at it.

'You did a good job kind lady, I am indebted to you.'

'Not at all sir, I am just thankful that I could bring my skills to help you,' she paused and I knew she had something on her mind, so I remained silent. At last she said, 'That same night they found a local merchant naked, bleeding and almost dead outside a restaurant. It was seen as a scandal sir; that he was found in such a way.'

My heart beat so hard I was sure she could hear it and I tried to calm myself and ask innocently, 'Oh yes, why was it such a scandal? Surely this kind of thing has happened before?'

'True sir, but not with the word "rapist" written in blood across his chest.'

I managed to keep myself calm and feigned disinterest and

asked casually, 'And did this man live or die?'

'Oh, he lives sir. He lives all right.'

Her tone of voice made me ask, 'You have issues with this man?'

'I shouldn't speak ill about someone like him, walls have ears but lots of people have issues with him. He is not a man to be trusted. There, I've said enough to get me hanged if he found out.'

I laughed, 'Surely he is not as important as that? He couldn't get you hanged.'

'Sir, that man has many in his pocket and afraid of him. I wouldn't put anything beyond him.'

I didn't show the old woman my anxiety and glossed over it saying, 'Well, then we shall all have to make sure we stay out of his way.' I was grateful for her warning; she'd guessed Kai and I were the culprits. I knew she would keep her own council, but I was worried just the same. One never wanted a man like Sato as a mortal enemy, which is what he was to me.

When I left her, I gave her a message for Kai. If he ever came back to see her she was to tell him I forgave him everything.

The next day, life took a different turn as Nakamura san took me to meet his important friend. I was unsure about this visit and in retrospect I realise that I was fooling myself. Living my dream and the possibility of having influence; fulfilling the old man's prophesy of greatness for me. I was curious, ambitious and lying to myself.

He lived in a large samurai house in the best part of Nagoya and I could see that he was a man who didn't have to worry about money. Nakamura san introduced me to his good friend Honda san. I bowed very low and he said, 'Makino is a name I have heard often from my sons when they talk of the emperor's court.'

My heart thumped as I quickly replied, 'Alas my family has no connection to the emperor's court.'

He nodded but looked at me curiously. I'd have to be careful around him. He was a man of wealth and importance so I

didn't dare speak unless I was spoken to first. We took lunch at his home, served by many servants and we spoke of general things, but after lunch, when the servants had left, Honda san said, 'Tell me young sir, what is your story? How were you able to save my very good friend here from almost certain death and then lead him to safety, a feat for which I am most grateful I may add.' He looked at me with a benevolent smile but I knew it hid a lot.

I told him of the fictitious life I had created for myself. My family were a poor samurai family from Kyōto. How I had played war games with my brothers and loved to learn things but we were just a poor, unimportant family. He encouraged me to tell him of my vision of our country. How I saw it now and how I wanted its future to be.

Again, my ambition to be influential and fulfil the old man's prophesy rose up in me, but equally, my fear of discovery surfaced. For a brief while, I'd been undecided if this was the moment to grab the opportunity of making something of myself. But even though Honda san's face stayed expressionless, I could see thoughts in his eyes and knew he was making a close inspection of me. It was then I realised couldn't go through with this. I had to refuse any help either of them could offer me because I knew I'd be found out. They were clever and I felt sure had their own spies everywhere. I couldn't keep up my disguise under the close scrutiny of servants and bureaucrats. Sooner, rather than later I would be found out. And then all hell would break loose.

Nakamura san would accuse me of betraying him, everyone would be incensed at my audacity and I would probably be beheaded, or worse, told to commit seppuku, for bringing shame on my family and making the government look foolish. This confirmation of my inability to carry my disguise under such circumstances freed me of my nervousness and I was able to let my natural oratory take me over as it did when I gave my speeches. My tongue flew like playful birds on the wing, enjoying the sweeping air currents. Dipping – diving – soaring with the excitement sweeping me along effortlessly: my words

coming out like poetry.

When I'd finished he was looking at me with open admiration. 'I see what you mean,' he said to Nakamura san. 'He is a true orator with a special gift. And he is so young,' he added.

The two exchanged a look and Honda san leaned towards me a little as if he was going to share a confidence. 'Young sir, I have never come across someone like you before. You are unique and I do not want to lose your talents. Nakamura has told me of his desire to become your mentor and help you on your way in this world of ours, such as it is,' he added wistfully. 'We need negotiators and people with vision and the skills to impart these ideas to others; to bring people with us into a new world. You could play a very important part in this. It is a great opportunity for you and you should take it with gratitude and do your very best for your country and work hard.'

The time had come for me to refuse. Sweat broke out on my face even though I was sure of my decision. I was being ungrateful and throwing back a great opportunity that few get and even fewer turn down. I was about to insult them with my rejection even though I didn't want to make enemies of these men: they were too powerful.

Still on my knees, I slid back a little on the tatami mats so that I was able to bow low to them with my forehead touching the mats. They waited and took my respectful bow and when I raised my body upwards, both were smiling at me.

'Sirs, you do me too much honour. I am totally unworthy of your views on my ability.' They interrupted by saying, 'No, no, young sir. Not at all.'

I continued, 'Life is short and the unexpected happens, we cannot dictate our fate. It is up to the gods to do that. From somewhere deep inside me I know the gods are speaking to me and telling me that my fate lies in another direction.'

Both sucked in their breath, saying nothing, but their eyes showed their astonishment and displeasure.

'Please forgive me sirs, the opportunity you offer me is one I would gladly accept if there was any chance that I felt I could do justice to your confidence in me. But I have a major flaw in

my personality and that flaw will stop me being the man you want me to be. I cannot tell you what it is, please allow me some privacy, but it is there and I cannot change it. I am sure there are other people who think like me, who would take an opportunity like this with both hands and revel in it, as I would do if circumstances didn't dictate otherwise.'

'But we can help you with any difficulty,' Nakamura san said, despair showing in his voice, 'you must not let fear dictate to you.'

'It is not fear sir, it is something that cannot be overcome as fear can be. Please believe me; this flaw in my personality is permanent and inflexible. I have been greatly honoured by your interest in me, but now, I have to take my leave of you and continue my work in my own way.'

Both looked at me with displeasure and Nakamura san had pain in his eyes.

'Tell me again that I cannot persuade you and I will accept your decision.'

'Thank you sir, but you cannot persuade me under any circumstances. Please do me the honour of accepting that I know what is best for me. I may be young, but I know myself.' I bowed with my head touching the floor again.

'Very well then,' Nakamura san said in a businesslike voice, 'that is that. But remember that I still owe you my life and if ever you need any help for whatever reason or are in a position to change your mind then you can always contact me. My personal address is written here on this card. Please keep it close to you and use it if you need to. Also, this is a poor substitute for my life, but please do me the courtesy in return by accepting this money that you can use to help you through the future.' He took a money bag out of his sleeve, 'This is full of gold coins, keep it safe and don't tell anyone you have it or you will be robbed or worse in these bad times. I hope young sir that we may meet again.'

Of course, I refused the money several times until form was appeased and I knew that I must accept it, even though it put me in his debt.

'You honour me too much sir, but I accept with happiness that I was able to save such a worthwhile person's life. I will never forget you.'

I stood and bowed to them again and Honda san clapped his hands. A servant appeared and escorted me out.

# CHAPTER SIXTEEN

## KAI

The day of our escape was the longest of my life. Bebe and I went over and over the various scenarios of how I could kill Masako. I had no weapons so would have to use my hands. I was not looking forward to it.

'You will have to strangle her,' Bebe said in exasperation.

'I could break her neck,' I suggested.

'Mmm, which would be best for you?'

'I think strangulation would take too long, she may wriggle out of it, I'm not as strong as I should be at the moment. And she could thrash about and make a noise, no, I have to break her neck.'

'Okay, that's decided then. Where will you do it – in the garden?'

'Yes, of course in the garden,' I said bad-temperedly.

'Don't snap,' Bebe snapped.

'Look, we're getting nowhere going round and round this. Just leave the killing to me will you?'

'Yes, but don't mess it up.'

'If you keep on about it I will mess it up from sheer nervousness. Leave it be now.'

'Yes, sorry, I'm nervous. The threat of imminent death or torture tends to play on one's nerves.'

'Really, I hadn't noticed.'

'Okay, sorry, let's concentrate on getting you stronger. I think you should walk up and down and do some exercises.'

Suddenly I laughed, and then I couldn't stop.

'What's so funny?'

'You sound exactly like my mother when I was a child.'

She chuckled. 'You're right. I sound just like someone's mother – oh, how awful.' We laughed together, and when we finally got ourselves under control, we fell into silence. It was blissful.

As darkness decended, the minutes turned into hours as time dragged out our last possible minutes on this earth. It was all up to Masako now.

Would she do it?

And if she did, would she succeed in killing him?

Or would an angry Sato come storming through that doorway with Masako lying dead somewhere?

Would she betray me?

Would she be caught?

'For goodness sake Kai, stop thinking the worst all the time. You're making me more nervous,' Bebe said bad temperedly and then, we heard someone fumbling with the bolt. It seemed an eternity before the thing was released quietly and the door opened slowly. My heart was beating so hard it was stopping my breath as I peered into the darkness. There was a full moon that night and the shape of Masako was illuminated in the doorway.

'Come quickly Kai,' she whispered.

I walked towards the door, wary of her in case she pulled a trick on me. As she moved aside I stepped through the doorway and looked quickly around. There was no one there, she had kept her word, and I realised I was free. A joy so profound hit me, and I knew then just how much I wanted – needed – to live.

'Do it now Kai. Break her neck quickly now.'

I tried to push Bebe out of my thoughts as I whispered to Masako, 'Did you do it? Is he dead?'

'Yes, he's dead.' she whispered back and then a sound came out of the darkness which shouldn't have been there. Masako grabbed my arm and pulled me behind a large bush. We waited: both of us stiff with fear as people came out of the house

exclaiming the beauty of the moon.

'Who are they and what are they doing?' Bebe hissed.

'They're servants by the look of them,' I said trying to get a better look without being seen, 'and they are having a moon viewing party – autumn is the best time to see the moon in all its glory.'

'Your peoples' love of nature will get us killed,' she said petulantly.

I took great pride in being able to tell Bebe to calm down; usually it was the other way around. I cursed the unexpected interruption. There was no way I could kill Masako now with others so close by. I had to think fast.

I whispered to Masako, 'Look, we cannot be seen together, I'll go quietly around the back of the garden to the gate while you wait until they go indoors and then sneak along to your bed. You must not be found outdoors, that's vital,' I said hoping I sounded convincing. My main thought was my own safety, not hers, but I had to convince her otherwise.

She looked at me with love and the moonlight shone on her tears as she nodded. I added for conviction, 'I'll meet you in three days as arranged. Don't worry, I'll be there. If I'm not, then I'm dead.' And with that I turned and moved silently away, keeping low. For all our sakes I hoped and prayed that she had left the outer gate unlocked. It came into view and I put my hand out and lifted the latch. It opened. I closed it behind me then cursed my stupidity at not asking where she had killed Sato. I didn't want to head anywhere near him.

'Stay calm,' Bebe said, 'let's go in the direction of Kawamoto san's house as we agreed. We will just have to take our chances. But go Kai. Go, go, go.'

I didn't need any further encouragement as I turned right and ran as fast as I could. When I got to the corner and turned into the next street I slowed to a fast walk. Then I heard the sound of running feet and shouts from the direction of the next street. My heart lurched as Bebe said, 'Turn left Kai, look there's a street there. Walk up there calmly, don't act suspiciously.'

'Yes, you are right.' My thinking was sluggish. I was glad again that Bebe was there to help me.

I walked all night, greatly relieved my broken leg was holding up well. I rested here and there until daylight and found a small, cheap inn where I knew they were used to customers like me and wouldn't ask questions. I asked for a quiet room and a substantial breakfast and not to be disturbed. As I finished my meal, I lay down and fell into a deep sleep.

I slept all through the day and night without waking and the next morning I felt stronger and was thankful to Bebe for letting me sleep. We decided to leave Nagoya as quickly as possible.

'But first,' I said, 'I must go and visit the old woman who sewed up Yoshi's scar. Then on to Kawamoto san who saved my life. I must thank them both profusely and show them that I am still alive and well and offer them assistance if they need it. It is my duty.'

'I understand Kai. One must never forget one's friends. I agree. Who shall we visit first?'

'I think the old woman. She is the nearest I think.'

'Good, let's do it then. The sooner we do that, the quicker we can leave Nagoya and be safe.'

# CHAPTER SEVENTEEN

## BEBE

I heard voices in the distance as I struggled with the forces pulling me. 'No,' I shouted, 'not now. I can't leave Kai now. Please, he needs me ... he needs me ... '

'Bebe,' someone was saying over and over. I thrashed about resisting the forces that were pulling me out of Kai's life but he was getting weaker and fading into the distance as the voices calling my name became stronger.

'Bebe, come back to me.'

'Bebe, come back to us,' another voice said. Was it Fumi?

Kenji ... Fumi ... their names went around in my head getting more prominent and then I was looking into Kenji's eyes and his look of love kept pulling me from the last tendrils of my other life. I remembered then my own life, one I wanted just as much as Kai's.

'Oh, Bebe,' Kenji said, his voice breaking. You're back. Thank all the gods that ever were.'

My vision cleared and I saw Kenji sitting on a chair at the side of my bed. I felt someone squeeze my other hand and turned my head and saw Fumi sitting on a chair on the other side. She too had tears in her eyes and was sniffing profusely.

'What happened?' I asked, as I looked from one to the other and they both sniffed this time.

'I was so worried, Kenji said. 'I couldn't find you and you'd been gone for over twenty four hours.'

'Twenty four hours,' I shouted in alarm as I looked from one to the other.

'Yes,' Fumi said, 'we were so worried and then we found you here in your apartment unconscious on your sofa. We moved you to your bed about an hour ago.'

'But ... wait a minute ... my mind is foggy ... let me think ...' I stared into space as I brought my own life back into focus, it was more difficult this time as I was still entrenched in Kai's life and I couldn't understand why it was taking me so long to come back ... was it the magic? Was it changing? Something was different. I pushed those thought from my mind and concentrated on now.

Thankfully, my mind cleared and I remembered my own life. 'But Kenji, why are you here? You said we must not meet yet because that man was still following you – it was too dangerous you said. I don't understand. How did you find me?'

Kenji looked over at Fumi and she said, 'Shall I leave you alone? Maybe you don't want me listening in.'

'That's kind of you,' Kenji cut in, 'but no, let's have no secrets. The truth is Bebe that when I spoke to you recently and said we still could not meet. I felt ... felt I was ... oh, this is hard to say, it sounds so silly now.'

I put my hand over his and squeezed it gently. 'Please, just tell me my love. I'm sure I'll understand.'

He smiled and put his other hand over mine, 'Thank you. Well, it was just that I thought I'd been too harsh when I spoke to you ... you know ... too distant, too uncaring ... I just wanted to tell you everything I do is for you. I was afraid my coldness had hurt your feelings. But I couldn't phone you and then, Hiro had a brilliant idea and suggested I buy a throw-away phone and call you on that. No one could trace it because they wouldn't know I had it. But I couldn't get through; my calls always went to voicemail. Oh, Bebe, I was so worried about you.'

My heart filled with my love for this man. 'Oh, Kenji, you are so sweet. Thank you ... and good for Hiro ... why didn't we think of that?'

'Well, never mind about that, we didn't,' said Fumi, 'but let's thank the gods for it, for if Kenji hadn't called you we would

not have known what had happened to you and the goddess knows when you would have come back … you were cold Bebe, and as you had been there for so long you would be dehydrated.'

Dehydrated? The word meant something to me. Where had I heard it? It was so familiar … but I couldn't grasp the thought. Then I realised that my throat was dry and painful. Maybe I was just thinking of my own thirst.

'I need to drink something.'

'Yes, here you are,' Fumi fussed, 'drink this water. But slowly now, you shouldn't drink fast if you haven't drunk for such a long time. There it was again. Why was that so familiar? But again, the thought slipped away.

As I sipped the water we talked. They told me all that had happened.

'But if I wasn't answering my phone Kenji, why didn't you just come here straight away. Was it the fear of the man following you?'

He sighed and nodded again. 'It was – and I now see how stupid I've been. I should have just come.'

'But you didn't know Bebe was in danger,' Fumi added, 'don't be too hard on yourself. We can all see things clearly after the event.'

'You're right Fumi,' he said slowly as if he was sick of it all, 'it will do us no good to dwell on the past. Let's work out what we have to do now.'

'Do you have any more of an idea who is following you?' I asked.

He shook his head and looked dejected. 'No, unfortunately, but I think it might be a policeman from my hometown, keeping an eye on me I think you say. Hoping I'll lead him to an accomplice to the murder of my family.'

'But Kenji, you've been cleared,' I said. 'The coroner decided that it was an accident and your brother fell and knocked over the paraffin heater.'

'I know, but the police don't believe that. They still think I killed them.'

'But why Kenji?' I asked as Fumi and I exchanged a look.

'I can't tell you that,' he said angrily as he got up and walked into the other room.

'He's very upset. I've never seen him so upset before,' Fumi whispered.

'Yes, he is. He's carrying a burden he feels he can't share. It's such a pity.'

Fumi nodded. 'I told him to tell you his secret. That he would feel better if he did.'

'He wouldn't tell you either then Fumi?'

She shook her head. 'He's in shock I think. It must be terrible for him. He's lost all his family ... and in such an awful way. He cannot accept it maybe. Not yet.'

'Yes, I agree, He's holding it all in. He can't let go while he thinks I'm in danger.'

'Yes, grief is strange and no one reacts in the same way. He told me he was not Mr Macho Man. I think he's trying to be Mr Macho Man for you.'

I looked at her for a few moments, 'I think you could be right Fumi. All this has had a profound affect on him – you know, Kai and everything, Nobu, the fire ... it's wearing me down too.'

Kenji came back in carrying three mugs of coffee. 'Sorry,' he said, 'I've had no sleep, but that's no excuse for my rudeness. Sorry.'

He put the coffee down and I sat up in the bed as he arranged the pillows behind my back. He sat on the chair and I took his hand in mine. 'There's no need to apologise my love.'

Both of us were vulnerable and exhausted. We looked into each other's eyes and I saw the depth of his love shining from them, far more than I had ever seen before – but there was something else too – grief, anger, sorrow. He let me into that place deep inside that one keeps for oneself. My heart went out to him and I let him see into my own inner place. No words were needed. Our understanding was absolute.

When we came back to the realities of the present, Fumi was looking out the window, drinking her coffee, giving us space.

We were quiet for a while until Fumi said, 'Have you remembered any more of what happened to you this time Bebe?'

I nodded, 'You're a mind-reader Fumi, because as we've been sitting here quietly, memories have been coming back to me.'

With both of them sitting either side of the bed again, Kenji holding my hand, I told them about Kai being in prison and Masako torturing him and of our escape and how we were going to see the old woman who had sewn Yoshi's scar. I finished by saying, 'This thing that happens to me, it's strange because it took me to Kai when he needed me – it saved his life. Then it took me out of his mind while his life was still in danger.' I shook my head, 'I don't understand it.'

'That's funny,' Fumi laughed. 'Who does understand it?'

We laughed at the absurdity of it all and it broke the tension. Good old Fumi.

All business, she pulled us back to the present. 'Well, we can't do anything about Kai and the past, but we can do something about this person who is following Kenji. We need an action plan, ne.'

'Yes an action plan,' Kenji said, jumping on the suggestion. 'Fumi and I were talking about this while we were waiting for you to come back to us.' He told me of their plan.

'It's a good one I think. It could work.' I thought for a moment. 'Kenji, you think that this man almost certainly follows you when you leave work in the evenings?'

'Yes, I can feel his eyes on me.'

'Okay, well let's start as soon as possible and get this thing finished one way or another. Fumi, can you arrange to be free tomorrow evening around six fifty outside Kenji's bank.'

'No problem,' she answered.

'Obviously, I can't be there as I'm easily recognised as a foreigner, but you can blend in Fumi.'

'I agree. I'll wear something dark and ordinary so that I don't stand out. Kenji and I decided that he leaves his bank at his usual time and walks to a bar a few streets away. That will give me a chance to see if anyone is following him. He stays in the

111

bar for half an hour and I'll watch to see if the man waits. We've chosen a bar with a coffee shop opposite it, so I can go in there and have a coffee but really, I'll be watching the man.'

'Unless he goes in the coffee shop too.' I added.

'Yes, he might, but it will just mean it will be easier to see what he does. I'm not worried about that. After half an hour, Kenji will leave the bar and go home and I'll wait and see what the man does. I'll be observing him.'

'But be careful Fumi – he could be dangerous.'

She couldn't disguise the excitement in her eyes, 'Oh, don't worry about me. This is exciting, I can't wait.'

'Be careful though, don't let him see you.'

'No, don't worry, I'll be careful and I'll keep in touch via my mobile phone.'

'I'm going to be on pins all evening,' I said.

'On pins?' They both queried together with raised eyebrows.

# CHAPTER EIGHTEEN

# KENJI

The following evening as I left work at seven I resisted the urge to look around for Fumi or the man. I walked at my normal pace to the bar, ordered a beer and kept checking my watch for the half hour I was supposed to stay there. It was the longest half hour of my life. Finally, the time went by and I left the bar and walked home.

I called Bebe and asked it she'd heard from Fumi.

'Yes, she called and said a man is following you. He's waiting near your apartment building. Unfortunately, she hasn't been able to see his face.'

My anger exploded. 'Well, whoever it is, I'm going down to have it out with him. I can't take this anymore.'

'Wait, he might be a skilled fighter, he might be mafia, you know, ya … I struggled for the Japanese word.

'*Yakuza*,' Kenji said.

'Yes, that's it, yakuza. You don't want to get mixed up with them.'

'If they were yakuza I'd be dead by now. Or at least beaten up and left on a street corner. No, he's not yakuza.' I paused trying to contain my anger. 'I have to do this Bebe, I can't let this go on. My pride is at stake and maybe your safety too' I put the phone down abruptly and stormed out of my apartment. I got to the street and looked around but couldn't see him. I walked up the road a short distance and saw Fumi just inside the doorway of a convenience store. She was pretending to look at magazines and when I passed she made a slight nod of

her head to an alleyway a short distance away. I crossed over the road and walked towards it. It was a dead-end alley used to house the bins of the restaurants. No one used it except them.

I turned into it and saw the shoulder of a man who was trying to hide in a side doorway of a restaurant. My anger mounted as I made to walk passed him and then suddenly turned and grabbed his arm and twisted it behind his back. I saw his face briefly as he put up a struggle. It was Nobu.

My anger exploded into uncontrollable fury for a few seconds but I managed to gain control of myself. I wanted to kill him, but that would solve nothing. My jujitsu classes had increased my strength and taught me how to hold a man's arm behind his back even as he struggles and more importantly, how to hold it in such a way as to break it if necessary. I pushed his body with my own until his face was squashed up against the door.

'What do you want? Why are you following me?'

'You have made a mistake my friend, I am not following you.' His voice was calm, too calm for an innocent man.

I increased the pressure on his arm and said, 'Your arm is about to break. It's up to you.' He said nothing. I used my free hand to push his face into the door hard and heard the cartilage in his nose break. He cried out in agony. I put more pressure on his arm and it snapped.

'Alright, I'll tell you,' he panted, 'oh the goddess help me … but only … ' his voice was failing, 'when you let go of me.'

I kept my grip and said through my teeth, 'What are you, stupid or something? Do you want to die? I'll let you go *after* you have told me why you are following me,' and I pushed on the broken arm for emphasis.

He cried out and drew in some ragged breaths, "Okay … okay … I wanted to frighten you. That's all, just frighten you.'

'Why?' I barked. When he didn't reply I pushed his face harder into the wall. He cried out in such pain he almost made me feel sorry for him.

He was hyper-ventilating but I still heard the venom in his whisper, 'You left me for dead, you and that *fucking girlfriend* of yours. You beat me … no one beats me and gets away with it.'

I was losing patience. 'It's Bebe isn't it? You don't want me; you're just using me to get at her. You're trying to ruin her life.' I was surprised by my calmness, I was detached, looking down on myself as I asked with exaggerated authority, 'Why?'

He was silent so I put pressure on his arm again and he yelled his agony.

'Tell me or I swear I'll kill you,' I hissed. 'I'm losing patience.'

He started to sob; I'd broken him. 'Please, oh please … stop the pain …' He was like a child telling his mother of his misery. 'The Goddess help me,' he sobbed. Because … because she's a foreigner. That's why.' He took a shuddering breath, 'I hate all foreigners. They think they are so superior, looking down on us Japanese … they try to change our ways … and … make fun of them … disrespectful …'

My anger mounted at his feeble excuses, 'But why Bebe? She's not like that. She's never done anything to hurt you.' I put more pressure on his arm and he screamed. I knew it hurt like hell and was pleased. By this time I didn't care if anyone saw or heard us. My anger had taken me beyond reason. I'd lost control.

'Tell me,' I said savagely and gave his arm another tug. He screamed again and I was glad there was a noisy restaurant fronting the alley.

'Because … oh, the Goddess … please … because she was there … and … she's beautiful … and intelligent … and … popular … and because she's controlling … controls you – a Japanese man – where's your pride? … and … '

'And,' I yelled as I pushed his face into the wall again.

'And … and … because …' I pushed harder until he finally whispered, 'and because she hates me … and  … I'm in love with her,' he said so quietly I almost didn't hear it.

His body sagged and I let go of his arm. He sank to the floor and I saw blood oozing from his broken nose and his arm hung uselessly. He was crying and his tears mingled with his blood and I saw every detail of this in the dim light of the alley as if it was illuminated with a spotlight. I suppressed the sympathy creeping up on me and turned and walked away

from him.

Fumi appeared at the entrance to the alley and said in a whisper so that Nobu didn't hear, 'I heard you both. He deserved everything he got, it was his fault you had to beat him so badly, he should have told you earlier. But we can't leave him like that. It's not human. Let's call for an ambulance.'

'But they'll find out it was me,' I said, 'I don't want to be put into prison for beating up a bastard like Nobu.'

'Not if I call for the ambulance from a public phone. You go back to your apartment now and I'll go to the railway station and make the call from there. They won't know it's me. Go quickly now, before anyone comes.'

'Thank you,' I said as left the mess of humanity that was in the doorway.

Once home, I poured myself a large whiskey. I was shaking all over and felt sick and ashamed. I'd never been so violent before but the man had pushed me too far. But what if he told the police it was me? I would be charged and the police of my hometown would probably hear about it and realise I could be violent. Damn the man. Damn him to hell.

I drank another shot and pulled myself together and called Bebe. Her swearing tested my ability to understand English, but I got the gist of it.

'What if he tells the police it was me?'

'But he couldn't prove it Kenji. There are no witnesses unless you count Fumi and I know whose side she would be on. Besides, that's not his way. He's devious ... no, he would find another way to get back at you. Be careful Kenji – promise me.'

'Don't worry, I will. You too Bebe. You too.'

I heard the ambulance arrive and looked out of my window and watched as they came out of the alley taking him away on a stretcher. Serve him right.

# CHAPTER NINETEEN

# YOSHI

My heart was heavy and tears blurred my vision as I left Honda san's house. I called to Lucky and he came running from the exact spot where I had left him outside. He was a good dog and was so sensitive and intuitive he knew something was wrong. He rubbed his head gently against my leg, like a cat. I loved him so.

There was no point in me staying in Nagoya: it was too dangerous. I went back to the inn to collect a few small items I'd left in my room and to tell them I was leaving. I always travelled light and only carried what would fit in my sleeves or would hang from my obi. Kai nor I wanted to be burdened with things to carry, our sword arms always had to be free. I kept a comb and a small towel in one sleeve and a money bag and a photograph of me in my samurai clothes in the other. I had it taken in Edo as I still found it hard to believe that it was possible to capture someone's image like that. Could you ever die if your photograph existed? What about your spirit? Where did that go? I felt awe whenever I looked at it. I'd keep that photograph forever and my ambition was to show it to my grandchildren and tell them my story. I chastised myself: pride had no place here and neither did stupidity. I'd never make old bones. And children? What a foolish idea. But deep in my heart, I still hoped … I cut my thoughts there. Stop it ! There's no future for you and Kai. If he ever finds out the truth he'll feel so deceived and upset he'll never speak to you again. He's a man after all – and that's how they think.

Nakamura san had been kind in giving the money, but it could cause problems for me. I could very well be murdered for such a large sum so had to disguise it. I bought two money pouches from a shop near the inn and when I got to my room I divided the money equally between them. One was for me and the other for the old woman. I would use my usual pouch to buy things so people would only see one with a few coins in it and I would make sure I kept the other well hidden.

I left a note for Nakamura san telling him how sorry I was and thanked him again for his generosity.

As I walked with Lucky at my heels my spirit was low. I was angry that the opportunity, a chance to do something important, was denied me because of my gender. It wasn't fair. I was just as capable as a man – better than most in many ways – and the more I thought of it the more my anger rose. I had let myself down. I should have accepted the offer and be damned with the consequences.

But what did it matter anyway?

I was only fooling myself with the old man's stupid prophesy. He was delusional and on the edge of death and I was a fool to think I could do anything to change the course of my country's future. Who did I think I was?

When I turned into the road where the old woman lived I hurried to her door and pulled myself together; she didn't need my problems, she had enough of her own just to survive.

I calmed myself and knocked. The door opened and the old woman's mouth dropped and her eyebrows rose in surprise. I didn't think anything of it at the time; it was a natural reaction to my unexpected presence. Even her extended silence didn't warn me.

'Well, well. Fate and the Goddess have come to my door. I didn't expect to see you again young sir.'

She bowed very low to me and bade me enter. As I did so I was seized by a strange feeling ... there was something different this time. As I took off my rather shabby straw sandals and slid my feet into the equally shabby guest slippers, I untied my long

sword to leave at the entrance as good manners dictated, when I saw another already there. My heart jumped into my throat and I started to shake.

'Come sir,' the old lady said with a beaming smile, 'go on in and I will fetch some tea.'

I stepped up into the house and turned and faced the door to her living room. I hesitated. Then slid the door slowly open, afraid it wouldn't be him. And then, there he was, standing in the middle of the room and I felt as if I'd been struck by a lightning bolt and every part of me quivered uncontrollably.

Neither of us moved and undisguised love passed between us.

'Yoshi,' he whispered in a voice so low I hardly heard its emotion as it caressed me in the most intimate way possible: in the way of lovers.

'Kai.' As the word left my lips it expanded and filled the room with my love.

The old woman came in then carrying the tea tray and said, 'You have found each other again. You see, the Goddess is looking after you and brought you back together.'

Her words hardly penetrated the feelings that were passing between us until she caught hold of Kai's sleeve as she sat on her knees and bade him join her.

'Sit down Yoshi san,' she said, 'come drink.' She poured the tea and said, 'A toast. To the Goddess for keeping you both safe and bringing you back together. It is my honour that it happened in my humble home.'

Kai and I picked up our small cups and both said, 'To the Goddess,' while not taking our eyes off each other. A bond was forming that I knew would not break as the shock of our unexpected meeting prevented us from hiding our deepest feelings. They were laid bare and only the brute force of death could part us now. We were married by that look – but nothing would be said – we could not allow it – I could not allow it.

We spent too long with the old woman as she was enjoying our company and inertia crept over us as we revelled in each

other's company. It wasn't until I asked Kai about the little teapot that reality surfaced.

'I left it at a friend's house,' he said. 'But don't worry, my intention was to collect it later and thank them one more time for saving my life.'

'They saved your life?'

He nodded, 'But more of that later, we should go now and not intrude on our good lady anymore.'

I realised that was his way of saying he had things to tell me that should remain for our ears only. I turned to her and took the bag of money I had prepared out of my sleeve. 'Please accept this token of my – our – gratitude dear lady.' I held it out to her and involuntarily touched my scar, 'Especially for this. Money is but small reward for such as you did but at least it will ease your way in surviving this turmoil we are going through.' I knew it was more money than she had ever seen before.

'Young sir, I did not do it for money. I did it from one human being to another.'

'I understand and know of your pure heart. But please take this very poor offering of money; you would honour me by doing so and I would feel so much better.' I knew she couldn't refuse then and she bowed and nodded as she took it from my outstretched hands.

As we collected our swords from the entrance Kai said, 'You still have the sword my father gave to you I see.'

'I treasure it more than you could ever know.'

'I see that,' he said. 'You obviously look after it well. I'm glad, that it means so much to you,' he said gently.

We took our leave then, promising to visit her again if we ever returned to Nagoya. I couldn't tell her that it was about as likely as Lucky turning into a cat – or me turning into a real samurai.

As Kai and I walked quickly along he told me what had happened to him.

'So, Sato is dead.'

'Yes,' he replied. 'No doubt about it.'

'And then there is Masako.'

'Indeed. We have to make sure we avoid her at all costs.'

'Then we need to get out of Nagoya immediately … but how is your leg Kai? Can it stand travelling?'

'It's fine, I have no problems with it, the doctor did a good job and you know me Yoshi,' he laughed, 'I'm as strong as a horse.'

I laughed back. The joy of being together again was bubbling up through our dire situation.

'Let's leave Kawamoto san's house as soon as we can.'

'With the little teapot,' I added.

He nodded. 'You seem attached to it Yoshi. I treasured it when I thought I would never see you again, because you had given it to me, but why are you so concerned about it?'

It was a good question but one I didn't want to tell Kai about right now. I shrugged. 'It was given to me by an old travelling woman on the road and she told me a story that resonated with me. I want to remember her that's all. I'll tell you all about it one day, but right now, we have more pressing matters.'

He accepted my explanation without comment as we rushed on. When we got to Kawamoto san's house she welcomed Kai with real affection and invited us to take dinner with her. 'It is late sirs, and the streets are dangerous at night, I bid you stay here and return to your journey tomorrow.'

'It makes sense,' said Kai.

I nodded agreement.

'Honourable lady, do you still have the little teapot I left here?'

'Yes, it's here, but I have a confession to make.' She hesitated and blinked several times, 'I'm sorry Kai san, I know that teapot is important to you, but I had an accident with it.' I gasped involuntarily which made her even more nervous about it. 'I'm so sorry,' she bowed as she said this, 'I'm afraid I knocked it accidentally with my kettle.'

'Did it break?' I interrupted.

'Well, that's the peculiar thing, it should have broken as,

unfortunately, I knocked it quite hard and it fell on the floor, but when I looked at it there was only a small chip on the handle.' She shook her head, 'It's very strange.'

'May I see it?' I tried to keep my voice calm.

'Of course,' she got up and went into another room and came back holding it carefully. 'I see it's very important to you also young sir. It's a strange teapot. It survived unscathed when Kai was attacked and only received small damage when I hit it.'

I took it from her just as carefully and examined it. As she said, it was undamaged except for the chip on the middle of the handle. I breathed a sigh of relief. I didn't understand the power of the teapot but I knew it did have power. The chip was on the edge of the handle and would always be touched as you poured the tea. I remembered the old travelling woman I met on the road telling me how damage to it could cause its magic to bend and go out of proportion and no one knew what that would bring.

'As you say good lady, it is only slightly damaged,' I said with relief but was worried just the same. I had no doubt that the words the old travelling woman on the road had told me were true. She had been on my mind a lot recently and the teapot too. I was relieved to have it back.

Kai took it from me gently, 'You're right, it is undamaged except for that chip,' he said as I saw his eyes examine the pattern. He looked up at my scar and then back and I could see that he too had seen that the design on the teapot matched the shape of my scar exactly. We remained silent.

# CHAPTER TWENTY

## KAI

The next day before dawn, we left Nagoya taking the good wishes and food Kawamoto san had given us. I had the teapot wrapped carefully in my small towel and tucked into my left sleeve. As we walked silently along, content in our togetherness, I thought back to the events of the past few days.

When I needed Bebe so desperately she had come. Neither of us knew for sure what forces brought us together or had any control over it, but I was beginning to wonder whether it was something to do with the teapot. I had asked Kawamoto san if she could remember exactly what day she damaged it. She said she remembered very well as it was her birthday. It was the very same day that Bebe re-entered my mind.

But if the chip on the teapot brought Bebe back to me, why would she and I be crossing over in time before the teapot was damaged? Was it just the teapot itself that caused the magic? And the chipping of it gave it more power, but in a different way? Bebe had said she'd bought it in Takarazuka, so was that the connection? Or Bebe's own reaction to it because she had an affinity with the magic – or was it me she had the affinity with? She always came when I needed her. Or was it the combination of all these forces? And if the teapot had such magic, where had it been before Bebe bought it? The teapot was given to Yoshi by the old woman on the road, so was Yoshi meant to join up with Bebe and not me?

Whatever the answers were I had to surmise that the teapot would keep its secrets because if I didn't know now, how

would I ever know? But I had to tell Yoshi about Bebe and the teapot. It was the only way now we were together again. He knew there was something wrong.

But we remained silent until we left the edges of Nagoya and joined the Tōkaidō Road.

'What are you thinking?' Yoshi asked.

This was my chance. 'We should make for Edo don't you think?' I cursed my cowardice.

'Yes, let's make for Edo.'

To turn his attention away from me I said, 'Something is bothering you, won't you tell me about it?' He looked down at his feet in silence, so I added, 'Problems that are shared can become lightweight when before they were heavy.'

He nodded. 'I know.'

We walked in silence for the rest of the day, both of us struggling with our thoughts and the inability to share them. Love does not always mean sharing I was beginning to learn.

As evening got nearer, we veered a good way off the road for safety and made camp in a small clearing in the surrounding woodland. The pine trees with their thick trunks and abundant foliage made a canopy over us and gave us some shelter.

Over the miles I'd decided I would – must – confide in him and it was now or never although I was unsure whether my courage would hold out. What would he think of me? I was not the man he thought I was: I was half man and half woman. He'd be disgusted. He'd never accept a woman's point of view or influence – I knew that much about his character.

We sat opposite each other and shared out some of the food Kawamoto san had given us. Lucky gulped his in a few bites while we ate slowly and in silence. She'd also given us a cask of sake and I drank from it in long draughts to gain courage.

'You're drinking a lot,' Yoshi said matter of factly. 'Is there any reason for it?'

'No,' I answered lightly, cursing my cowardice again.

'Yoshi,' I said at the same time as he said, 'Kai,' and we both laughed nervously until he added, 'you go first, you're the eldest, you take precedence.'

'Yes: I've noticed you say this when you don't want to do something,' I said wryly. But I couldn't get out of this, not now, so gathering my courage blurted out, 'I've got something important to tell you. It may be the most important thing I ever tell you.'

He gave me a puzzled look, but remained silent.

I swallowed another long draught of sake and said, 'You might not like me afterwards.'

He raised his eyebrows, 'You intrigue me, please continue.'

Yoshi had gone into his superior mode and it annoyed me, 'You are acting like this is a nothing, of no importance, while I'm struggling to tell you. You're not making it easier.'

'I'm sorry,' he said kindly, 'I'm sure it cannot be so bad that I will not like you afterwards. Don't forget I'm privy to most of the things you've done since we met and most were honourable; if not all,' he added as an afterthought.

'Well, you don't know it all,' I snapped and then regretted it and softened my voice. It wasn't his fault I was in this predicament. 'There's a big part of my life you know nothing about but I have to tell you because it's becoming impossible to hide it.'

He sat and slowly stoked the dog while I spoke fast and without pause into the air in front of me, unable to look at him. 'I thank the gods Yoshi that we met again. It's something I had my doubts would happen and have to think that our meeting was fated. We are destined to be together for fate is always throwing us into each other's path. I treasure this relationship over anything I've ever had and because of that I want it to be totally honest. If we are to continue our work and friendship, then I cannot withhold this from you.' I looked at him.

Meeting my gaze he said, 'Well, tell me then. You're right, we must be honest with each other, our relationship has grown stronger since our parting, we must keep it strong.'

'You *will* tell me your secret when I've told you mine?' I asked like a child.

'Do I have a secret?' he laughed and looked away so I couldn't see his eyes.

'Well you certainly have something that's bothering you.'

He hesitated, 'Yes that's true.' He met my gaze again, 'I promise to tell you what is bothering me.'

I was relieved and took a deep breath, 'Well ... as you know I sometimes get very bad tempered ... and ... and do strange things ... I'm going to tell you why that happens.' I stopped: afraid again.

'Go on,' he said in a soft voice.

'The only way I can tell you this is to tell you outright, quickly ...' I took another deep breath and looked up towards the sky, as if the answer was there. 'Sometimes, a spirit enters me,' I blurted out.

He looked at me puzzled. 'Is that all? Many people have spirits inside them.'

'I know, but my spirit is ... is ... from the future,' I blurted again.

His eyebrows rose in the way he has of silently questioning things.

'And not only that,' I pushed myself on, 'but this spirit is a ... is ... a ...' I took yet another deep breath preparing myself of his ridicule ... 'a woman,' I said quickly.

My heart was beating hard as I waited a few moments for that to sink in before saying, 'There, I've said it. I have a woman's spirit inside me and she's from the future.'

Yoshi didn't say anything for a while, I thought he'd laugh but he didn't. He continued to sit on his knees, motionless, deep in thought. I waited, trying to control my erratic breathing, while my stomach churned so much the alcohol inside it felt like it was fermenting.

At last, staring ahead, he said, 'Obviously, I knew there was something greatly amiss with you but it wasn't until we'd parted that I wondered if it could be a spirit that was affecting your behaviour. But I had no idea it could be something different to the ordinary kind of spirit. Now you have confirmed it ...' he looked at me, 'and it is a woman you say?'

'Yes.'

'From the future?'

126

'Yes.'

'Mmm … *most* interesting … how old is she?'

'Twenty six.' I let him think some more before asking, 'You're not angry with me?'

'Why should I be angry?'

'Well … because I am not one hundred percent male. When the woman is in my head I'm … well, I'm … half man … and … half woman.'

He laughed.

'I know, I know, it's stupid and I'm incensed at having a woman inside my head, *a woman!* What have I done to deserve such a fate?'

His voice took on an edge, 'What's wrong with having a woman in your head? Why is it worse than having a man?'

I was shocked into silence. *What was wrong with it?*

His look turned to amusement and I didn't know how to react. I decided to go for bravado, 'Well, women are inferior creatures to us men.' I laughed nervously, 'We all know that.'

He laughed again. I was so confused.

He became serious, 'That is the way men think. I am hoping that with my influence our country can change its attitude towards women. Treat them with respect and give them power. This notion has been growing slowly in my mind and your words have helped me to formalise my thoughts.'

'But we do treat women with respect,' I argued unsure of what Yoshi meant. 'We look after them and keep them safe within our families: safe to bear children.'

His voice hardened, 'So safe they have no real lives. They live shadow lives: without meaning.'

I was astounded. 'I'm sorry, I don't understand.'

'I'm saying Kai, that women are *not* respected. They cannot earn their own living, or travel freely; they cannot have any influence in the way our country is run. They *must* marry and be under the control and command of a husband. They *must* bear children, they *must* stay in the home. They *must not* meddle in anything except household matters. Ha! Do you call that respect? Do you call that a life worth living?'

He was upset and his distress was almost as shocking as having Bebe inside my mind. What was going on?

'Look,' he said, 'I have long thought that women were treated badly. Not given the chances that men have.'

'But how can they be Yoshi? They are not men.'

'No, they are not men, but they *are* human beings, exactly like men are human beings. They have feelings, emotions, minds and bodies just like men do.'

'Well … not quite like men,' I added, looking for levity but failing.

He glared at me. The gods help me; I didn't know how to react to this. 'I thought you'd be angry with me for having a woman inside my mind – making me weaker.' I sounded petulant but I didn't care.

'Are you weaker with her inside you?'

He kept his gaze on me until I had no choice, as much as it chaffed I had to admit the truth, 'No, I am not weaker with her inside me, in fact, as we are being honest, the opposite is true. I am much stronger in spirit and wiser in mind.'

'Then why didn't you say that at first? Why did I have to prise it out of you? That wasn't honest was it?'

I hesitated, 'No, you are right; but it's hard for a man to accept that a woman is more powerful than he is. That she is more intelligent and … and … is better than him altogether … I'm so ashamed.'

'I understand Kai; I'm not insensitive to your views. You see life through a man's eyes.'

'And you don't I suppose.'

He smiled, 'You forget Kai, I am not yet a man.'

'And what does *that* mean?'

He shook his head. 'It's not important.'

'Are you shocked?' I asked quietly.

He nodded, 'Yes, I am. I had no idea it was anything like this. It will take some getting used to.'

He thought again, 'Is she inside you now?'

'No, she left me just before I met you again. One minute she was there and the next she was not. As I told you, we have no

control over it.'

'And you have no idea how or why it happens?'

I needed some action, as if it could help me with what I had to say next, so I stood up and paced around the clearing – the time had come – but I was still hesitant, afraid of his ridicule, until finally, I blurted out, 'I think it's something to do with the little teapot.'

'Oh,' he said in a way that a hundred words could not have conveyed better.

I continued pacing. 'Bebe – that's her name – told me she bought the teapot in Takarazuka and the shop owner had told her it dated from around 1860 … or it could be older I suppose.'

'Did it have any chips?' he asked urgently.

'Yes, two she said, one on the handle and one on the lid.'

'So, we have another chip to go,' he said looking pensive.

'I stopped pacing and looked at him. 'You believe it's the teapot then?'

He stared into space, pondering, 'I think I do. In the absence of any other reason, I think the teapot fits. The old travelling woman told me that I should be careful with it and not damage it in any way as it could bend the magic of it.'

'The magic … she told you it had magic? Why didn't you tell me?'

'I didn't get a lot of chance if you remember,' he snapped.

I sat down in front of him. 'You believe it does have magic then?'

He ran his hand over his face and breathed deeply, 'I do,' he said quietly. 'Spirits have more power than us, and I think there is a spirit in the teapot that maybe has a sense of mischief … or malice.'

I shivered. 'You are frightening me Yoshi. What do you mean exactly?'

'I'm not sure. But not all spirits are good … they live in a different place to us. We only have this world, but spirits may be able to travel between worlds, past and future and the Goddess knows what else.'

129

'If that's the case then they can control anything they want in our world. How in control of things are we?'

'I don't know … you say this woman, this Bebe, tells you things?'

'Yes.'

'What kind of things? Does she tell you of the future?' His eyes sparkled. 'Can she tell you what happens to us – to our country?'

I was reluctant to tell him, his hopes were so high. 'Unfortunately not. She says that when she's in my mind she lives for the moment and cannot remember the future. She remembers things that are personal to her and of her life in her own time, but history and politics somehow don't travel with her.'

'Mmm, that's a pity. It could have made all the difference. But I suppose it is too much to ask: too easy a solution.'

'There's more.' I said bluntly.

'More? He said looking at me and our eyes held, 'What kind of more?'

I tried to conquer my fear. I knew he'd think I was mad. I forced myself to say it, 'Yes, well, you see, I … I … go into her mind too … into the future.'

He looked stunned. 'You go into her mind too … into the future?'

I nodded.

'Let me understand this, you are saying that you know what the future looks like?'

I nodded again.

'And you remember it?'

'I do.'

His eyes became alight with excitement. 'By the gods Kai, do you know what this means? We can do so much if we know the future.'

'I'm not sure that it will help us because I don't understand most of what I see. Everything is so different, life has changed … and …' I stopped, feeling a failure again. I knew Yoshi would be disappointed when I told him.

'And what?'

I had to tell him, face his wrath once more. 'I don't know *how* we changed.'

'What do you mean?'

'Well, I don't know the politics of it. How it all happened. I can see the result, but I don't know if the shōgun or the emperor wins. I can only remember what happens to me: what I see and feel. I think I understand more when I am inside Bebe's mind but when I come back to my own life, it's gone … I'm so sorry.'

He looked at me, but there wasn't the anger I expected, instead I saw compassion. 'Mmm, interesting: so she doesn't remember and neither do you?'

I nodded.

'That must be part of the way this thing works. Maybe we are not meant to know because it would cause too much upheaval and change the course of history. That would be nice .. but … well, never mind, we can't have everything.'

'You're not angry?'

'You are funny Kai, why should I be angry? It's not your fault. I think you have coped well under the circumstances. This has been a trauma for you; I can see that, but why not enjoy it. Take advantage of it. I think part of the trauma is because it has been a woman who has entered your mind, ne?'

I nodded again, unable to find any words.

'Is she a good spirit? Is she decent and honourable? Does she try to take you over?'

I had to think for a while as I hadn't thought about Bebe in those terms before. I struggled to put aside my prejudices and look at her impartially, 'Yes,' I finally admitted, 'she's good and decent and honourable. And … no, she doesn't try to take me over … she influences me; yes, that's what she does, she influences me.'

'Well then, what more could you ask? Stop concentrating on the negative aspect of this and look at it in a new way. What does the sex of the spirit matter? It's a spirit from the future and it's in your mind. It's how you use this spirit that matters.'

I stood up again and paced up and down as it helped me to think. I knew at once he was right, that I'd been a fool. But how to admit it – even to myself? I needed to keep Yoshi's respect. In the end, I knew honesty was my only way out of this. I sat down opposite him again, as one has to look people in the eye when one is being honest, 'You're right Yoshi, I can see it now. Why can't I see things as you do? I apologise for my stupidity,' I said as I bowed my head to him.

He smiled with compassion I was relieved to see. 'You're being too hard on yourself Kai. When you're fighting something on your own, especially something as unique as this, well … it's difficult. It's easier to share a problem. I can see it from the outside looking in, which is different to having to cope with it in your head. You did your best under very difficult circumstances.'

I noticed he didn't say he couldn't have done better, but I kept the thought to myself because I knew he would have. He was being kind to me and I appreciated it. He'd taken it much better than I could have hoped.

'But we need to share this together now, don't you agree?' He said.

'Yes … yes, it would be a relief to share it with you.' I answered gratefully.

He smiled his gentle smile again, 'Then tell me, what have you seen? Give me as much detail as you can.'

I thought back over the times I'd been in Bebe's mind, accompanied her as she went about her business. I remembered the time I came into her mind when she was on one of those awful train things. It was terrifying, and my fear suddenly appearing in her mind made her jump until she realised it was me. She calmed me but I found the whole of the new world shocking.

I did my best to tell Yoshi about the things I had seen through Bebe's eyes, but it was difficult – how do you tell the impossible? Television, radio, loudspeakers, trains, cars, roads, the strange clothes and the odd food – and the abundance of everything. How the shops were huge and full of light. How

they stocked goods we had never seen and how fast the world moved and how dour and unhappy the people looked. No one spoke to anyone else; no one seemed to know anyone else.

I could feel Yoshi's excitement growing, but also his puzzlement, so I stood up and found a stout stick. I sat down beside him and in the light of the moon drew sketches on the earth of what trains and cars and buildings and fashions looked like. He was fascinated and had lots of questions and before we knew it, it was morning and the only one who'd got any sleep was Lucky. But we had crossed a barrier: now we were sharing secrets that no one else knew.

'Knowledge is power,' Yoshi said.

'Yes, but how can we use this knowledge? What use will it do us? People will say we are mad and lock us away.'

'That's true,' he said as he moved his head from side to side as if having a discussion with himself. I waited patiently, knowing not to interrupt.

At last he said, 'You are right Kai, but what if we used that knowledge secretly. Knowing what we know, we can steer our country in the right direction. From what you say, we modernists win the war and the foreigners are allowed in to trade with us and we with them. We are obviously a rich country in the future. We would not have all those things without trade. Mmm, this is fascinating.'

We sat in silence until he said, 'I'm greatly excited by this Kai. I'm having trouble keeping myself calm and my excitement is making it difficult to make a judgement. Maybe it's best to feel our way along and see what develops. We cannot make plans for we have to react to events. The opportunities will offer themselves up in time.'

'It's a lot to understand … and you're right, we must keep these things secret while letting them influence our decisions.'

Then Yoshi asked the question I'd been dreading. 'What happened the last time Bebe came back into your mind?'

I didn't want to tell Yoshi of my weakness and how Bebe saved me. I felt ashamed of it, but he was not to be put off.

'Tell me Kai,' he said in that soft, gentle voice he sometimes

used. It always went through to the heart of me, making me want to hear it more and more.

I looked away and a sigh escaped unbidden, 'I'm sorry, it's not easy …'

'Take you time,' he said in that same soothing voice.

I gathered my strength around me like a protective blanket and told him slowly and deliberately about my capture by Sato and Masako. How Bebe came back into my mind and saved my life. How she created a plan that worked perfectly – well almost – and how I realised how much I needed her.

'Mmm … interesting: I'd like to meet this Bebe of yours. She sounds like a woman to be admired.'

I covered my astonishment. *Yoshi admired her!*

'Coming back to the present,' he said, 'as far as we know, Masako doesn't know you have betrayed her yet?'

'No, not yet.'

'When she finds out she is going to be very angry.'

'I think she'll be more than angry; she'll be murderous. let's hope we are well away … I wonder what she'll do? Stay in Nagoya, leave for Edo … '

'Knowing Masako,' he cut in, 'I'm sure she'll be full of hate for you and want vengeance. She'll guess you will head for Edo. I think that's where she'll go, in the hope of finding you and taking out her revenge.'

'I hate to admit it, but I think you're right – *again*, I added and my petulance suddenly seemed silly and I laughed at the absurdity of it all. Yoshi joined in and it was a relief to be relaxed together again.

I pulled myself together, 'Look Yoshi, shall we make a pact? Let's not be upset no matter what happens. We have to support each other totally and have confidence in one another. If we die, as long as we die together, then I don't really care.'

He surprised me by crying out, 'Not care! Oh, please care Kai, don't be defeatist. For me, please care. I don't want to die, not now, life is too exciting and now that we know what the future looks like I want to be around to see how it happens … and I want to do it with you at my side,' he added gently.

I looked at him and it was difficult to hide my love. I wanted to take him into my arms and cover him with kisses ... and more. I realised I was letting my imagination and personal feelings rule me. They must not stray into my mind again.

I pushed out all emotion and concentrated on practical things. I'd been so engrossed in our discussions and how they affected me, I'd forgotten about Yoshi's secret. I turned to him and said, 'What about your secret? Won't you tell me now?'

# CHAPTER TWENTY ONE

## YOSHI

As dawn opened her lazy eyes, bringing the world slowly into focus, Kai and I were wide awake and preparing to share the rest of Kawamoto san's food for breakfast.

I was dumfounded by Kai's secret. It had never occurred to me that his spirit could be from the future – and a woman too! I had to stop myself from crying out with joy when he told me. Poor Kai, it was difficult for him, he was so upset that it was a woman – and afraid that I would be upset because of that. It was the irony that made me laugh. I wanted to shout my delight but knew I must not. I decided then that it was not the time to tell him of my own secret. He was so traumatised by having that woman, Bebe, in his mind he would find it very hard to accept I was a woman too.

'I'm starving,' he said as he divided up the remaining food. He turned towards me, chewing on a rice ball, 'It's your turn. I'm full of curiosity; please tell me your secret.'

He was so formal, I stifled a laugh and covered it by eating my own rice ball. I gave one to Lucky who ate it in one gulp.

'That dog will get indigestion,' Kai said, 'he gulps everything down in one.'

'Well you would too if your mouth was that big. I expect it falls out if he chews something like a rice ball. He's not daft,' I added with a look of fondness to Lucky who put his ears back and opened his mouth letting his tongue loll out in that special smile he always gave me. I bent over and kissed his head and he wagged his tail furiously and licked my face with enthusiasm. I

knew it upset Kai and that made me laugh.

Kai sighed and waited, making it obvious that he was not amused.

'Sorry, I'm ready now,' I said swallowing the last of my food. I stood up and walked around the small clearing. It made speaking and thinking easier.

'When we went our separate ways,' I started, 'I had the idea that you might have had a spirit enter you, but I had no idea that it would be as fantastic and extraordinary as you have told me. My secret is much more down to earth.'

I'd decided to tell him of Nakamura san and hoped that the drama of it would distract him from following up my real secret.

I told him of rescuing Nakamura san, of how I had to go into Nagoya with him, how I met Honda san and was offered a position in government with mentoring from Nakamura san himself and how I refused the offer.

'And you *refused?*' Kai yelled. 'You *refused?* I can't believe that. Why did you *refuse?* It's the answer to our dreams. *Why? Why would you do that?'*

As I had hoped, the drama of my story distracted him from realising I was not talking about my real secret but I knew I had to give a persuasive answer for he was right – it was the answer to our dreams. To be on the inside of government, albeit in a lowly position, but under the mentoring of an important man like Nakamura san would guarantee advancement, until something happened to stop that. I couldn't tell Kai what that something was.

'There were several reasons,' I lied, making my voice confident, 'For one thing it didn't seem to fit right.'

'Fit right?'

'Look Kai, please keep your temper, if I am to tell you my story then you must listen without interruption. No matter what you think it was my decision, not yours. Let's sit down and discuss this reasonably. He looked thunderous but we sat down on our knees, facing each other.

'That's what I said,' I continued, 'it didn't feel right,' I lied

again. 'There was something that made me suspicious. I couldn't identify it but it was there. It was too good to be true.'

He sighed and I could feel his frustration, 'But sometimes life is like that. We must take our opportunities when they come. You are not a fool Yoshi, but I think you acted foolishly in this case.'

'Thank you for your plain speaking,' I answered keeping my temper under control. Maybe he was right, I was foolish to turn it down, then I reminded myself that I wouldn't have lasted long in that environment without my secret being discovered. Then I was tempted to tell him all, but thought no, I should stick to my original feelings about this. Take Kai's wrath and bear it.

'But if I had taken the offer I would not have met you again and even if I had, you could not come with me.' I sighed, 'Truth is Kai, I wanted to be back with you. Nothing had any meaning without you.' I hoped that this bit of flattery would pacify him, but I was wrong.

'Why couldn't I have come with you? That doesn't make sense ... there's something you're hiding from me. I know you are not that stupid Yoshi. There is something else isn't there?'

I didn't know what to say, how could I get out of this? His reaction had confirmed my worst fears that he acted on his emotions and if he found out I was a woman, his attitude towards me would change totally. He would want to protect me and think of me as an inferior, would try and take over whether it be on the road, as we are now, or if I was employed in government. It would be a disaster. His thought processes were too deeply engrained to accept me as an equal. Look how he felt about having Bebe in his mind. No, I couldn't take the chance.

'Well, you may think me stupid, but that is what I did. I will not change my mind. The subject is closed and I want to continue doing what we are doing, I lied again. I think I can be of more help to our country doing this with you than being shut away in some bureaucratic place without any real power.

I would be given all the mundane things to do and have to work my way up to make important decisions, that's the way it works.'

'But if you get into government now, you will be well placed to be part of a new order. It will come, it has too,' he said with great confidence, 'it cannot go any other way.'

'I wish I had your confidence Kai, but I cannot take the chance. Please give me the respect of accepting my decision as being the right one for me. Not you – me !'

We lapsed into a silence until he got up and stormed off into the woodland, I assumed to answer a call of nature, or to calm his raging temper.

I packed up our small belongings and took the little teapot and looked at it closely.

I examined the chip on the handle. We knew now that there were two chips in Bebe's time. The first had already happened in our time and was probably responsible for bringing Bebe back into Kai's mind at that vital moment. But for that, Kai might be dead by now. But what about the second chip? How would that happen and what would it change? For I believed it did change things. I was sure now that the teapot was the cause of all this. What had Kai said? Bebe had bought it in Takarazuka and they said it was made during the 1860's – or earlier?

So, we know what the future looks like one hundred and fifty years ahead – I just wished we knew the future for the next few months.

Kai returned, 'Ready to go?' He asked sharply.

'Yes, I am, but I was just thinking about the teapot. We know it gets another chip on it sometime and I'm wondering whether it would make a difference if you or I carried it … you know, would one of us influence the teapot and it's power in a different way to the other?'

'I see what you mean. Well, I for one don't want the responsibility of it, you carry it Yoshi. Bebe is all the responsibility I need. And after all, the old travelling woman gave it to you, not to me.'

'Yes, you're right. I'll take care of it,' I said as I wrapped it in my small towel and slipped it carefully into the inside of my sleeve.

# CHAPTER TWENTY TWO

# BEBE

Kenji and I were getting back to a normal life – as normal as it gets for us that is. A couple of weeks had passed since Kenji had his fight with Nobu and we were doing our best to forget it all. Nobu had been seriously hurt and the joy of that was that he was out of our life; for a while at least. We relaxed and enjoyed each other.

That particular Wednesday morning, Kenji was not with me as he had a late night business meeting the evening before. As it was near his home it made sense for him to go to his own apartment to sleep so he wouldn't disturb me. When I got up, I went to my window and pulled back the curtains, full of optimism as I looked out onto a beautiful autumn day. The river shivered in the sunlight as I looked across it to the tall, closely packed blocks of apartments on the other side and worried about earthquakes taking them down like dominoes. But behind man's commercial greed, the tree covered mountains rose up in their autumnal red, yellow and russet splendour. I felt they were cocking a superior snoop at the people below, displaying themselves with pride, their leaves flickering and catching the light like the flames of a fire in a gentle breeze. Then I noticed they were packed together just as tightly as the buildings below them.

I could never make up my mind whether it was because so much of Japan is now covered in concrete, tar and steel, and that those things highlighted and intensified the thrusts of nature that survive, or whether I was picking up the Japanese

skill of seeing only the nature and not the man-made ugliness of many places. Would I have noticed nature so much if I'd been surrounded by it? Or was it the lack of the natural world making it more precious when it did manage to survive? Whatever the reason, I was moved to tears by the sight of it. Kenji would have been proud of me.

I left my apartment in good time to get to work and to call into the Sorio Shopping Centre to buy my lunch. It was only a few minutes' walk from my apartment and I passed the glass walls of the Washington Hotel and crossed the quiet road to the back of the Sorio. I usually called in every morning as I loved Japanese obento lunch boxes and was thinking which variety to buy today as I ran lightly down the back steps which were a short-cut to the underground food mall.

It was quiet at this time of the morning and inside, my footsteps echoed a lonely tattoo on the marble floor. The mall's assortment of high quality take-outs units were at the far end of the mall and I had to walk through the middle of two lines of restaurants, all closed at this time, to get to them.

I was about half way along these rows of rice, tofu and noodle restaurants, when I approached an empty unit. The door was open and I could see it had been stripped out and although there were tools and boxes dotted around, there were no workmen. They did that sort of thing in Japan. Security was lax as there was no need for anything else. No one would abuse it.

I felt a pang of disappointment as it had been a noodle restaurant I particularly liked and used often, but I wasn't surprised as restaurants here changed owners with alarming regularity with many busy restaurants disappeared overnight with a new one up and running a week later. It was a Japanese thing. Nothing must get stale. New is king.

As I was thinking this, I vaguely remember footsteps approaching rapidly from behind but I didn't take any notice as people often ran through the mall to get their lunch before catching their train from the station next door. A slight breeze

in the stagnant air made me turn my head as a man came alongside me, grabbed my arm roughly and pushed me into the empty unit.

It happened so quickly I had no time to react before I was inside and Nobu was pushing the door closed with his foot. I felt rage surge through me that I had been caught by him and anger at the absent shop-fitters, but those thoughts were over in a flash as my body hit a wall and Nobu was pushing himself against me.

His plastered broken arm was at my throat while his good hand was tearing at my blouse. His strength tore the material and he pulled so hard on my bra it broke the fastenings and he pulled it down, exposing my breasts. His rough hands grabbed and squeezed them as if he was kneading dough as his lips frantically sought mine. I kept turning my head back and forth to avoid him but he increased the pressure on my throat until I couldn't breathe.

He hissed in my ear, 'You won't get away this time, my sweet Bebe. I'm ready for you. That's right, struggle some more. The more you struggle the better I like it.'

He threw me onto the floor and I banged my head painfully, and then he was on top of me desperately trying to pull down my trousers. The sound of his panting turned into grunts of frustration as he had difficulty doing this with one arm as I struggled like a wild cat in a trap.

I made myself think of Kai. What would he do? Where are you now Kai when I need you so desperately? But I had no more time to think as Nobu increased the pressure on my throat and I knew for certain I was going to die. My lungs felt like they would explode through the effort to get air into them when, suddenly, I took a huge, shuddering breath and realised his weight had gone. I heard crashing noises and although I was dazed, I managed to lift my head enough to see Kenji standing over an unconscious Nobu on the other side of the unit.

I went to say something but nothing would come out. My throat felt crushed and I was breathing rapidly. Kenji rushed

143

over and knelt next to me. 'Try and calm yourself,' he said, 'breathe slowly, you are safe now.'

As I attempted to raise my head again to look over at Nobu, to make sure he was still prone, Kenji said, 'Don't worry about him my love, he's not going to wake up for a very long time,' and I swear I heard him add, 'if ever.'

He covered me with his jacket, his best one and I wanted to say, no, that's your best jacket don't dirty it, but again, nothing would come out.

It was all a blur, it had been so fast, but I knew Kenji had saved me from certain death. He sat on the floor next to me and lifted me up gently propping me against his chest with his arms around me, comforting me. We stayed like that for a while, neither of us speaking as I calmed myself down, regaining some equilibrium.

Finally, I managed to croak, 'Oh Kenji, you've saved my life … thank you, thank you … but how did you get here?'

'Never mind that my love; I'll tell you later. We should get out of here as quickly as possible. I don't want us to be found with him.'

'Yes … yes of course … you're right,' I said as I tried to stand but my knees had turned to jelly.

'Let me help you,' he said standing up and putting his hands under my arms. He lifted me gently and we stayed like that, with Kenji holding me up while I got the strength back into my legs.

'We need to get to your apartment, can you walk now?'

'Yes … yes, I think so. My legs are not shaking so much now. Help me with my clothes … make me decent.'

He pulled my blouse around me and slipped his jacket on me doing up the buttons and pushing up the collar and cuffs. 'There, that's not too bad – you look decent. It will have to do and we must hope that we see no one we know.'

He looked around and picked up my bag and the things that had fallen out of it and as he did this I gathered myself enough to walk over to Nobu and peer down at him. 'I want to kick him where it hurts,' I said, 'but I don't have the strength.'

'That's good. I don't think it would help matters.'

'You're right again,' I said as he handed me my handbag.

'You should carry your bag as otherwise it will look strange if I carry it for you,' he said gently.

I took it from him and as we turned to leave exclaimed, 'Wait … let me think … we're not finished here Kenji. Not finished at all.'

'What do you mean?'

'Think about it. What would be the worst thing that could happen to him?' I said nodding towards Nobu.

'He would be caught?'

'Exactly.'

'But we can't get him caught without us being involved.'

'That's where you are wrong. We can. Look, hold my bag,' I said as I pushed it into his hands and rummaged inside it pulling out my lipstick. I took the top off and managed to kneel next to that disgusting man without retching. I held his shirt taut with my left hand as I balanced myself to write.

'What are you doing?' Kenji demanded.

'I'm going to write *rapist* across his shirt front.'

'My love,' he said softly, taking hold of my hand that clutched the lipstick, 'you are not thinking well. The police will connect you – and me – to him if you write in English. They will find out he went to your school and I had trouble with him at work. Think Bebe, please don't do this. It's not worth it.'

'It is Kenji – it is. I know it is,' I said, annoyed. I stood up and thought for a moment. 'Okay, yes, I see your point, so why don't you write it in kanji,' I said holding out the lipstick to him. 'No one will know it was a man who wrote it.'

He shook his head and looked frightened. 'Please Bebe, let's just go.'

'Please Kenji … please … 'I implored him, still holding out the lipstick.

He closed his eyes and sighed, 'Okay, I can see you are determined. I'll write it but then we must go.'

He bent over Nobu's prone body and pulled his shirt taut and wrote the word, rapist, in kanji across it. I felt empowered,

as if watching this from afar. I was not going to let that bastard get away with it.

'There, that is it,' Kenji said curtly, 'now, let's go.'

'Yes, let's go,' I agreed as we turned and looked around to make sure we had not left any incriminating evidence. 'Wait ! What about fingerprints?' I hissed, 'Do you think they'll look for some?'

'Oh, the Goddess help us, will we never get out of here ... but yes, good point, we can't take any chances. Think Bebe, what did you touch?'

'I don't know, it was all so fast, but maybe I touched the wall he pushed me against. The floor's concrete and as far as I know you cannot get fingerprints from it.'

Kenji looked around and picked up a piece of sandpaper left on the workbench and rubbed the wall down with it thoroughly. He put it in his trouser pocket and said urgently, 'Let's go, the shop-fitters must be back soon,' as he opened the door and looked up and down the mall. There's no one around. 'Quick,' he said, guiding me through the doorway. I slipped through it as Kenji quickly wiped the door handle inside and out and we made our way up the back steps.

'Don't stare,' Kenji said when we got to the pavement, 'but I think those men sitting on that bench overlooking the river are the shop-fitters ... probably taking a break.'

I looked over briefly to see four men laughing and chatting together. One of them rose and looked at his watch and said something to the others. They all put out their cigarettes and rose and turned towards the shopping centre so we turned and walked in the opposite direction. 'They'll get one big surprise when they get back,' Kenji said.

'Do you think they'll call the police ... they won't try and help Nobu out by letting him escape?'

'No, never ! Do not forget they are Japanese.'

We held hands and I squeezed his, 'Thank goodness for Japanese morality,' I said as we walked the few minutes to my apartment. If anyone was asked if they saw a lone woman who looked distressed, they would not think of a couple.

Fortunately, we saw no one we knew.

When we got back to my apartment I pulled myself together to do what had to be done. I phoned my franchise system's head office and explained I'd been taken ill and asked them to send a replacement teacher for the next few days. Fortunately, my throat was so sore it sounded as if I had the 'flu. That done, I persuaded Kenji to get to work as fast as possible and to make up some plausible excuse like a stomach upset.

He was reluctant to leave me but I assured him I was alright, but really, I just wanted to be alone. As much as I loved him, I needed space to come to terms with this, but as he was about to leave, I realised I didn't know how or why he had come to the Sorio Centre in the first place.

'I was on my way to work,' he explained quickly, 'when I saw Nobu making his way to the railway station. I decided to follow him and when he went onto the platform for the Takarazuka train I was filled with fear. I phoned my office and said I had been delayed by an emergency and would be in as soon as possible. I made sure he didn't see me and got on to the opposite end of the train. I watched at each stop to see if he got off but he didn't so I knew that he was headed for you.'

He rubbed his hand back and forth over his hair again, agitated. 'When the train stopped at Takarazuka I jumped off and watched everyone leave the platform but there were so many people I could not see him. I ran to your apartment and searched it, but you were not there. I was running back to the train station when I remembered that you bought your lunch from the Sorio Centre most days. I ran down the steps and around the food hall but you were not there. I was running back when I noticed the empty restaurant and something stopped me, a noise perhaps, so I tried the door. That's when I found you.'

His voice hardened, 'The gods helps me Bebe but I don't know how I didn't kill that man. I was so angry. I pulled him off you and before he knew what was happening I had hit him so hard on the chin he went down like a puppet and hit his head on the concrete floor. I thought I had killed him but

he was breathing and I'm still not sure if I was happy or sad about that.'

I put my hand over his, 'Kenji please … please be glad he's still alive, I could not live without you. I don't want you in prison or worse.'

'No … no of course not,' he ran his hand over his face, 'I'm not a bad man Bebe, I've just been pushed too far. I'm desperate to protect you and that man is threatening us all the time, I think any man in such circumstances would have done the same.'

'Yes, I understand.' I took his hand, 'You saved my life, I have no doubt of that but the police must never know it was us. We must make certain of that.'

I wiped some tears away, angry they had appeared, 'Look, I think we must act quickly, we mustn't get emotional. You must get to work as soon as possible.'

He looked into my eyes and I saw his frustration, 'Yes, you're right, I must. I'll come back tonight as soon as I finish work.'

I kissed him lightly on the cheek, 'Thank you: thank you for my life.'

After Kenji left I let the feelings I'd tried hard not to show him surface. I admitted to myself that as much as I wanted to take him into my arms, I couldn't. I didn't want to be touched, even by Kenji.

I swore and cursed at Nobu in a frenzy of anger as I tore the clothes from my body and rammed them into a large bin bag. I never wanted to see them again. I needed to purge myself of that man and his evil. I ran the shower and spent a long, long time cleaning myself: washing my hair and body over and over again as if I could wash his vileness away. I had a headache and felt a lump on the back of my head. I tried to ignore it – I didn't want any remembrance of that bastard – even a headache. I dried myself roughly and threw some clean clothes on.

I made some coffee and used the ritual of grinding the beans and the coffee making process to calm me. I took the coffee pot to the sofa and poured myself a cup. My hands were

shaking. I was still filled with anger at that man and my inability to do anything to stop him. My realisation that I couldn't prevent him from raping or killing me was festering inside me. The violation was raw and intimate. It was as if I was of no value: just a thing to humiliate. A thing to make that bastard feel superior or get revenge for some warped injustice he felt.

I knew that rape was not about sex, it was about power and control. The fact that Nobu was stopped before he could finalise the rape didn't prevent me feeling violated and vulnerable. I needed time to come to terms with these feelings. I didn't want Kenji to see this. He couldn't help me. He would make things worse. But how do I tell him so that he can understand?

When Kenji came over that evening, he gave me a bunch of red roses. 'Twelve red roses for love,' he said handing them to me with a formal bow. I couldn't stop the tears. How could I tell him?

I recoiled from his arms around me, it was too soon. Poor Kenji: it wasn't his fault. I had to make him understand.

I walked to the window and looked out at the scene below me and saw nothing but my thoughts. I didn't turn around, unwilling to see the hurt on his face I knew would be there. 'I never really considered in detail how rape – or even attempted rape – affected someone.' My voice trailed off, much to my annoyance.

I gathered my strength as best I could. 'I don't deserve this Kenji. I didn't expect any of this when I came to Japan: time-travel, wars, killing, rape; all the things that had never touched me before. Where is it all going to lead?'

Before he could answer I added, 'I've made a decision, one I hope you can understand.' I turned to look at him. 'Please forgive me … but … well, I need to be alone for a while … need to come to terms with this. It's affected me more than I can say. I need to cry … and rant … and get the anger out of my system – because I'm full of anger Kenji. Anger at Nobu and the world that created him. Anger at society that let him. Anger at … oh, I don't know and that's the problem. I need to

sort out my feelings and I need to be alone to do it.'

I turned and saw the hurt in his eyes as he tried to disguise it and my heart ached for him. 'Kenji, please believe me, I don't want to do this, but it's the only way for me. Can you understand?'

He looked at the floor for a few seconds. 'I'm trying hard to understand – maybe I can. It's the anger that defeats you. I feel terrible anger too. When you needed my support I kept my anger in check, but now it's rising up from me like a volcano. The hatred I feel towards that man is overpowering and it's much worse for you. I understand that. We both need time to chew up our anger and spit it out – for we *must* spit it out – otherwise it will destroy us. And I agree, it's best done alone. I'll not contact you. Tell me when you are ready, but remember this; I am here for you always.'

He came towards me but didn't touch me. 'I too have never thought deeply about how this kind of thing can affect someone. I'm learning fast. I should have killed him in that alley and then this would never have happened. And I should have killed him today, with my bare hands, made him suffer.'

He turned and left before I could respond and I was filled with fear by his words: what had happened to my nice, kind, gentle Kenji?

Another question rose up like a threat. Where was Kai when I needed him? Why hadn't he come?

# CHAPTER TWENTY THREE

## KENJI

I left Bebe's apartment angry and confused. I was trying hard to understand her desire to be alone, but at the same time, I wanted to be there to help her. I thought I understood her feelings about coming to terms with what had happened, about being alone with her anger, but now, in the fresh night air, I was not so sure I did understand. I had feelings too and I think that sometimes she forgets that.

She said she had to come to terms with everything – but so did I. Why had she rejected me? We loved each other, but was it enough? Where were we going, Bebe and I?

She couldn't trust me, that's what it boiled down to. And why should she? I kept secrets from her, how can you trust someone who won't tell you the most important thing about himself. I've got to tell her. Oh, the gods help me, I've got to tell her. But do I have the courage? Do I have any courage at all? I should have killed that bastard, Nobu, when I had the chance, but I let him live ... to do this !

I was walking fast, my head down, vaguely aware of charging past the railway station, over the bridge and the new blocks of apartments, past Minamiguchi station – needing to walk.

Earlier that day, I'd gone to work as Bebe had advised but I was useless. I couldn't concentrate, but after all that had happened to me, my bosses were lenient and Hiro, good old Hiro, he carried a lot of my work for me.

The next thing I knew I was standing outside Hiro's apartment in Mondo Yakujin, ringing his bell, my finger staying on it until

I heard his sleepy voice over the intercom.

He let me in pulling his dressing gown over his pyjamas, and seeing the state I was in, sat me down on his sofa and put a half full bottle of whiskey and two glasses on the coffee table in front of me. He poured two large ones and took a long swallow. 'I think you had better tell me about it don't you?'

I took a similarly long swallow of the whiskey, a deep breath and told him about Nobu, his attempted rape of Bebe and how she had not wanted to see me for a while. I had to tell him. I needed to talk to someone.

It was one of the few times I'd seen him speechless. His mouth hung open and he took another long drink of his whiskey. 'The gods help us Kenji, what next? The man's a nightmare ... a demon ... a ... a ...'

'I blame myself,' I cut in, 'I'm the man, I should be looking after Bebe, but she's always looking after me. She doesn't even trust me to help her over this. I can't even tell her about my secret ... I'm a coward. A pathetic coward.'

'But you just said you saved Bebe from Nobu ... so how can you be a coward?'

'I should have been there, I should have stopped it getting that far.'

'But how could you do that? Talk sense Kenji. You are not a coward.'

'She didn't trust me. She didn't trust me to help her over this and why should she when she knows I am hiding things from her. I wouldn't trust me either.'

'Well, you know what I think. You should tell her about your family ... about ... you know ... the ...'

'Yes, I know,' I exploded. 'But how can I take that chance? I can't take much more. I don't know what to do.'

'Look, Kenji, it's up to you, but let's be honest here ... I think you are cracking up. I'm no psychiatrist, but I think you should go and see one. Talk to someone about your feelings for your family, what happened to them ... and Bebe.'

We were silent for a moment, looking at each other. I looked down at the floor. 'I can't. I just can't.' I couldn't tell him about

Bebe and Kai, it would be too much of a betrayal and I couldn't tell anyone else either. 'No Hiro, I'm talking to you, you will have to be my psychiatrist.'

He snorted derisively. 'Me! Big joke man. Talk sense.'

'No, I mean it. I can't talk to anyone. You are the person who knows most about me, you know my secret, you helped me when the police arrested me. I owe an awful lot to you.'

'And this is how you repay me?' He shot up and fetched another bottle of whiskey, slamming it down on the table as he sat down and poured two more large glasses, swallowing his down in one gulp. 'You want me to be your shrink? It's too much man, you need professional help. Look at you at work. You can't concentrate, you've lost your humour, your face is so miserable all the time. Man, you'll get the sack if you don't pull yourself together.'

I took a swig of my whiskey, 'But that's just it, how can I do that? Things keep going round and round in my head. Could I have saved my family? Was I to blame for it all? Could I have prevented their deaths if I'd been living there? I abandoned them. I feel so guilty. I can't get them out of my mind.'

'Of course you can't. It was a terrible thing, but man, come on, what happened to them was not your fault. You're not responsible – it's nonsense ... now I do sound like a shrink ...'

'I wish I could believe you, but I have nightmares and it all goes round and round and I see their faces and I hear their cries and I feel their terror... and I can't tell Bebe ... and ... I'm so ashamed of my weakness.'

'Come on. You are not weak ... in fact ... oh the gods help me where are you taking me – to places I don't want to visit – but if you want me to help you then I have to tell you Kenji that I admire you more than any man I ever met.'

I looked at him in astonishment and saw the pain in his eyes. 'It's me who is the weak man,' he said, 'not you. I can't even commit myself to loving someone. I push women away from me. I'm afraid of being hurt ... I'm afraid of rejection ... I'm afraid of happiness in case it's taken away from me ... what you never had you never miss. No, you are not a coward

Kenji. You've let yourself love someone, even though you are afraid. You try to help her and do everything you can for her while I sit on my hands and look at women from behind my beer glass. Even those bar girls frighten me. Oh, I know I take them to love hotels – there – see – I can't even bring them to my apartment, that would mean commitment – they'd know where I lived and how I live, no man, I just can't do it. I'm the coward.'

The alcohol took hold of me then and I burst into tears. Hiro's reluctant confession was the tipping point. I knew what he said was true, I saw the pain in his eyes, I realised I was not the only man suffering from insecurity and fear of love. His act of selflessness in telling me these things pushed me over the edge - the whiskey, everything that had happened, my feelings of guilt, loss, despair, all came to the surface and I cried like a baby.

I don't know what Hiro did while I sobbed, but I remember him bringing in a spare futon and laying it out on the living room floor and guiding me to it. I remember him saying, 'Lie down and stay here tonight Kenji,' before he staggered off to his own bed.

I lay there in the dark, unable to stop the tears and sobs, and wondered if I was having a breakdown.

The next morning, Hiro was up early and making me coffee. I had eventually fallen asleep and woken up groggy, with a huge headache and an ache in the core of my being.

'I got one great, big hangover,' he said miserably, 'but I'm okay to go to work, but you must take a few days sick leave Kenji,' he said gently, 'I'll tell them you are ill.'

'I'm so sorry Hiro, I didn't mean for any of this to happen. I don't know what to say, I'm so ashamed.'

'No, no, my friend,' he surprised me by saying. 'It is I who is ashamed. I should have seen your suffering, but I just played the fool, pretended that nothing had changed for you.' He poured the coffee and we sat at the kitchen table facing each other, looking everywhere but at each other.

'Look man,' he said gazing out of the window, 'I should have

been helping you to cope with the terrible thing that happened to your family. I was the coward. I just couldn't do it. And before I lose my courage, I need to say thank you to you.'

He looked me in the eyes then, his as bloodshot as I felt mine were, 'You made me talk about my own problems … and I saw myself for what I am … a stupid shadow of a man who is afraid to live life. We all have our problems Kenji, and I have recognised mine by talking about it to you – that and the whiskey.'

He slurped his coffee quickly as if was the answer to all his problems. 'Look Kenji, before the alcohol wears off, because I'm still drunk … I … I, well, I didn't sleep last night, I just thought about me and my stupid life and about you and your courage and I've got out of bed this morning a changed man. At least … I think I've changed … I want to change. I want to learn from last night.'

I was astounded. I turned my mug around between my hands as I absorbed what he'd said through the haze of alcohol still inside me. I was still drunk too. 'I never thought I would hear you say anything like that.'

'Well, there you are. Life is strange, ne?'

I nodded. Well, in that case maybe it's time to ask Yoko san out. You go to that coffee shop all the time and you never stop talking about her. Come on, she likes you I can tell … and you keep looking at that selfie you took of you and her… you know, the one that gave me an alibi … that saved me.'

I swear I saw a tear come to his eye, 'Yeah, right man, she's different all right.' And then I did see a tear, several of them as he wiped them away looking down at the table. 'Oh, the Sun Goddess help me, I've been so scared of asking in case she said no.'

I did something then that I've never done before. His hand was on the table and I put mine over his and squeezed it. He didn't take it away, just sniffed.

'We've crossed a barrier Hiro … you and I … we are both good men afraid of our emotions but we have broken that taboo, don't you think?'

He sniffed loudly and nodded. 'I'm supposed to be helping you, and here you are helping me … you're a good friend Kenji.'

'And you have helped me more than you can ever know. I can see things more clearly.'

He looked at me hopefully, 'Really, you can? I helped?'

'Much more than you will ever know.'

'Then you … you okay now? Do you need me right now?'

I shook my head. 'Thank you. Thank you for everything … you too have helped me to see myself as I am rather than as I think I am … I will do as you say and go home and take a few days off work. I need to think.'

'And be kind to yourself man,' he grinned, never one to stay down for long. 'I'm going to have breakfast at the coffee shop. Yoko san is on early shift this week.'

'Well, take a shower and do something with your hair and use a mouth-wash before you go,' I advised, and we laughed. It was the laughter of embarrassment – of a different degree of friendship – of getting used to seeing the inner core of someone you had known for a long time. We had secrets we shared, deep, personal secrets most people keep hidden.

'Do you … do you think … she might laugh at me?' He asked, letting his insecurities show.

'Don't you dare try and back out …'

'No! No backing out, I promise,' he said as he disappeared into the bathroom.

And I wondered if I could be as brave as him.

I used my sick leave to think deeply. My evening with Hiro had changed everything – made me look at myself in a different way. Through him and his problems, I saw myself: the way I was living a shallow, unfulfilled life because of fear. The way all men needed to confront their demons and overcome them, or at least, recognise them.

I'd been keeping my emotions about what happened with my family under such control that they had turned to stone. I took a metaphorical hammer and smashed them all to bits. It was

hard and I cried and talked to myself and cried some more. I wept for my family and their misfortune, for their horrible and undeserved deaths, but if I'm honest, I also cried for me – for my guilt at my selfishness. That was the hardest part: the guilt.

I had come to terms with the knowledge that I would not get over this quickly – if ever. But I was facing my demons and not ignoring them. Time would tell how I coped.

And the worst part of it was that I still didn't know if I could tell Bebe. That fear was as strong as ever even though I was beginning to appreciate the western concept of sharing deep emotions and feelings: but it wasn't my culture's way.

I began to understand that as much as I loved Bebe I had kept her separate. She was something that happened to me rather than what she was becoming – had become – a part of me.

Oh, the gods help me. How do I tell her and inflict another burden onto her?

# CHAPTER TWENTY FOUR

# YOSHI

'We have to decide where we are going Yoshi,' Kai said. 'Do we head for Edo and risk meeting Masako? Or go in another direction?'

'We should go to Edo. It is either Edo or Kyōto, the two main cities of influence, but Kyōto is a city running with blood and not the place for us. No, it has to be Edo.

We kept going all day, buying food from roadside eating places. We always used the cheap shacks, doing our best to ignore the delicious aromas of the luxury restaurants catering to the rich travellers. As we walked along I got flashbacks to my life before this: it seemed like a dream – my influential family, our riches, my pampered life. I'd changed so much but would much rather be living this life. I had purpose and excitement and I knew the future of my country: we would be successful, even if I didn't know whether the shōgun or the emperor were responsible. How I wish Bebe could tell us. She hadn't been in Kai's mind since Nagoya and I was disappointed as I really wanted to talk with her – through Kai of course. Does she know I'm a woman? If she does, would she let it slip to Kai? Then I realised I was being stupid; she only knows what Kai knows. She's in his mind, not mine. Oh, how I wish she had come into mine – what fun we could have had. I would have welcomed her with open arms and it could all have been so different.

Kai interrupted my thoughts. 'You are in a world of your own. What are you thinking?'

'Oh nothing: just thinking about Edo.'

'Yes, and when we get there you must seek out Nakamura san.'

I sighed, 'I've already told you, I will not do that.'

'We can use him for our own ends.'

'What do you mean?'

'You can influence him: tell him of your experiences on the road, the way people are thinking and feeling. How it is in Kyōto.'

'I'm sure he knows all about Kyōto, and besides, we don't know which side wins. The shōgun's government could be the losers and then where would I be?'

'But that's just it, we don't know and it is the shōgun's government in power now. We can't alter that, but we can influence it. Have you thought that your influence could be a deciding factor?'

I kept a strong control over myself, for nothing would please me more than to work for Nakamura san. Kai was right; it was my dream come true – oh why oh why was I born a woman. Life would have been so easy if I were a man.

I cursed my sex. I cursed my good looks, for even with my scar, certain men would find me too attractive to leave me alone. And I cursed Kai for being so persistent.

I hid it all as well as I could and said curtly, 'You're living in your dreams. I could never be that important.'

'Why not? I believe you can do anything Yoshi my friend.' He put his arm over my shoulder and patted it.

'I'm not a dog,' I said, irritated, shaking him off, 'don't pat me and don't humour me. It's difficult enough as it is to make a decision without you being so patronising.'

'Oh, so you are thinking about it then?'

'No. I'm not.' I said even more bad temperedly. I was letting my feelings show. I'd have to watch that.

'But we could do this together. Look, if I helped you, we could do it.'

'No we couldn't,' I shouted. 'Let's just drop it please.'

'I will if you tell me the real reason you turned him down. I

know you are hiding something from me.'

'I'm not. You are mistaken.'

'I'm not mistaken Yoshi, you are the one who is making the mistake. This is our chance.'

I sighed. He was like a persistent dog digging for a bone and I knew I'd have to give him another reason, one I hoped he could understand. 'Look,' I said, keeping my voice under control, 'What we're doing is new. Travelling the country and talking to the farmers, peasants and merchants – well, no one else has done this kind of thing before.'

'How do you know that?'

'Have you ever heard of such a thing? Has anyone ever told you of such a thing?'

He shook his head and shrugged his shoulders.

'Well then; I don't think anyone has ever talked to them as we do, as if they mattered, as if they had an opinion, as if they could express that opinion.'

'They can't.'

'That's the point Kai; they can't now, but what about in the future? What happens when it all changes? We know for certain that change will come. We have to prepare the people for that change – for a different world: one where they will have a say, where others will listen to their views. Where their children will be educated and people will be allowed to travel and have different jobs to their family's traditional ones. I'm talking about freedom, Kai. And people who have never known freedom have to be taught that it exists, that it is coming … and how to recognise it. I want to inspire some of them to become leaders to have the courage to come forward, to come out of the cocoon of tradition and be brave enough to step into the unknown. To help turn our country into one which values all people as long as they try hard enough. Oh, Kai, can't you see the possibilities here? I must have the freedom to do this. I cannot have such freedom if I am working for the government.'

'I can't agree, Things will change only from above. You can influence the poor people far more if you have power.' He was

right, but I couldn't let him see me waver.

'But what power would I have? Freedom of choice is not something that is encouraged in government. You know that as much as I do. I would have to agree with my peers, follow my superior's orders and he follow his superior's orders and so on. When the wind blows the weakest stalk of rice must bow with the others.'

Fortunately, there were no other travellers on the road to overhear us as we came to a natural stop and turned to look at each other.

'I'm not convinced Yoshi. Look, the poor people will not rise up until they are forced too. I agree we can influence them by showing them a different world, one they can dream about, but the change has to come from the top. The poor can't change our society on their own. They need a friend in government: someone who will support them and promote fairness for all. You have the chance to become one of those powerful people. He folded his arms and looked at me hard. 'I can't understand you. You are always so sensible. I'm sure you can see the sense of my argument, so I know there is another reason. One you are refusing to tell me. Why? Why keep it a secret? Can it be so terrible?'

I was angry he wouldn't let this go. He didn't used to be so forthright. It must be Bebe. He's been thinking about her a lot, remembering things she's told him. I catch him staring into space and know he is remembering, thinking about her.

'You are wrong Kai,' I said, knowing he was right. Change had to come from the top and I cursed my position again, but I dare not enter that world. I wished I could tell him my real reason. But it was impossible right now … maybe one day. I needed to distract him. 'Maybe I'd feel better if Bebe came back into your mind. We could ask her questions.'

'Well, she hasn't been and I haven't been into hers either.' He shrugged, 'Maybe something has gone wrong with the magic. Maybe that chip altered things?'

As he said this, I saw his eyes roll upwards and he staggered a little, I took his arm and led him to the side of the road and

sat him down, propped against a tree. I could see that he was no longer of this world and I had to hope that he had gone into Bebe's.

I was afraid for him and powerless – and that was hard to cope with. But I was excited and intrigued. My heart beat so fast I could hardly breathe and I cursed again the fate that put Bebe into Kai's mind and not mine. There was nothing I could do but wait, so I settled down next to Kai and Lucky lay down beside me and put his head on my lap. I tickled his ear … thinking.

# CHAPTER TWENTY FIVE

## KAI

I drifted and the world went out of focus. Thousands of needles pummelled my skin and then I was inside Bebe's mind again.

'Kai ... Kai ... is that you?'

'Yes, it's me. Are you alright?'

'Yes, I'm fine.'

'No, I don't think you are. There's something, I can tell. You are upset. What has happened to you?'

I felt her resistance crumbling as she let me deeper into her mind and I could understand the trauma of the attempted rape.

'Sato !' I yelled, making Bebe jump violently. 'It's Sato – oh, the Goddess help me.'

'Calm down, it's not Sato,' she said, 'it's my ex-student Nobu ... but there's a possibility that he's a descendant of Sato ... don't you think?'

'Well, he had me fooled ... that chin ... and those deep set eyes like mean dots ... and that same aura of menace. The Goddess help us Bebe. Is there no way around these people? They plague us in both our lives.'

'But Sato is dead in your time is he not?'

'Yes ... yes, of course he's dead,' sorry I was confused. But I hope that if you meet that Nobu again, I'll be with you and it will give me great pleasure to help you kill him. I was thwarted with Sato and had to rely on Masako, but if I get the chance ... 'I broke off realising my insensitivity. 'I'm sorry,' I said,

163

feeling her pain. 'I should have been there when you needed me. I don't know why I wasn't this time. In the past … well, I was reluctant and angry about being in your mind, but now … it's all changed and I welcome it, but when you needed me so desperately, I wasn't there. I don't know what to say.'

'It's not your fault Kai; I haven't been back into your mind either. Something has changed.'

'I think … I'm sorry Bebe, but this may sound silly to you but … well, I think it is something to do with the teapot you bought.'

'Yes, I know,' she said simply.

'You *know*?' And then I could see her memory and felt her shock when she recognised the teapot Yoshi was giving me as the same one she had bought in her own time.

'I see,' I said, 'but I didn't pick up your thoughts about it at the time.'

'Well, you did have more pressing matters to take your attention,' she said quickly. I think she was trying to distract me away from the pain I had felt when Yoshi left me, and I was grateful. I had to smile to myself at the irony of it all.

'You know Kai, I've always had a special feeling for the teapot. When I first saw it, it hit me with a force I couldn't explain. I knew I had to have it – that it was special. I just didn't know how special. It all seems so … well … unbelievable.'

'Well, believe it. I'm convinced it's the link between us. When I went to collect it from Kawamoto san, she confessed that she had accidentally damaged it.'

'Damaged it? In what way?'

'Don't worry, not too much damage. It now has a chip on the handle.'

'A chip on the handle,' she said in great excitement as she rushed to a cupboard and took out the teapot and showed it to me.

'Like this one?'

I tried to control my excitement. 'Yes, that's it. The chip is in exactly the same place and looks identical.'

I let Bebe into my memories of the teapot and the discussions

164

Yoshi and I had had about it. How he had been given it by the old travelling woman.

'Well, I thank Yoshi and the old woman and whoever else was involved in putting me and the little teapot together.'

'You're not unhappy that this has happened to you?'

'No, absolutely not. Oh Kai, I can't tell you how I've come to love my life with you, seeing and understanding things I would never have been able to. It's been a privilege and an honour. Just think, in this huge planet of ours, I travelled to the other side of the world and walked into a large department store and found the tiny space the teapot inhabited and we were joined together. It's just … just … extraordinary.'

I didn't want to dampen her excitement but I had to be sure. 'I'm sorry Bebe, but I have to be sure, can you hold it up so that I can see it in detail.' She picked it up and turned it around, running her fingers gently over it so that I could see and feel it.

'It's the one isn't it?' she said. 'It's the same teapot; oh don't tell me now that it isn't.'

'I want to be sure and examine in detail the pattern down the side.' We looked at it closely and then I was sure. I could see the pattern of Yoshi's scar … Yoshi … my mind drifted to him and she said, 'You love him don't you?'

I jumped with annoyance at my lapse.

'You can't lie to me Kai, you know that.'

'Yes, that's true, and you can't lie to me. I love him deeply – as you love Kenji.'

'Yes, it works both ways; I cannot lie to you either.'

She put the teapot down, 'When I bought this it had two chips on it, as you can see. But are you telling me that in your time, it only has one?'

'Yes.'

'So, we have another one to go … what if the second chip doesn't match this one?'

'Well … I can't see why it wouldn't because everything has matched so far. Both of us having possession of the teapot … the unusual design that matches Yoshi's scar … the identical chip in both our times … I can't see any reason why it wouldn't

match Bebe. But if the first chip brought you back to me – and I am more grateful than I can ever express that you came back and saved my life – what will the other chip do?'

'A conundrum.'

'Yes indeed. Do you think we need to worry about it?'

'I'm not sure,' she answered. Her mind was so active I had trouble following her thoughts.

'I've been thinking so hard about the little teapot,' she said. 'How it all works. Let's just go back to when all this started. My first indications of something happening were the strange feelings I got on the Hankyu trains travelling between Takarazuka and Nishinomiya Kitaguchi. It got stronger as time went by and the feelings of going back in time got more real until I finally found myself inside your head, fighting other samurai.'

'Yes, I remember I got a knock on the head and when I woke up you were inside it – although I didn't know it at the time.' I laughed at the memory; it all seemed so long ago. 'We are different people now Bebe.'

'That's true, but going back to how it all came about, I'm sure this happened before I bought the little teapot.'

'*Before* you bought it? Are you *sure?*'

'Yes. The more I think about it the more I'm sure.'

'So, it's not the teapot !' I said, disappointed for some reason. 'I so wanted it to be.'

'Well, again, I've been thinking. You and I both live and lived in Takarazuka – there's one thread. The Hankyu Railway is important in Takarazuka because it brought prosperity to an isolated and unsuccessful spa town with the Takarazuka Theatre Company. The railway covered lots of land and I'm wondering whether it goes over some shrines or spirit places and disturbed them?'

'Ah, yes, spirit places. It's hard to understand spirits.'

'Or maybe Takarazuka itself is the spirit place – it always feels like a magic place to me. It has a special quality I can't define.'

'I understand your meaning. I have felt it too.'

'Maybe our spirits are joined somehow? For example, why would I have travelled half way around the world to a country I knew nothing about and had little interest in? Out of the whole of Japan, why did I end up living in Takarazuka? And to cap it all, how come I went into a department store and found that particular little teapot among the many on display? Why did it resonate so strongly with me?'

'I don't know Bebe, but I have been thinking similar thoughts. I wondered whether the teapot may have been intended for Yoshi and you. '

'What an extraordinary thought !'

I felt her thoughts tumble over each other as the ramifications of having Yoshi in her mind instead of me developed. I also felt her trying to squash down the interest she had in Yoshi.

'Don't worry,' I said, 'I understand that things would have been very different if it had been Yoshi inside your mind: probably much more exciting – and easier – than having me.'

'Well, it would have been different ... but you know Kai, I'm glad it was you. You have given me so much even though it was hard going sometimes,' she laughed. 'No, I'm happy it was you. Please don't ever think otherwise. You and I are a team now.'

'Thank you, that makes me so happy. I feel we are a team too. I'm glad it was me and not Yoshi.'

We relaxed for a moment in mutual admiration until her ever active mind said, 'You know Kai, we don't know how many other people have owned the little teapot before us and used its magic – or owned it and not used its magic because it was not strong enough for them. And we don't know how many people might have felt the magic while they were travelling on the Hankyu trains, but it wasn't robust enough to take them further because their spirits didn't quite gel. Maybe only certain spirits can connect to the teapot. Maybe yours and mine connected, but maybe Yoshi's and mine would not have. I think everything is linked, not just the teapot, although I feel that is the most important, but all these things had to come together for the magic to work and it got stronger as time went by. After I bought the teapot things really started happening –

and here we are. It's an incredible adventure don't you think?'

'I agree and I am so grateful. Because of you I have become a better person – no, that's an understatement – I have become a man I could never have believed possible in my old life.'

'Me too, I've changed so much, and am grateful too.'

'I'm relieved that the teapot is at least one of the things that brought us together. I love that teapot.'

We laughed. 'I love it too,' she said and we settled into calmness, silently allowing ourselves to feel satisfaction with it all.

Then I became aware of time slipping by. 'I'm sorry to rush you Bebe, but we don't know how long we have with each other and I need to talk to you about Yoshi. Since we were last in each other's minds I have met up with him again. I opened my memories and let Bebe see what had happened to Yoshi and subsequently to us.

'He won't accept the government post,' I said, 'there's some reason he's not accepting it, but I have no idea what it is.'

A noise from the street distracted her and she walked to the window and looked out – I suspect to give herself time to think about Yoshi. I shuddered as I saw how high up in the air she lived.

Finally, she said, 'Yoshi is an enigma but I'm afraid I cannot help you. I have no idea what is troubling him.'

'I want to help him so much. I think he's important to my country's future.'

'I can tell the pride you have in him Kai ... if it will help you I could look up Japanese history on the internet and tell you what happens.'

'What's the internet?'

'It's ... a devise that connects to a satellite and links all kinds of information.'

'I'm sorry, I don't understand.'

'Okay, never mind what it is, let's just use it and you will understand?'

'Okay. But can I ask a question first?'

'Of course.'

'When you came into my life you told me you cannot remember the history of my time – that it doesn't transport with you.'

'That's true, it doesn't.'

'So, whatever I learn about history here, I will not remember it when I go back.'

'I suppose that's true.'

'So what use is it to find out?'

'You're right Kai. It will be of no use at all … but it will be fascinating nonetheless, and you never know, it might be different this time? You might remember. Come on, let's do it. Let's find out.'

I laughed with sheer pleasure, 'You're right. I should know by now never to assume. The impossible is possible – as we've found out.'

I'm not sure she was listening to me as she walked quickly over to a small table set against a wall. She sat down before what looked like a large, black book.

'This is known as a computer and we can connect to the internet with this.' She felt my confusion, 'Don't worry, it will become clear.' She pulled up the top and it divided into two – not a book then – and said pointing, 'This is a screen.'

'A screen?'

'Yes, and I'll use these keys here to tell the computer to look up information and then we click on the information we are interested in with a mouse.'

'A *mouse*!'

She laughed and I was even more confused.

'I'm sorry Kai, I shouldn't have laughed so much, and I agree, it's a stupid word. It's not a real mouse of course.'

'Okay, I realise this is all future stuff I will not understand so I won't say another word, just show me.'

'Good, I'll type in Meiji Restoration and see what comes up.'

Meiji Restoration I wanted to query, but held my peace as within seconds a lot of writing appeared on the screen. It was not Japanese but when I looked at it I realised that I could read it. I was surprised, although I'm not sure why for if we can

speak each other's languages when we're joined together, why shouldn't we be able to read the language too?

I'll read it aloud,' she said, 'so that we can follow it together. "In 1867, after a civil war that lasted for fourteen years, the emperor's forces defeated the shōgun's last army near Kyōto."'

'Wait a minute – *defeated* the *shōgun's* army?'

'That's what it says.'

'The Goddess help us. Yoshi and I are on the wrong side !'

'Calm down Kai, let's see what else it says, "They marched from Kyōto, the old capital, to Edo and renamed it Tokyo – the eastern capital."'

'They changed the name of Edo?'

'Yes, everyone knows it as Tokyo now.' She laughed. 'I can feel your shock Kai, but sometimes new worlds need new names.'

'I suppose so, it was just so unexpected. Oh, I hope I can remember this to tell Yoshi.'

'Well, let's continue, "they installed the new emperor, who was only sixteen years old, and he became the symbol of the new Japan, which, in forty years had transformed itself from a feudal society to a military and economic power that could defend itself and stand up to the West."'

'Stand up to the West ! Oh, thank you Sun Goddess, that's … that's …' I was so excited I couldn't get my words out but Bebe ignored me. '"The emperor was re-named Meiji and the era is known as the Meiji Restoration, (Meiji for enlightened rule and Restoration for the re-instatement of imperial rule.) The people governing at this time were a small group of mostly, young samurai, and they started to build the new Japan, making up the rules as they went along."'

'The Goddess help us Bebe, Yoshi could be one of them …' I could hardly control my excitement and it was beginning to get uncomfortable for Bebe, I needed to calm down.

'Maybe,' she said quietly, but I could tell her excitement was almost as high as my own. 'Let's continue, "The nation was in chaos and the countryside erupted in spontaneous outbreaks of hysteria as people tried to comprehend what was

happening to them. Their lives had been turned upside down. Bringing order to anarchy was the key challenge to these Meiji bureaucrats as they struggled to build a new administration that would work and advance their country.'"

'But Bebe, Yoshi could be part of all this – I'm so excited – do you think this is what all this has been about?' I didn't wait for an answer, 'Just wait until I get back and tell him.' A realisation crept up on me that I might not remember, so I read it all again and again and Bebe was very patient. I wanted to get it lodged into my mind. But there was one thing that was standing out like a sword being present during a tea ceremony – out of place and threatening – there was no doubt we were supporting the losing side.

Bebe interrupted my thoughts. '"It was a time of new ideas which were absorbed from the west but at the same time, these young samurai had no real understanding of western ways of thinking, They had been nurtured and educated in the feudal system of their ancestors and although they were desperate to change things, those values were still in their veins and hearts. It resulted in a modern Japan on the outside, following the examples and advice from western allies, but underneath it all, the deep traditional values of the old Japan were still ingrained and revered.'"

She was quiet for a while and I didn't interrupt her although my excitement was still quivering like an arrow.

'Thinking about it,' she said, 'how could it be any other way? How can a country throw away thousands of years of culture just like that? It's impossible. Deep psychological changes like that take decades to change – if the people want to change of course. And maybe deep down, the Japanese people don't want too. It's their culture, their uniqueness in this world of sameness.'

'You're thinking thoughts I can't follow,' I said.

'Sorry, I was just mulling over things I hadn't thought about before. You can't understand modern ways of thinking – and why should you? I think that just knowing that things change drastically for your country in a very few years is all you need

to understand. You are a samurai and cannot change the values that have been imprinted on you, the same as I cannot change mine and adopt samurai values. We're at opposite ends of a pole … but maybe we can try and understand the other's point of view and respect them. That's a great starting point. You know, many western people thought that because Japan changed and adopted western technology, dress and architecture, their mindsets had changed too. That's why Japan is so fascinating. It's what goes on underneath all that modernity.'

'I'm sorry Bebe, but you are confusing me.'

'No, it's me who should apologise. One of the drawbacks of having someone else in your mind is there is no privacy and I'm trying to work out things that I see around me and have not been able to understand. I've read about the Meiji Restoration before, but it's always been so complicated. Having read this simplified version, it all becomes clearer, helped me to understand what I've seen in your time and how things are today.'

I didn't know what she meant by that but decided not to pursue it. I said, 'This is all so exciting, I just hope I remember it when I get back. Yoshi would be astounded.'

She laughed, 'That's an understatement, I'd love to be there when you tell him – if you remember that is.'

'I'll do my best, and this has made up my mind for certain. I need to get Yoshi into government. I don't know how I am going to persuade him, but I must do it. When you read out our history I felt I was reading of Yoshi. I got a feeling deep inside me, a certainty.'

'Good luck Kai, you deserve it. Maybe everything that has happened has been to get Yoshi into government? Have you thought of that? Perhaps it needed the three of us to make all this happen?'

'An interesting thought … but as I said, we will never understand the spirit world and never know for sure. But what I do know for certain is that we are all different people to the ones who started out on this incredible journey – and I for one am grateful for it.'

'Me too,' she said, 'it's been an incredible journey.'

'And it's not over yet, let's not forget that. The teapot still has another chip to come and I can't help wondering what effect it will have on us ...' suddenly disorientated, I stopped speaking as I realised the floor was swaying and Bebe nearly fell over. 'Earthquake,' I shouted, and I had to believe that the gods had something to do with sending me here now.

I felt her body stiffen, and that was one of the worst things you could do, you needed to remain relaxed to prevent injury. It was the same with fighting. But all thought was thrown from my mind as Bebe fell onto her hands and knees and I realised this was a serious earthquake.

'I can't stand up,' she said, 'Kai, help me. What do I do?'

'Nothing. There is nothing you can do now, it's too powerful. Just stay where you are.'

The building was rocking back and fore, faster and faster. I was as terrified as Bebe. I'd been in lots of earthquakes in my own time, but it was different then, we didn't have these huge buildings up in the sky and it was easy to get outside where there was a lot more space than here in this new world.

'I can't move,' she shouted back, still on her hands and knees, 'I fall over if I try to move.'

I could see some things falling off shelves, 'Things are falling Bebe, but I cannot tell how serious this earthquake is – not up here in the sky ...'

'The teapot,' she shouted. 'We must save the teapot.'

'Get on your stomach,' I commanded, 'now, fast, and crawl to the cupboard.'

'I didn't put it back in the cupboard; I left it on the counter. I can see it Kai, it's at the edge of the counter, it's going to topple.'

'Move faster,' I yelled as she tried to crawl there in time but it was impossible as the room continued to sway violently and I saw some of the furniture begin to shift around. This was getting serious.

We saw the teapot fall off and hit the tatami mat and the lid rolled away. She managed to grab the teapot and clutched it to

her stomach, curling around it. Some other things fell off the counter top and a few cupboard doors fell open and china fell out, but thankfully missed us as Bebe yelled, 'The lid, where's the lid? 'I can't move Kai. What shall I do? You have more experience of earthquakes'.

'But not in a building like this. This makes it much worse than anything I've known before. I'm as terrified as you, but we have to stay calm. Terror causes injury. Just stay as you are and keep your head tucked into your body with your arms over your head.'

'But what about the lid?'

'The teapot is no good if you are dead. Protect yourself Bebe. You are more important.' I realised the truth of what I said after I'd said it. Nothing was more important than our lives and in this case, Bebe's life meant mine too. The teapot had no power without us.

Thankfully, she did as I told her and I tried to forget I was up in the sky, with a long drop to the ground. Fear slows time significantly and the shaking seemed to go on forever.

I tried to shut out her tumbling thoughts and visions of the building collapsing and burying us inside. How they stayed up anyway was a mystery to me: one of the secrets that the people of the future had discovered. I was in awe of them, but right now, they put the fear of death in me. I didn't mind dying by the sword, but trapped in a hard building high in the air was something very different.

Then it stopped. Out of nowhere it came and to nowhere it went. It made me wonder if the spirits were warring with each other and the earthquake stopped when one became the victor.

We lay there motionless until she whispered, 'Is it over?'

'I think so, for the moment. But there are always smaller shocks afterwards.'

'What do we do? Do we stay like this and wait?'

'No need I think. We can never predict when aftershocks will come, let's move around … but carefully.'

'Oh, Kai,' she cried out alarmed, 'I can't move, I'm stuck.'

I felt her terror and her helplessness – that's the worst – the

helplessness. 'Don't worry, it's because you've been so tense and your muscles have frozen. Just relax and they will soon unfold.'

'Easier said than done,' she said, but I felt her muscles begin to relax and she looked down at the teapot and ran her fingers around it, feeling for cracks.

'Is it okay?' I asked terrified it was damaged and I could be stuck here forever. I realised then, just how much I wanted my own life back – and Yoshi. As much as I now treasured Bebe, I never wanted to come back to this terrifying future. Bebe picked up on my thoughts but fortunately, was too distracted by the teapot.

'It's all in one piece,' she said, her breath coming in short jerks, 'I can't feel any cracks.'

I kept my voice as calm as I could, trying to help her overcome her fear. 'How about chips?' Are there any more?'

The wait while she checked it was agonising, 'I can't feel any, there's just the one chip on the handle as before. But where's the lid?'

We looked around at the cluttered room. Things I had no names for had fallen around and some of the lighter furniture had moved, but it could have been worse.

'There it is,' she yelled, pointing to a corner of the room as she made her way gingerly to it.

'It is damaged?' I asked trying to keep control of my worse fears.

She picked it up and examined it. 'No, oh thank goodness, there's just the same chip it had before. Our guardian angels have been watching over us.'

I didn't know what guardian angels were and I didn't care as I thanked all my own gods and goddesses. Relief like I had never known before enveloped me in its gentle cloak and I tried to impart this feeling to her. 'It's over now,' I said, 'calm your mind; we're alive.' I couldn't stop that last statement resonating around my brain, and I said it again with gusto, '*We're alive.*' I realised then that my samurai training of not fearing death, and treating life as something casual, that can be replaced by

another life, had died during the earthquake. I knew I wanted the life I had now and no other: I wanted my life with Yoshi. Other lives were of no consequence and I couldn't wait to get back to him.

And then, as if I was being flung around by some giant creature, the world spun and thousands of needles pierced my skin and I opened my eyes and saw the Tōkaidō Road.

# CHAPTER TWENTY SIX

# BEBE

Kai had gone and I felt a finality; a finishing of something. I called out to him several times but there was no response. I felt sad, bereft. Recently, whenever we were in each other's minds, we were becoming as one in an odd way. We'd got used to our situation and learned respect for one another and it was becoming normal and natural for us. But he was gone and I brought myself back to coping with the present and Kenji filled it.

Had he been killed? Not knowing was unbearable.

I was frantic. I hadn't seen him since I'd asked him to leave me to come to terms with my anger about the Nobu business. I now realised my stupid feelings, and coping with them, were meaningless. This was real life – survival.

And if he had survived the earthquake, would he still want me? Feel the same about me? Rape, even attempted rape, can colour people's perception of the victim. I didn't believe in Kenji's Sun Goddess – or his gods – but I prayed to them all to keep him safe and to still want me. I felt selfish thinking this. For all I knew people could have been killed and I was only thinking of myself … but I couldn't control it.

I searched around for my phone throwing things aside in my haste. He'd told me earthquakes were more dangerous for people in older buildings like mine as they were not built with the latest earthquake technology. The buildings had also been weakened the Great Hanshin Earthquake of 1994 which destroyed a lot of the area we lived in. Kenji's bank was

situated in an old building and although mine had survived, it didn't mean that Kenji's had.

At last, I found my phone under a pile of towels in the bathroom – how had it got there? My hands were shaking as I pressed his speed dial number. The wait for it to connect was agony as the silence lengthened. I tried dialling again … and again and again. I checked the battery; it was full. I dialled again. Nothing. His mobile was not working. Had it been damaged? Had he been hurt? Was he … no, I refused to think the unthinkable.

I ran out into the street expecting devastation around me, but to my astonishment, there was not as much damage as I had envisaged. A lot of this part of Takarazuka had been rebuilt since the Great Hanshin earthquake. There were a few large cracks in the road and traffic had come to a halt. It was the middle of the day and there were people standing on the pavements looking around stoically, if a little shaken. I ran towards Minamiguchi station and relief flooded me as it looked undamaged. As I ran towards the ticket barriers an official stopped me.

'No trains Miss,' he said to me in slow, easy Japanese, 'we must check damage.'

'When will that be?'

'Depends on aftershocks. We will do our best.'

'How about the buses?'

He shook his head, 'No, the same for buses. We must keep passengers safe. It is our job.'

No trains or busses for hours – or days?

In desperation, I tried calling Fumi but there was no connection.

'The telephone is not working,' the railway man said. 'System collapse: too many people calling at the same time.'

'What about Nishinomiya Kitaguchi?' I asked him. 'Is it bad there?'

He shrugged, I'm sorry miss, I don't have any information, it's too soon.'

I didn't know what to do. Should I walk the eight miles or

so to Nishinomiya Kitaguchi? But that would take a long time and what if there were aftershocks? I didn't care quite frankly. I just wanted Kenji. I laughed at the irony of it. I left England convinced I didn't want a husband and a 'normal' life and now here I was on the other side of the world, living through an earthquake and all I wanted was the man I loved and a life with him. Everything else was small compared to that. My values had changed. I'd changed so much I knew my parents wouldn't recognise me. Would they be pleased I wanted to settle down with a Japanese man? I threw those nanoseconds of reflection out; amazed my mind had indulged in it. I was still left with the dilemma of what I was going to do?

I went back to my apartment to think, ignoring the mess around me as I kicked things out of the way. What should I do? I needed to do the right thing. Think woman, think. What would Kenji do if he was safe?

First of all, he would help his colleagues and his company as that was his job and responsibility. Then he would come to find me. Yes, that's what he'd do, I reasoned, so, I must stay put and wait for him.

I cleaned up the debris, throwing out my broken things and making sure the little teapot was safely in the cupboard wrapped in a thick, soft towel. I tied the cupboard door to the one next to it so that the door wouldn't swing open if there were aftershocks. There was no electricity, so I took out my pan and brush and swept the tatami mats so thoroughly they were in danger of being damaged. I kept looking at my watch every few minutes and it was the longest four hours of my life. When I heard his key in the lock I ran to the door and pulled it open fast. He stood there, looking tired and untidy.

'Oh, Kenji, are you alright?'

'Yes,' he said breathlessly, 'I'm sorry, I'm out of breath running up your stairs, I'm fine. How about you?'

'Yes, I'm alright,' I said pulling him inside and slamming the door shut with my foot. I put my arms around him and hugged and kissed him so hard it was painful for us both but I couldn't stop.

At last our lips parted but we still clung to each other. 'Oh, Kenji, I'm so happy you're alright. I've been so worried.'

'Me too: I'm sorry I couldn't leave earlier as many of the older buildings around my bank were damaged and people had been hurt. We all helped them as much as we could until we were not needed.' He took several deep breaths, 'I was half walking, half running to you when I found a damaged bicycle in the street and managed to straighten it out so that I could use it. Oh, Bebe, I'm so happy to see you.'

Through our kisses I said, 'I'm sorry. I was stupid to drive you away. I'm sorry. I'm sorry. I'm sorry.'

We kissed again and I thought we'd never stop. I felt his hardness against me and my passion inflamed even more. I led him to the living room, kissing him as we went. I'd never been so inflamed and intense desire zipped through me and hit every nerve. I could tell that he was feeling the same. There was nothing that could stop us right now – except death.

I pulled savagely at his shirt and some of the buttons popped as we tore at our clothes and fell to the floor in a frenzy of passion and instinct. A celebration of still being alive.

We were in a blur of sensations as we made love over and over until we were spent. We hadn't even made it to the bed, but still lay on the soft tatami mats where we had fallen on each other. Darkness had fallen but the moonlight was strong and shone off the river and through the windows making romantic glows and shadows which danced through the room. Everything that had happened that day left me with a certainty deep within me that I had reached a turning point in my life and if I didn't speak of it I knew I would burst.

I disentangled myself from his arms and knelt beside him caressing his brow with my fingertips, 'You know how much I love you.'

He smiled that secret, smug smile of passionate lovers in repose and I tried to ignore it as it sent shivers of desire through me again. I had to concentrate.

'Don't look at me like that Kenji,' I laughed, 'I have something important to say.'

'What? More important than this?' He lifted himself up on one elbow and tried to kiss me again and we laughed as I pushed him back down.

'Yes,' much more important than a kiss. Be serious please, for a moment.'

He looked worried. 'What is it? Has something happened?'

'Yes, in a way.' I spoke slowly, forming my thoughts into words. 'Something has happened to me since this earthquake, something deep inside me has changed. You are used to earthquakes and this one was not so big by your experiences, but for me, it was huge … distressing … and very, very frightening. It made me realise how easily life can be ended without warning. One second you are going about your business and the next the earth is moving under your feet. You don't know if you will survive or not. In my own life – this life – it's the nearest I've come to death and it has made me realise what I want most … and it has given me the determination to ask for it.'

'But you've been close to death when in Kai's life? How is this different?'

'I'm not sure … I suppose, it's made me realise that I could die in this life just as suddenly as in Kai's. I was always ready to die in Kai's life, sort of expected it, but there was nothing I could do about it. But here it's different: I'm in control. But during the earthquake, I was powerless. I didn't know if you were alive or dead and I had no way of finding out. It was agony and it made me realise just how deep my love for you is.'

He went to say something but I put my finger to his lips to stop him. 'No, let me finish please.' I swallowed down the emotion that was springing up inside me, determined to finish this.

I wanted to do this properly, so I went on one knee and said, 'I want you in my life forever – in the most intimate way possible. Kenji Yoshida, will you marry me?'

I was so sure he would answer yes, his silence didn't worry me at first, but when he turned his head and looked away my stomach felt punched.

The silence lengthened, and I felt more vulnerable than I could have believed possible, as my proposal hung in the air, rising up between us like a barrier.

I knew how much he loved me, I was so confident he wanted me as much as I did him, that I couldn't comprehend his words when they finally came.

Still with his head turned away he said, so quietly I could hardly hear him, 'You know ...' his voice faltered, 'you know I can't Bebe. I've told you before. It's impossible.'

Emotions welled from deep inside me. I tried to swallow them down but they felt like rocks in my throat.

'Why? Why is it impossible? You love me as much as I love you. I know that.'

He nodded.

'Then why? Tell me. I deserve to know.' My tone became harsh as my humiliation turned to anger and I sat back putting a distance between us.

His silence was like a death sentence.

'This is to do with that bloody secret you guard so well isn't it?'

He didn't move for a few seconds and then nodded.

'Don't you know by now that I don't care about your stupid, bloody secret. I don't care if you have done the most awful thing in the world. I just don't care. Don't you understand?'

He sat up, angry himself now. 'And you don't understand that I haven't *done* anything. It's not what I've *done* it's what I *am*.'

'What do you mean?'

'I can't Bebe. I can't.'

'But why? Don't we stand for something you and I? Doesn't our love overcome all obstacles?

'I can't do this to you.'

'Do what?'

He was silent.

I'd had enough of this Japanese reticence not to tell the truth if it's painful, to hide behind manners and traditions: to not share your traumas with others. To keep everything bottled up.

Endure: even if it kills you – even if it's the stupidest thing in the world and can be so easily solved.

I stood up, looking down at him, 'Look Kenji. I've had enough of this,' my voice was hard, *'you have to tell me.'* He was silent again and away from the heat of his body, goose bumps started to rise up over me in the chilly night air. I felt vulnerable standing there with no clothes on as I realised how hard it is to express your anger when you're naked. I stormed into the bedroom and put on some underwear, a pair of jeans and a sweater.

I felt more assertive as I walked out of the bedroom. Kenji was standing in the middle of the room getting dressed. He tucked his practically button-less shirt into his trousers and looked for his tie.

My stomach flipped sickeningly as I realised that he was going to leave. 'Kenji, don't go,' I pleaded. I took his hands in mine and looked into his eyes. 'I'm telling you the truth. I'm not one of your Japanese women who won't tell you their deepest feelings. When I tell you I don't care what the problem is, I mean it. *I don't care.* If you are married already, *I don't care.* If you have the worst family in the world, *I don't care.* If you are a criminal – or whatever it is – *I don't care.'*

His face creased in pain and I put my arms around him and held him close. He was suffering as much as I was.

'Just tell me my love,' I said softly.

I felt his heart beating hard and fast and his breath came in short bursts, and I could tell the effort it cost him to say, 'I cannot get married Bebe, I cannot have children … I have to be the last in my line.'

Perplexed, I kept my voice soft and encouraging. 'Tell me. Tell me why? You know you can trust me. No one else will ever know … just tell me.'

He took a deep breath and it shook from deep inside him, 'Keep calm,' I reassured him, 'it's alright. Everything is alright.'

'I'm afraid of losing you if I tell you.'

My anger rose up unbidden and unwelcome, but I couldn't stop it. I walked away from him, needing some space between

us and the decision came naturally, without forethought. I knew it was the only way. I turned and looked at him. 'Well, then I will make it easier for you. You *will* lose me if you don't tell me. I want to know why my offer of marriage was refused. I never thought I'd want to marry anyone until I met you. But I cannot stay with you unless you tell me.' I walked over and stood in front of him, looking straight into his eyes, and said more softly, 'You tell me or lose me because if you don't, somewhere in the future the secret will destroy our love.'

He walked to the window, looking out for what seemed like an eternity before turning to me, looking vulnerable and defeated. 'Okay Bebe, I'll tell you.'

My anger lost its force like ice cream melting in sunlight. 'Thank you,' I said very gently.

He walked around the room a few times, his hand going up to his hair constantly, in that way he has when stressed. I stayed silent.

'Okay,' he said, his voice shaky, 'well ... all of my family ... all except for me ... have ... have an illness ...' I waited while he paced some more. 'They ... they are ... oh the Goddess help me Bebe ... they are mad. There now you know; my family is mad – *mad, mad, m-a-d*.'

My breath caught in my throat; my stomach flipped. Whatever he was going to say, I hadn't expected this. I kept my voice low and soft, 'What do you mean by mad? What illness?'

He breathed deeply. 'Schizophrenia. They all had schizophrenia.'

I gasped then cursed myself for it, hoping he hadn't heard. The moonlight was strong and I glimpsed the grief and suffering etched onto his face.

'Let me get this clear Kenji – you don't have the illness?' I asked in as strong a voice as I could. I needed to be strong for him. Sympathy at this time would not serve him well. He'd crumble under it.

His voice still trembled, 'No ... no Bebe, I don't have it but I could develop it at any time.' He looked at me from across the room: his silhouette outlined in moonlight. It was a perfect

image for romance, but now it only served to emphasise his misery. My heart went out to him.

'That is what the doctors told me. This kind of schizophrenia comes from the genes. It is in my family's genes. I cannot risk having children it would be a terrible thing for a wife and child. What if I went mad? I know what it's like. I've lived with it all my life. I could not inflict that on you. I love you too much.' He shook his head adding, 'I should never have started this relationship. It was selfish of me. I broke my own rule not to have love in my life and I cannot forgive myself for putting you through this.'

I rushed over to him and hugged him close. 'Never, never say that again. You have given me joy and happiness and we'll get through this together.'

He was silent for a long time. 'Do you mean it? Really, really mean it?'

'Oh, Kenji, do you think my love is so thin and breakable? No, my darling man, I am not and will never leave you, no matter what. I love you and want my life to be with you. I don't care about anything else.'

We stood hugging each other for a long time as a storm of tears engulfed him.

'Let it go my love,' I encouraged him. 'Let your tears flow, let the grief out, you need to find peace. Sometimes we have to break in order to heal.'

Finally, his tears ebbed and he was able to take a shaky control of himself. I sat him down on the sofa and cuddled up to him and said, so very softly, 'I don't know much about this illness, but I do know there's medication. Many people have schizophrenia and are able to live good lives.'

Equally softly he said, 'Yes, that's true, and my family were on medication. It's okay as long as you take it, but sometimes, if you have a … a … relapse I think you say, the medication needs to be changed but sometimes the person doesn't realise it and … well, things … well, things happen. My brother maybe needed increased medication – or a different kind. He shook his head, 'But he was always troublesome, sometimes refusing

to take it, saying it made him feel different. He didn't like it and preferred to drink beer and whiskey instead. My mother was always watching him, making sure it took his medication.'

'Yes, I can understand that, but normally, as long as you take it, it's okay?'

He nodded. 'Yes, usually.'

'People can live normal lives … can't they?'

He stroked my hair, 'I think it's time to tell you from the beginning.'

# CHAPTER TWENTY SEVEN

## KENJI

Bebe and I sat on our knees either side of the small table. I needed a distance between us but also to see her eyes: her reactions. I could trust the look in her eyes. It's hard to disguise that. It was vital to me to know her true feelings.

I'd put a bottle of cold tea and two small cups on the table and sipped my tea until I was sure I had my thoughts in order and I could say them in English. Looking back, it was easier to say them in English as if it put a barrier between me and my feelings.

I took a deep breath and cursed when it shuddered, 'I started to think my family were different when I was about five. We were not treated like other families, people avoided us and as time went by I realised none of us had any friends. I was taught to rely only on my family.'

'That was hard.'

I nodded, 'Well … my older brother … when he was fourteen,' I stopped, trying to keep my emotions in check as I was about to tell her something I'd never told anyone else before and that I have not really recovered from.

She waited patiently.

'When he was fourteen,' I said quickly, 'he threw himself in front of a train and was killed.'

She gasped and took hold of my hand across the table and squeezed it gently, 'I'm so very sorry.'

I looked into her eyes, 'He was mad. He could not take it anymore. The way he was bullied at school, the voices in his

head, his delusions, he thought everyone was trying to kill him. It was a way out for him, a relief from his fear, but after that, things got worse for us and people were even more nasty.'

'That must have been terrible for you,' she said, and I saw only compassion in her eyes.

I nodded. 'I suffered of course, so did my mother, but the rest of my family didn't care because they were ill. They didn't know how to make friends – didn't want friends – or a social life. People with this disease live within themselves, but for my mother and me, we suffered. I know how cruel people can be.' I cursed the catch in my voice, I didn't want sympathy, I wanted understanding.

Bebe wiped away tears as I took refuge behind the pretence of drinking more tea, thinking how to tell her the next part. She waited silently and for that I was grateful.

I forced myself to look into her eyes again, 'My father was diagnosed with the disease when we children were young, and he was given medication. I don't remember much about it. When my older brother started to behave badly and withdraw into himself it was not recognised as schizophrenia, as doctors at that time didn't think that children could develop it. It was not until he killed himself, and later my younger brother started to show the same symptoms, that my mother told us that she had begun to fear the worse. We knew about my father of course, but the thought that I – or my sisters – could develop it was the biggest shock of my life. The "family curse" my mother started to call it.

Again, there was nothing but compassion in Bebe's eyes. 'That must have been terrible for you – for all of you – how did you cope?'

I thought for a moment, 'Well, my sisters didn't seem too bothered, they had always been a little withdrawn, living in their own world – and being happy in it I think – but for me, well, as I said, it was such a shock: the realisation that I could become like my father and brothers.'

'Oh, Kenji,' she put her hand on my arm and squeezed it gently. 'I understand so much more now. It must have been

terrible. But what about your family, your father and mother's families, did they help? Were they affected by the illness?'

I shook my head. 'No ... maybe you haven't quite understood. People here are *afraid* of mental illness, especially one as awful as this. Her family suspected something was wrong years ago and forced my mother to tell them. We never saw or heard from them again. And my father was an only child of elderly parents. They had died years before and we don't know of any other family members.

'It must have been so hard for all of you, but especially for her.'

'Yes. I think she tried to block things out, not think about it too much. She loved my father and us, she wanted to support us. As you know, we Japanese have to endure, we do not try to change things, we just endure it. Suffer in silence. It is our way.'

'But anything can be changed if you want it to. It all seems so ... so pointless.'

Her voice was gentle, caring, but I had to put her right. 'But not here. Not in Japan. It is how we are taught from childhood. My mother was just an ordinary woman – a good woman – but ordinary. She knew no other way.'

She nodded, sighed, then looked at me with such love, it gave me hope. That hope was like a heavy pain inside me for I couldn't allow myself to dream the impossible. Could I?

I had to finish my story, 'Then my younger brother was expelled from school. He had not been diagnosed as schizophrenic, but neither had my older brother. As I said, people did not know then that children could be schizophrenic too. It is rare, but it does happen. My parents didn't understand. My younger brother refused to co-operate at school, he had no friends – and he caused trouble because you think people are persecuting you, following you, determined to kill you, but it's all in the mind. Schizophrenics cannot reason, cannot see things as they are. They live life in a different place – not in reality, and that causes many, many problems.' I paused, but forced myself to hurry on, to get this over with. I had to know my fate.

'My sisters became ill after they'd grown up. I could see it happening bit by bit, first the younger one, and then my elder sister showed symptoms. My mother could see it too and we were both terrified; for it became clear that I could become ill as well and neither of us was willing to say that.'

I paused, remembering. 'So you see, our family could never work outside the farm, we would not be accepted anywhere, people avoided us, no one spoke to us in our village. My parents used to drive to different towns, where no one knew them, to do any shopping and sell their produce.'

Bebe caressed the back of my hand with her thumb, looking thoughtful. I had seen no repugnance in her eyes, only compassion and that hope of acceptance surged again and I had to squash it down in case I was disappointed, I couldn't bear that.

'So that's why you supported your family?'

I nodded.

'It must have been very difficult for you and your mother.'

'Yes, my mother kept her views to herself. She loved my father very much. When they married, he was normal.'

'How does the disease develop?'

I shrugged, 'No one really knows all the causes. It is complicated and there are different types. But it can be genetic and because so many of us had it, they think that's the cause for my family. It comes from my father's side and maybe that is why he had no relatives.'

Bebe took both my hands in hers and leaned over and kissed me on the mouth, so, so gently. A kiss of comfort and support and it had never been so welcome.

She pulled back a little and looked into my eyes and I saw love and something more, something ... was it admiration? Could it possibly be?

'Tell me,' she said softly, 'How did you cope with all this when you were a child?'

Tears came to my eyes and I pushed them away annoyed with myself. I gathered my thoughts wondering how I could tell her so she could understand the isolation and hopelessness

I felt. With a heavy heart I said, 'When I was at school I learned from the things that happened to my younger brother. When he became ill, he was withdrawn and thought everyone was against him – that's part of the illness. He was badly bullied by the teachers as well as the other kids - but he always fought back – and got the blame.

'I got a lot of hostility from the teachers and the other kids because of my brothers and I knew the school was looking for an excuse to expel me too, so I learned not to fight back. The only way out of this – and the gods forgive me – to escape my family, was through education. I desperately wanted to move to a city where I could be ... normal ... anonymous ... have a good job and live the kind of life I saw on TV. So I avoided trouble and never fought back which gave me lots of black eyes and bruises but I didn't care as long as they didn't destroy my mind. I had a talent for rugby and made myself their best player. They needed me to keep winning matches. Eventually, I gained respect by being a fearless player, even from my teammates – the ones that had bullied me for years. But I was never friends with them. Their families wouldn't allow it. I kept myself to myself.'

'You must have been very lonely.'

'I was strong then Bebe. Farm work and rugby training had hardened my body and I was fit and very strong – not like now ... but yes ... very lonely.'

'I like you as you are now,' she said.

I smiled, grateful for her support. 'But you have to understand – I have to make you understand – I could develop it at any time. Anything could start it: a virus, extreme stress or upset. It is in my genes. I cannot inflict this on you ... or on any children I could father. It's just not fair.'

She squeezed my hand hard, 'But Kenji, don't you see?'

'See what?'

'Nothing could be more stressful than what has happened with Kai and Nobu, but it hasn't made you ill – you're still okay - still Kenji. You've not changed. You've become stronger in fact. Surely you would have been showing some symptoms

now if you were going to?'

I was amazed. My heart beat so fast I had difficulty breathing; could that be true?

'Think about it Kenji, I think this shows *you will not get it.'*

My hope soared, 'If only I could believe that … but no one knows how long symptoms take to appear. We cannot be sure. I'm sorry, I'm no doctor, but I think you are being too – how do you say – optimistic?'

Disappointed she said, 'Well, we'll just have to read up on it.'

'It's a good thought. I like it. But don't be too sure my love, you can never be sure. That's the problem.'

'Yes … yes, I see.'

'Let me finish my story, I want … need … to tell you all.'

'Yes, of course, I'm sorry.'

Again, I looked into her eyes, sensitive to any change in them, 'When I left school, I took my courage in both hands, for it did need a lot of courage, and I went to see our doctor and demanded that he told me the truth. He was a good man and did his best to explain, but even medical staff shied away from mental illness, especially this one. It's different in Japan Bebe; we don't have a good attitude to mental illness. I looked it up on the Internet. In other countries there is more understanding but we Japanese think it must be your own fault. You should pull yourself together, cope with it, get on with life, do not be soft. It's changing a bit now, people are more educated about it but even so, people who have a mental illness are still to be avoided in the eyes of most Japanese. They do not understand it and therefore are scared of it and of the people who have it. We Japanese all have to be the same, you know this.'

She nodded.

'So, now you know and I don't blame you if you never wanted to see me again.'

She laughed and I was confused. Why was she laughing?

'Oh, Kenji. Kenji, Kenji. You have made me so happy. I thought your secret was much worse than this: But you are telling me that you may have an illness because of your genes. It's nothing to do with you. You are not at fault. It's just nature

gone the wrong way.'

I must have looked shocked and she smiled as she took my hand.

'This is not so bad you know. I'm not Japanese: I have a different attitude to mental illness. It can be treated, and you haven't even got it. What could be better than that?'

'But I could develop it, and if people knew they would not want to be friends with me and I would lose my job and not be able to get a reference. What would I do then?'

'But why would they know? I wouldn't tell them. No one would know except us. And do you know what?'

I shook my head, afraid of that hope which was now surging so high within me.

'*I don't care,*' she said loudly. 'I – do – not – care.'

She took both my hands in hers and leaned closer, 'This secret of yours is not so bad. If you got ill then medication and love and support can make life good for you. And I will be there for you. But it hasn't even happened. It's only a maybe. I'm so happy.'

'But what about children? I could never risk it Bebe. Can you understand?'

'Yes, of course, but who cares about children. As long as I have you, that's all I need.'

'But you may feel different later. You may want a child.'

'Then we can adopt.'

'But no one will give us a child when they find out about my background.'

She looked deep into my eyes as she said, so softly and lovingly, 'Then I will have you all to myself forever. What could be better than that?'

The hope within me burst into an explosion of such exquisite pleasure, like nothing I'd ever felt before, that I didn't know what to do. I was grinning from ear to ear.

I had to be sure. 'Do you really mean it Bebe? *Really, really, really* mean it?'

The look she gave me was one I will treasure for the rest of my life. It was so full of love, sweet, pure love. The kind I

could only have dreamed of and here it was, being offered to me by the most wonderful woman in the world.

'*Really, really, really,*' she said as she looked deep into my eyes and I knew it was true. I stood and held my hands out to her and she rose and moved into my arms. We stayed like that for a long time, holding each other tight, letting our deepest feelings intermingle. I'd never felt such emotional power before, it overwhelmed me and I knew then, for absolute certainty, that Bebe loved me without reservation. That she would be mine forever and I made sure that she felt my feelings, my emotions flow into her, that she understood I loved her completely and would never leave her or do anything to harm her. She was mine. I was hers. We were one.

# CHAPTER TWENTY EIGHT

## YOSHI

Kai looked as if he was asleep. His body was relaxed and his breathing normal. He'd been gone for only as long as it took to eat a leisurely breakfast but I was desperate to have him return to me. I couldn't stop thinking – what if he didn't?

What was happening to Kai may be a great adventure, but it was hard on the people left behind. I was afraid of being without him and fearful he may come back differently, not my Kai anymore. As these negative thoughts burrowed deeper, I started to think this may not be such a great adventure after all. Then, Kai's body jumped violently and he slowly opened his eyes.

'Kai … are you back?' He looked vacantly at me. 'Oh, Kai, please come back. Don't leave me, I need you. Come back.' I was shaking him, getting his attention as his eyes kept rolling up into his head. I slapped him hard across the face.

'What … what's happening,' he shouted as he rubbed his face and shook his head, dazed.

'Kai, are you back with me?'

'Yoshi,' he eyes focused on me, 'Yoshi, oh, thank the gods, I'm back.' He took several deep, shuddering breaths, 'Oh, Yoshi, I'm so very, very happy to be back with you, in my own life,' he looked at Lucky, 'and back with Lucky,' he added with a smile.

'How do you feel, are you hurt?'

He thought for a moment, 'No … I'm not hurt, I think I'm okay, but … 'his voice trailed away.

'But what?' I asked, shaking his arm, frightened he was drifting back into that other life.

'I'm not sure … there's something … it's like a finality has occurred. A cutting of something … as if the magic has been broken.'

'What do you mean?'

He stared into space, lost in his thoughts, 'I don't know exactly, but this feels different to the other times I've returned. I feel more myself, more belonging to this world and Bebe is fading.'

'You think the magic has been broken somehow?'

'I'm not sure.'

I tried to keep the frustration from my voice, this was so disappointing to have just discovered this incredible thing and now it was fading. I had to find out as much as I could. Keeping my voice calm, I asked softly, 'If it's fading, can you tell me quickly what you remember?'

'Yes … I think so … Bebe and I were looking at our teapot … the one we have here.'

'*Our teapot?* You were looking at *our* teapot*? In the future* !' I tried to calm myself. 'Tell me quickly, before you forget.'

'Yes, all right, give me a moment to collect my thoughts.'

I sighed, realising he was right. I was rushing things. He rubbed his face again, hard this time, as if waking up from a deep sleep, 'We were at her home and we were looking at the teapot and there was an earthquake.'

'*An earthquake?* My voice had risen to feminine levels and I hoped he was too confused to notice. I pulled myself together. 'Sorry, I'll stay calm and wait for you to tell me in your own time.' I was desperate to know but this was something that couldn't be rushed.

He told me about the earthquake and how frightened he was, "Up in the sky in a building that reached for the stars," and I couldn't understand until he drew it in the earth and explained that people lived in places called apartments, little houses one on top of the other. I couldn't believe it. What an extraordinary way to live.

'Are they all prisoners living on top of one another like fish boxes?' I asked.

He smiled and I was pleased to see my old Kai was still there. 'No, they are free to come and go as they please but the odd thing is, they seem to like living like that.'

'*Really !* Yes that is odd.'

'And the future scared me. It's worse than facing the fiercest warrior without a sword to defend yourself. You know what's going to happen to you then, but in Bebe's time, everything was unknown terror. Oh, Yoshi, I'm so happy to be back – and even happier I'm back with you. I hope I never go there again. The way they live, the noise, the speed at which things happen, the repulsive smells. Everyone had an unpleasant sweet smell about them which Bebe said was either perfume or soap or something called shampoo.'

'Strange names they have.'

He nodded. 'But it's the smell in the streets … it's sour and catches in your throat and smoke comes out of the backs of those things they call cars and that smells the worst. Oh, Yoshi, I hate the future. I'm scared when I'm there, I don't understand anything that goes on. It's all so different. I never want to go back.'

'What about Bebe? You'd miss her.'

'Yes, I know. She's been so important to me – to us – and I don't want to lose her, but if it means I have to go back to that noisy, smelly, unfriendly, overcrowded place I think I'd rather die. I'm sorry Yoshi, I feel I'm letting you down, but it's how I feel.'

My heart went out to him – and to me – for I would have loved being in Bebe's mind, in her life, in the future. There was no use agonising over it, but I did wonder whether things would have been different had I kept the little teapot.

My self-indulgent thoughts were interrupted when Kai began to laugh. 'This is all so ridiculous,' he said. 'Here we are talking about living in the future, magic teapots, changing our country … and, oh, I don't know, maybe flying to the moon next.'

'Now that is ridiculous Kai,' I laughed, and then we couldn't stop and Lucky got so excited he jumped onto my lap and started to bark furiously, wagging his tail, bouncing up and down.

When we recovered ourselves, I moved Lucky off my lap and took the teapot out of my sleeve. 'Let's have a look and check it's the same one you saw in Bebe's time – this is so exciting.'

'It had two chips in Bebe's time.'

'*Two chips !*' But ours only has one … oh Kai, then it can't be the same one.'

I fought my disappointment as I unwrapped it and laid it on the towel. When I examined it, an undignified screech came from somewhere deep inside me. 'The Goddess help us Kai, there is another chip – on the lid !'

'*What,*' he shouted as I handed it to him. His eyes widened in disbelief. 'It's the same one … it's the same chip I saw in Bebe's time …' He fell silent just sitting there looking at the chip. 'I can't believe it. The Goddess tell me Yoshi, how could that have happened?'

'I'm no Goddess. I don't know … the lid was undamaged when I put it in my sleeve and it was wrapped in the towel.'

'I wonder if it happened when Lucky jumped on your lap.'

'Lucky !'

Could it have been Lucky?

I pulled my thoughts together, 'We'll probably never know how it happened … but you said you felt differently this time – after you'd come back – that something had altered … well … maybe the magic *has* gone.'

'But how?'

'Let's look at this logically, we don't know how the magic works, but maybe it's best that this has happened. You couldn't go on the way you were, you and Bebe going in and out of each other's minds, it would destroy you both in the end. Maybe the teapot's magic has a life-span – and Lucky broke it – if it hadn't been him it may have been someone, or something, else. And, thinking it through, why should his exuberance have damaged

it? The teapot has taken more of a battering than that and not been damaged. I don't know, but I wonder … maybe the time has come for the magic to stop … or it didn't like you seeing it in the future and then seeing it in your own time?' I screwed up my eyes in deep thought, 'Maybe the magic has only a certain time – and then it reverts back to being a normal teapot – and gets damaged in the natural way.'

'Oh, it's all so complicated, and I think we'll never know, but I follow your thinking and hope you're right – I want the magic broken. I've had enough Yoshi.'

'Poor Kai: I can see you're exhausted by it all … but we shouldn't take any chances. We don't know for sure what changes will come from this chip. I think it's best not to use it again. You don't want to go back to the future and maybe Bebe doesn't want to come back to us either.'

He shook his head in wonder. 'You're amazing – how do you know these things?'

'What do you mean?'

'Bebe told me she didn't want to be trapped in my time – said she couldn't bear living like a Japanese woman.'

My heart thumped with excitement, 'Why not?'

'Oh, something about freedom and domestic slavery and no opportunity … ' he stopped abruptly, 'she sounds a bit like you Yoshi,' he added, giving me a strange look.

'She sounds wonderful …'

'Don't mumble, I can't hear you if you mumble.'

'Oh, it was nothing. Let's wrap the teapot up carefully and buy a box for it so it won't get damaged, for only the spirits know what else might be lurking inside it.'

He gasped. 'You think there may be more spirits in there?'

'Who knows, but never underestimate the spirits. Look what happened to you,'

'The Goddess help us. You're right. Let's not take any chances and put it away. I never want to go back to the future again.'

He was feeling weak after his return and I wondered if this was another pointer to the teapot losing its magic but I didn't say anything. We decided to rest for the day so we moved

further from the road into a little clearing and sat on our knees opposite each other on the hard earth and Lucky lay with his head on my lap again and I stroked his ears absentmindedly. He loved that.

I was as excited as a new puppy discovering the world. I wanted to know everything at once and had to be patient and sat in silence until he was ready.

'Can you remember any more this time Kai?'

'I think so, my mind is quite clear at the moment.'

I hid my excitement again, 'Good, let's go through it bit by bit.' I couldn't resist asking the question that was burning on my lips, 'Tell me about the women. From what you've told me about Bebe I get the impression their lives are very different to women here.' When he hesitated I added, 'Do women have more power? Can they live their own lives?'

He nodded again. 'They do Yoshi. Shame on them, they do.'

He infuriated me by not enlarging on this and I had to tell myself to keep it casual, I didn't want him to think I was too interested.

I feigned a disinterested air, 'Well, tell me about the people then, the men and the women. How they differ in status? Is it the same as here?'

He rubbed his hands over his face as if he wanted to block out the memory. 'I don't know in great detail, but I discussed this with Bebe as I was so shocked at what I was seeing around me. She explained many things until she finally said that my disbelief and distress had given her a headache.'

Oh, Bebe, I thought, I would not have given you a headache, there was so much we could have shared together … but Kai interrupted as he said, too fast and too hard, 'I'll tell you Yoshi, but be prepared for some horrible things.'

'I'm prepared Kai, please continue,' I said trying to contain my excitement.

Again, he spoke too fast and I had to concentrate to follow everything. 'As far as I can see there is no difference in status between the men and the women. Women are everywhere and Bebe told me many do not even get married! They don't need

a husband; they can support themselves with jobs. So if they don't want to get married they don't have to.' His face had gone an angry red.

My breath caught in my throat and my heart beat wildly – don't have to get married – can support themselves with jobs.

I gained control, 'Are they educated ... like men?'

He started his diatribe again, 'Yes, they are. It's a scandal. I saw girls going to school on those abominable trains. Boys and girls together – can you imagine that? *Unbelievable*! Bebe told me they are educated together in the same schools studying the same subjects. You can't have women going around as if they were men ... it's not natural.'

My whole body had started to shake I was so excited. I had to try hard to keep my  tone casual, 'Do women do the same jobs as men?'

He snorted. 'Yes, as far as I can understand it. I've seen men and women working together.'

My mind shouted hurray, as I asked quietly, 'What sort of jobs?'

'Well, shops and restaurants ... that's not too bad, women have always played a part in those things ... but honestly Yoshi, they were so brazen.'

'Brazen?'

'Like men. They acted like men – confident, talking loudly, laughing, not showing the great respect we men deserve. Women should remain silent in the background. It was *scandalous*. And then there are things called banks – which are shops that only deal in money – how *undignified*. That's a good place for women to work – no self-respecting man would work handling money like a common merchant – no samurai would lower himself like that. But men work there - lots of them – and I saw them *deferring* to women ! Asking them how to do something and ... and  ... letting the *women show them in front of other men ! Disgusting* ! Where was their pride?'

My pride in women was increasing so fast it was in danger of engulfing me. I took deep breaths and hid my joy.

'And there's more,' he said with anger.

'*More?*' I asked with delight.

'Some women even live in their own homes – alone. With no husband or family to keep them under control. '

'*They can live alone?*' I was incredulous as a whole new world took shape in my head.

'Yes, I know, it's awful.'

'You mean they can work and have enough money to live alone and do what they like? Is that what you mean?' My heart was pumping so hard I could hardly breath.

'Incredible as it sounds, but yes, that's what I saw. Women travelling alone on those train things. Bebe said some were shopping, but many were going to work … to their jobs !'

'They travel to work? They have the freedom to do that?' My delight was turning to ecstasy.

'Not only that they use those strange boxes on wheels … those car things … to travel wherever they want – *on their own!*'

I kept control of myself as best I could. 'So, you are saying women have *jobs* and can *live on their own and travel and shop where they like* – and do all this *independently – without men?*'

He nodded and then looked at me and his gaze lingered and turned to puzzlement. I was letting my feelings show. I had to calm myself but it was hard. I felt as if I'd been told about paradise.

'How far can these women travel?'

He shrugged, 'I don't know.'

I had an image of women travelling everywhere, doing anything they wanted and I felt a happiness inside me that was about to explode if I wasn't careful. I wanted to jump for joy, shout and sing. But I stayed motionless and tickled Lucky's ear although he squeaked a few times when I got too enthusiastic.

'Do you mean ordinary women travel to work, or rich women?'

'They all look rich to me. They are well fed and clean and although their clothes are strange, they are of good quality.'

'Tell me about their clothes Kai. What do they look like?'

It was difficult to explain, so he drew me pictures in the earth again and I was stunned. No kimono ! Showing their arms and

legs for anyone to see ! Light, loose clothing – extraordinary things called trousers – clothes for freedom and comfort. I felt I was floating on a cloud. I could live in that world. The sheer joy of it: I envied those women. They lived like men and they didn't have to dress up and pretend to be one. They could do as they pleased … and presumably, love who they pleased.

And then melancholia took over. I felt cheated, born too soon as my mind raced around thinking of what I would do if I could have that freedom.

'Yoshi, what's wrong?' Kai asked with great concern. 'You've gone pale and quiet. Did I say something to upset you? Was it those shameless women? It was wasn't it? You want women to have more power in our time, but you had no idea it would lead to such debauchery. Women here know their place and wouldn't dare to act like a man.'

Poor sweet Kai, what a shock he was going to get one day. He ranted on about the women as if they alone had upset him, but I knew that wasn't so. It was because he could understand about them whereas he couldn't comprehend most of the other things he saw. He was on firm ground with the women and was desperate to save face with me so he concentrated on them. He didn't have enough confidence; that was always his problem.

But I'd heard enough to get a picture in my mind of the possibilities of life, how it doesn't need to stay the same, of how it is up to the people to change things. It settled my resolve to do as much as I could to guide my country into the right future and I knew that future had to throw off the past.

I shivered and felt a depression wash over me as I tried to think this through.

Kai interrupted. 'You are deep in thought. Something troubles you I can see?'

I closed my eyes as if that could shut out what I was about to say – had Kai realised this too? We had to discuss it. 'You're right. Something is troubling me deeply.' I looked up to the sky, gathering my thoughts, 'You told your father, I remember, that you thought the samurai way of life wouldn't survive, that

our culture has to change – and you were right – you have confirmed there are no samurai in the future.'

'Yes, that's true.'

'So, don't you see Kai, it means the shōgun doesn't win because you cannot have a leader of samurai when there are no samurai.' We looked at each other in panic, 'We're fighting on the wrong side !'

He looked stunned, 'By the Gods Yoshi, you are right.' He shook his head as if to clear it. 'If there are no samurai then there can be no leader of samu … ' and then I saw a flicker of memory flash through his eyes.

'Did you discover this history Kai? Tell me quickly, what can you remember?'

His breath came in shallow bursts and his face creased up with effort. 'There's something Yoshi, I know I learned something … '

'Take your time, relax and let the memory surface.' I spoke softly but my insides were jumping around – he had to remember – he just had to.

His face puckered with the effort, 'Relax,' I said, 'you can do it. Just close your eyes and relax. It might come to you then. It often does.'

He nodded and closed his eyes, adopting a meditative stance. If only he could remember … if only. My thoughts were tumbling and crashing into each other until, some good while later, he said, his voice so low I hardly heard him, 'It's no use, I can't remember anything. I'm so sorry. I'm useless at this. I wish it had been you who went back and not me. You would have remembered I'm sure.'

He looked so dejected my heart went out to him. 'I think you give me too much credit,' I answered gently, 'I've been remembering you saying that the history of our country doesn't transfer between the times, that Bebe couldn't remember either, so it's not your fault Kai, it's just the way it works … it was worth trying though.'

I hid my disappointment under the platitudes, 'Don't feel bad,' I added, 'I could not have done better. You must be

kinder to yourself.'

We sat together deep in thought and Lucky came back and laid his head on my lap again.

Kai broke the silence, 'There's nothing we can do except carry on as best we can and keep ourselves alert. We cannot know how things change and it may take many years yet so I think the best thing we can do is to get to Edo as fast as possible and find Nakamura san. You must take up his offer of a job in government. That's the way forward. You can tell him what you know about the future.'

I bristled. 'I've told you before. No.'

'But you have seen some of the future through me, you know the samurai disappear,' he argued.

'And how do I persuade him what I say is true? Tell him my friend, lowly samurai, Matsuda Kai, has been in the mind of a woman from the future – via the magic of a teapot – and seen for himself? No Kai, my position is the same as it was before.'

He swore – good samurai swearing that helped him clear his frustration.

'Let's just go to Edo and see how things are there,' I said. 'We can get the latest news and then maybe think again.' I had no intention of thinking again but he didn't need to know that. Maybe something would turn up and quite frankly, I didn't know what else to do.

Over the past couple of years our country had changed and our people were confused. The poor didn't treat us as well as they had when we started preaching to them. We frightened them now with our progressive talk.

It was different when we started out – people didn't know what was happening or how it could affect them – they were not antagonistic. But now, if we tried to talk of the future they got nervous and shouted and told us they didn't want their world to change. It was too frightening. The civil war had touched them and they had heard of, or seen, foreigners and were terrified. They didn't want a land full of foreigners they couldn't understand: who were bossy, rude and bigger, with

vile body odour and strange clothes.

Edo was even busier, as many more people had arrived since I was last there, and it was chaotic. There were also more foreigners than I remembered and I could see why people were afraid of them. They strutted around as if they were in charge. They were unpleasant, impolite – everything had to be done now, no time taken for the niceties of life. I found them frightening too, but also fascinating. They were certainly different and I wondered if their way – their brash, pushy, get things done right now, no time to waste attitude – was how they had become so powerful and prosperous. Did we have to become like them to succeed in this modern world? I shuddered.

We found a small inn and took separate rooms. I needed time alone to think. I told Kai I would see him for breakfast and not before.

But the night was not restful. My mind was still trying to puzzle out the things I had learned about the future. Kai and I had talked all around the subject and I think I had all his knowledge as best he could tell me, but it didn't help much for, like Kai, I was confused about what it all meant.

I kept going over all the things I'd learned – of how there were no more samurai so the shōgun must fail. But conversely, surely the emperor would also have kept the samurai. He wanted to close the country against outside interference, throw the foreigners out and rule as his ancestors had. If he had won he would surely have kept the samurai loyal to him to ensure his law was followed.

The Goddess help us. What do we do?

The answer always came back as nothing. Nothing. Nothing. Nothing.

And who do you think you are? I chastised myself. You're only a woman, what can you do?

Then that familiar fury took hold of me and I rebuked myself. 'I am not *only* a woman. I am a woman and *proud* of it. Deep down, all women know they are as good, and often,

much better than many men. Women think things through instead of reacting with swords: women see the options of persuasion, bringing others to their viewpoint.

I calmed myself as I realised these were not rational thoughts: men have good points too. Look at Nakamura san. He's thoughtful and doesn't use violence to get his own way. He uses his intelligence and good sense. Life is so unfair. I admire him so much and am desperate to work with him. Life could take on a whole different meaning with him as my mentor. Oh, the Goddess help me, what can I do? How can I avoid discovery?

The next morning, I met Kai for breakfast. He looked rested and handsome while I felt defeated.

As we ate our food, I asked him how the cuts Masako had inflicted upon him were healing? He waved his hand in dismissal, 'They are healing well, thank you.'

'They must be sore?' I persisted.

'Yes, I cannot deny that, but I took a long, hot bath last night and the cuts are not deep. As long as they don't go bad, I can cope. It was the dehydration that was killing me.'

He gave me a look that said, leave this subject alone. It's not your problem; I don't want to talk about it. His silly pride was still asserting itself from time to time, so I let it be.

'I have more important matters,' he said as he leaned towards me in a state of excitement. 'I asked the owner of this inn if he knew of Nakamura san and he told me he was an important man in the shōgun's government. A man of reason and goodwill with a good reputation – and I know where he lives.'

'You know where he lives?'

He nodded. 'Let's go there after breakfast.'

'No ... no, I don't think so.' My heart was beating fast as I remembered Nakamura san giving me his address and asking me to contact him: but I didn't dare. I wanted to see him so much, but knew it would all end in failure. I couldn't keep my secret from him while working together in such close proximity. It was hopeless.

But after breakfast, things were taken out of my hands as a palanquin arrived for me with an invitation for Kai and I to visit Nakamura san at his home. He was indeed a powerful man to know so quickly that we had arrived in Edo. He must have spies everywhere – and that was why I knew I would be exposed if I worked for him.

Kai was overjoyed and as excited as a child and I had no choice but to go.

Nakamura san lived in the grounds of the shōgun's palace. I was used to opulence but the size of the place overawed me. As far as the eye could see, miles and miles of palaces, buildings, walls, moats, guards, people – people and yet more people: yet more buildings, yet more palaces and gardens. It was like a fantasy land that was no fantasy. Real life was here and I had no doubt it was cruel.

I imagined the countless intrigues and internal battles for power and influence with the ultimate ambition to get close to the shōgun himself – and Nakamura san was as close as they come. I felt overawed by the possibilities that could open up for me, and the impossibilities of it happening and my resentment rose up again like an angry snake with poisonous fangs. I had to keep cool and in control of my thoughts. I was trapped in my own deceit.

Nakamura san's palanquin stopped outside the main gate to the *Honmaru*, the compound of the shōgun, and on giving our name to the guards, we passed through without trouble. They were expecting us and a severe, well dressed servant with an aloof attitude was waiting for us and led us through various compounds. He explained, in his snooty and disapproving voice, that Nakamura san lived close to the shōgun's residence, confirming his importance. 'You must be respectful' he said, 'and our guards will be watching you at all times. Do not, I repeat, do not attempt to go – or even look – at the shōgun's residence. It is forbidden,' he barked, which annoyed me but Kai and I remained silent and merely bowed our heads in acknowledgement as we walked along.

The supreme elegance of the buildings and gardens were otherworldly. I felt rough and out of place and I glanced at Kai whose mouth was hanging open. We caught each other's eye and quickly looked away again, embarrassed by our reactions to such magnificence.

'This is Nakamura san's garden,' the servant said after a long walk, and lowering his voice, showing affection for his master, added, 'it is his joy.'

I felt someone needed to say something so I answered, 'I can see why. It is perfect ... like a painting.' As I expected, everything was in proportion and cut and shaped to perfection, but this was more than that. Thought, precision, and a mind that was at one with nature, had created a magnificent spectacle of continuing undulations, miniature woodlands of crafted trees, bushes harmonising in glorious autumn colours; open spaces gave way to curving ponds with lazy turtles relaxing on their edges as golden carp swam languidly in the sedate water. A peaceful haven in frantic Edo.

And then, Nakamura san was there: standing on the veranda which surrounded his house.

'You like my garden I see Young Yoshi,' he said smiling broadly.

I looked up, 'Indeed I do sir, but I like seeing you much more.' Kai and I got down on our knees and bowed our heads until they touched the delicate softness of the moss growing across the ground.

'My dear Yoshi,' he said, 'and your esteemed colleague Matsuda Kai san I believe I am addressing. Please rise and come in.'

His sensitive politeness moved me as we stepped up into his house. It was as exquisite as his gardens. His large reception room was built of finest quality cedar wood and the light golden colour of the tatami mats glowed. As with all rooms of rich people, it was perfected by its emptiness. Apart from the golden glow of the cedar wood and the tatami mats the only colour in the room was provided by a long, narrow, sparse painting in an alcove depicting the autumn reds, yellows

and russets of the momiji leaves before their death falls. I'd grown used to the cluttered huts and houses of poorer people, who could not afford the space of an empty room, and this opulence took me back to my youth at the emperor's palace.

The paper shoji doors in the middle of the room stood open giving a vista of the magnificent garden. The simplicity was absolute and glorious; restful and soul restoring.

'Please sit young sirs,' Nakamura san said, indicating we should sit on our knees in the place of honour behind the low, highly polished cedar wood table facing the garden. The tatami mats were as soft as silk under my knees and I caressed them with my hand when Nakamura san was not looking. He sat at the head of the table and said, 'I'm delighted to see you young Yoshi,' his smile confirmed his words, 'and you too young sir.'

Kai said, 'I am surprised you know of me sir, for I am nobody.'

'On the contrary, I know you well as Yoshi told me all about you. You forget that we spent several days together.'

I laughed at Kai's astonished face and said to him, 'What else would we talk about but you Kai?' And I recalled my eagerness to talk about him.

He looked embarrassed, 'You're teasing me,' he whispered, but the look he gave me told me that he was pleased.

Tea was brought in on a black lacquered tray with tiny, delicate gold cups which matched the porcelain teapot. The servant, dressed in a pure silk kimono, depicting the same scene as the painting in the alcove, kneeled and with practiced elegance, placed the tray on the table.

'We will serve ourselves,' Nakamura san said to her and she bowed and rose in one graceful movement and glided from the room.

We talked of things in general for a long time, building up a rapport and relationship before the business itself.

Nakamura san asked me again about my views and I was careful to point out that Kai also held them. I told him again how I wanted education for all people, the women too. 'We are a great nation and we can become even greater if everyone

is educated and is able to contribute their thoughts and ideas. Just think how many good minds stagnate in the rice paddies and inside the home. Free them and give them choices in life. Don't force them to follow their ancestors' profession: let them free. Give women the same rights as men and allow them to contribute to society.' I paused to give that thought emphasis. 'I know of the great technology the foreigners posses and how their life is much easier than ours. I believe we can change and I want to be a harbinger of that change.' I looked down, suddenly aware that I had become passionate and overstepped my boundaries.

'I'm sorry sir; please forgive my bluntness and presumption.'

He smiled. 'I'm getting confirmation that I was not wrong in my assessment of you. You are just the kind of young man I want to encourage, for I share those views and want to work towards them. But one step at a time, we have not got that far yet, but it is good to have dreams. Hold on to yours, one day if I can influence matters, it will come to pass.'

Then we talked of politics and the situation with the emperor in Kyōto and the Shishi who controlled him. How they wanted to close the country again, depose the shōgun and reinstate the emperor as leader.

'Although,' Nakamura san said in a low voice, 'we in Edo are not sure how much the emperor understands that his rule would be a rule of straw as the leaders of the Shishi would be the true rulers.' He sipped his tea delicately, and leaned towards us, 'But there are rumours of dissent among the Shishi and the situation is confusing ... unfortunately, what they whisper to the emperor in private is not known to us.'

'Indeed sir, I see.'

'You understand why I need someone younger, someone who can go into places a man like me could never go. My powerful position means people would not speak freely in front of me.'

'You have spies sir, can they not do that work for you?' I asked.

'I do have them of course, but they are not as politically

211

astute as you are. They miss lots of nuances and are unable to decipher the smell on the breeze from Kyōto: the unspoken. What I am telling you are not state secrets, but if you accept my offer, you will become privy to some secrets that you must guard with your life. You have to understand this.' He looked at me but not Kai. This message did not include him and that worried me.

'I need someone I can trust absolutely and can train in the politics of the past, the present and the future – for they are all different but rely on each other for progress. The past affects the future no matter how radical that future may be. It is a rare person who can do successfully what I need and I believe you are that person Yoshi. I've been looking for someone like you for a long time: someone not infected with the poisonous attitudes and jealousies and personal ambition that can affect people close to the court. I need a stranger, someone untainted by the politics of the past. I need someone with a delicate touch, whose advice and analysis of things I can trust. Someone others will like and have confidence in and will confide in. You have those qualities.'

Kai and I were speechless.

'Yoshi and Kai, young men like you are the future of our country. Things are changing fast and we need to change with them. I want to influence those changes and be a part of them. I've dedicated my life to my country and now, in these uncertain times I want to be sure that I understand what is going on around me so that I can influence events where need be to get the results I am certain my country needs. Our beliefs coincide, let us work together.'

He looked at me, then Kai, and back to me. 'Forgive my plain speaking, but it is time for it. I am old and sometimes it is difficult for me to keep abreast of the times, but you are part of this new world. You can be my eyes and ears and if you do well, as I feel sure you will, I will promote you to more important work as time goes by.'

I sneaked a look at Kai and his eyes were shining with excitement and he glanced at me and gave a tiny nod of

encouragement.

'We can do this Yoshi,' Nakamura san said, 'I firmly believe we can lift ourselves out of our feudal past and show a modern face to the world. We are a proud nation, we have to make the world respect us but they cannot do that while we are a throwback to olden times. Samurai culture has caused stagnation for centuries. Look how we had to keep our people down – by starvation rations and ignorance. We have a good country full of fit, intelligent people who can rise up and be a match for any foreigner. I know this and so do you. We just have to make the circumstances right for it to happen.'

He was silent, looking out at his garden, and neither Kai nor I dared to speak or move.

He looked at Kai. 'I have work for you. I need someone to travel around the country and send me regular reports on what you find. How the ordinary people are behaving, what they are saying. How this war is affecting them.'

He looked at me. 'Come with me Yoshi. I am not long for this world but I want to know that I leave a young man of vision and strength and knowledge in my stead. Let me be your mentor. You have strong vision and intelligence, a rare person. You remind me of myself in many ways. We are men whose foresight and intelligence puts us apart from others. My day is coming to an end, but I can still influence tomorrow. You will be part of my legacy. Join me I urge you. Do your duty.'

I had tears running down my cheeks. The unfairness of life was weighing me down like a rock. I wanted to say yes – yes, yes, yes – instead, I rose up and said, 'Forgive me sir, for I am destined to disappoint you once again for I cannot join you.'

Unable to control myself, I turned and ran from the room and that place of possibilities.

When I got to the inn I threw myself onto the tatami mats in my room and cried like I had never cried before. I heaved and sobbed and even screamed my frustration. I was beaten. I knew it then absolutely.

Later, I cannot tell how long as grief has no timescale, Kai

213

came running into my room.

'Yoshi,' he said, panting like a dog, 'what on earth is the matter with you? I can't understand you. Why have you said no yet again? And running out like that – are you mad? You have the chance of a lifetime – many lifetimes – and you turn it down.' He was shouting and striding up and down like a caged wild animal. *Yoshi, what is the matter with you? Just tell me why?'*

I jumped up and screamed at him. 'You don't understand.'

'No, I don't,' he screamed back. 'Tell me.'

I was beside myself with rage and lost my decorum totally.

'You want to know why? I'll tell you why,' I shrieked at him as I tugged at my clothes.

My obi fell to the floor and my jacket followed in quick succession. I tore at my trousers and pulled them off in a frenzy and finally, with a last frantic movement, ripped off my short kimono and the binds hiding my breasts and stood in front of him naked.

His mouth hung open in disbelief and his eyes were huge as they roamed over my body: my breasts, my waist, my lack of manly parts. He blinked many times as if he couldn't believe it. Then he looked at my face and said, very quietly, '*You are a woman.*' As if it was the most wondrous thing in the world. As if he was looking at the Goddess herself. And then he laughed. Riotous laughter that confused me and made me feel foolish.

'You are a woman, Yoshi. A woman! I can't believe it. A woman.' He couldn't stop laughing.

'Why are you laughing? It's not funny. How would you like it if you were a weak woman?'

'Oh, you are not weak – you are the strongest person I've ever met – and I am not *homosexual* – I'm in love with a *woman*. Oh, thank you Goddess. I am so happy: so very, very happy.'

He came towards me then with his arms outstretched and I had been so astonished at his reaction I realised I was still standing there naked. I pushed him away as I pulled on my clothes, not bothering to do them up, just wanting to cover my vulnerability.

He tried again. 'No, Kai,' I put my hand out to stop him

214

hugging me. I wanted to hug him so much I knew once we started we wouldn't stop. 'I might be a woman, but I am not an available woman. We must still keep our distance. This is not the right time.'

He looked at me with such an intensity of love.

'Now everything becomes clear,' he said, 'why so many things happened and why you said no to Nakamura san. Oh, why oh why didn't you tell me before. Didn't you trust me?' His eyes showed his deep hurt. He deserved the truth.

'It wasn't anything to do with trust,' I said gently, 'it was because you are such a masculine man. A man who has been brought up to think that men are infinitely superior to women and it is your job to protect them at all costs. A man of honour and decency and loyalty who would have used all those values to protect me once you knew I was a woman. You worried enough and were too protective with me being a boy; it would have meant disaster for us if you were always looking out for my safety. You can see that can't you?'

He looked down at the floor and a frown of royal proportions graced his face and my heart went out to him once more.

It took him some time of deep thought and then he said, in a resigned voice, 'You are right. As always, you are right. I would have behaved like that. I see that now. I would have made everything impossible.' He hesitated and then his eyes glowed with excitement, 'but now, anything is possible, don't you see?'

'No, why does this change anything, I am still a woman and will be discovered very soon in Nakamura san's employ. He has spies everywhere.'

'But not if I come with you.'

'But how can you come too?'

'I don't know, maybe I could be your servant? Or assistant? Or something ...'

'I still don't see how that will stop anyone discovering me.'

'Let me think a moment,' he paced up and down so vigorously I thought he'd wear a hole in the tatami. He snapped his fingers, 'I've got it. I could be your servant and do everything for you.

For example, you do not go into the baths with other men because you have a skin condition and I treat it for you. You have a health problem that saps your energy so that you do not join in with parties and, well, men's stuff.'

'But won't people think that's odd, and start to wonder and poke about just the same?'

'Possibly ... but if we also put out the rumour that I was your lover ... then people would understand and not be so curious. It would take the mystery out of your strange ways.'

I thought about it. 'It's not a bad plan. It could work.'

'We could tell Nakamura san that you said no because you didn't want to leave me, but if he will have me as well as you. If he will trust me as much as he trusts you, then you will say yes.'

I started to secure my clothing in a slow deliberate way, using the time to think it through. I looked at it from every angle and although it was daring and may not work, I realised it was a chance - my only chance. I had to take it and silently thanked Kai and his selfless love and for giving me this opportunity.

I secured my jacket with my obi as he faced me from across the room, his eyes searching mine. I said very slowly, 'I think this just might work.'

He smiled.

'Yes, it just might,' I repeated, 'with Nakamura san's support. Thank you very, very much for your selfless act.'

I walked towards him and put my hand up to his face running my fingertips over it. He shivered violently and my nerve endings were aflame.

He put his arms out to me again and gave me a beseeching look and I had to say yet again, 'No, Kai, we must do our duty to our country. Put that before our own happiness. If we're together I will not be able to devote all my time to the important work I believe is awaiting me. I love you so much I could not concentrate. I cannot know the joy of your love and your body, for it will overpower me.'

He stroked my cheek. 'And you me, my love. I will most certainly not be able to concentrate on anything once you are mine. I see that. I agree.' He looked down at the floor, 'I've

216

changed – in an instant. I see so much more now. Then he said with such honesty I admired him, 'I've been a fool: a stupid, arrogant, bumpkin who doesn't deserve your love. I see now what you have had to do to gain the power I have as my right – just for being born a man. I see now that being a woman doesn't make you inferior to me, for I know deep down in my deepest being that you are my superior. I've always known it – and now, I learn you are a woman … as Bebe is … who is also so much more than I could ever be.'

'Oh Kai,' I jumped in, 'I don't think that's true. The fact that you have not only understood this, but have admitted it, tells me that you are a man of intelligence and foresight: a man to be proud of and treasured.'

'Can you forgive me for my past ways?'

'If you can forgive me for deceiving you.'

He smiled. I smiled. Our eyes locked as a slow, gentle laughter rose up between us. It was sweet and joyous and then it overwhelmed us. We couldn't stop. Every time we tried to gain control of ourselves we looked at each other and laughed again. It was the best medicine we could have had. All the stress of the past dissolved in mirth at the things we had done, thought, agonised over, and here we were, two people who finally understood each other. We were joined together in the relief of being ourselves and accepted for what we were.

Kai was the first to gain control and he did it by going to the window and talking to the outside world with his back to me. 'And now our country is changing and I want to be part of it.' He swung around looking at me, 'Even if it is only in helping the most wonderful, intelligent, rare person, as Nakamura san called you. I agree with him. You are a rare person. Someone born for this time and even the misfortune of being born a woman has not stopped you achieving the unbelievable. I want to share this with you, help you in any way you need. And if that is platonically for now, then I agree. I guarantee I will never try to change things. You decide when the time has come for things to change – and when … and when they do … oh Yoshi … shall we be married?'

He looked so hopeful, I couldn't help teasing, 'I haven't been asked yet.'

His look turned serious as he cleared his throat, 'I always knew that if I ever took a wife I wanted her to be a challenge. Full of life and vigour: who would keep my interest ... someone unusual ... pure of heart and full of courage ... someone I could admire. I had no idea I would ever find a woman like you ... that I could ever be so lucky.'

I fell into his smile willingly. 'My wonderful, beautiful,' he took in a deep breath, '*magnificent* , Yoshi, will you honour me by becoming my wife?'

My body tingled with pleasure. I had never allowed myself to think of a life with Kai – as his wife – and I realised just how much I wanted it: desired it. I wanted it all – power and influence and a life with Kai.

'Oh, Kai, yes, yes and yes again,' I said as my joy almost overwhelmed me.

We bowed our heads to each other in formal acknowledgement.

Kai approached me and took my hands in his, 'Sit down a moment,' he said, pulling me down gently. We sat on our knees, facing each other. 'I owe you an explanation and I have a confession too.'

I raised my eyebrows, waiting.

'I want to tell you why I laughed when I found out you were a woman ... it was not because I glad I was not homosexual – I don't care about that as long as I have you – it was because ... well, I was so happy because it would mean we ... if you were agreeable of course ... we could have children ... you know ... oh this sounds so ... so ...'

'Just tell me my love; there are no secrets between us now.'

He nodded, 'No secrets. Well, I have recently had this ambition to build a ... new family dynasty ... there, I've said it. I know it sounds grand and pompous coming from a lowly samurai like me, but now, well now, I am going to marry an aristocrat, a woman from the highest echelons of society, my dream could come true.'

'*A dynasty* ! You think big – I like that.'

'And you're the mother to start it. If only our children would have just half of your talent, just think what a family we would be.'

'With half of your talent too Kai, we could conquer the world.'

I smiled at him and he squeezed my hands gently. 'Would you like that? It would be very different to the life you have now.'

'Yes, it would be, but this life cannot last forever, one day we have to stop and become normal people again, and then Kai, then, I would like that very much. When the time comes, creating a new dynasty with you would be a legacy I could boast about ... and who knows, I may even be able to tell our children and grandchildren of my life before them. I would be honoured to have your children. Nothing would give me greater pleasure.'

I reached over and picked up my long sword which lay on the tatami. 'This sword, the sword your father gave me and is your family's heirloom, will become our family's heirloom. All our future generations will know the history of it and how your grandfather became a samurai and you, his grandson, became influential in changing their country.'

'And you. How their mother proved herself the equal of the best in the land.'

I laughed, 'An exaggeration Kai, but thank for the thought ... yes, we will tell them how the sword helped to save and influence *our* lives and in turn, made it possible for them to be born and honour it in their turn. When the time comes for our marriage,' I said softly, 'we should tell your family, they will need to know.'

He stared into space for a while. 'I'm not sure; I don't think I would be welcome, certainly not by my father or brothers. They regard me as a bad son and I'm sure they would see me as being instrumental in destroying their society and leaving the country open to the "foreign devils".

'But surely, by that time they would see that there was no other way?'

'I'm not really convinced of that. You know how stubborn my father can be, but even so, I wish I could have visited them over the past couple of years. I missed them, but I didn't want to burden you with my family troubles, when you had lost all yours.'

'Thank you,' I said softly, appreciating his concern.

'And there's something else we have to think about. If we went back with you as a woman, well, they are bound to recognise you as Yoshi – my male friend. They would know your secret and that would scandalise them even more than a radical son. They could never show their faces to their neighbours.'

'They know Kai.'

'What !'

'At least your mother and sister know my true identity.'

'*What do you mean?* I can't believe what you are saying. It's not possible.'

I smiled, 'Oh Kai, it is possible and they do know.'

'But *how?*

'It's funny when I think back, but at the time it wasn't – it was the end of the world.' I rubbed my forehead with the palm of my hand and looked down, embarrassed by my stupidity at being discovered. I sighed, 'They walked into the bath house when I was getting out of the bath …'

'They what? They saw you … naked?'

I nodded, still ashamed of my folly.

'But … I don't understand. Why didn't they tell everyone?'

'I had to tell them the truth about me and my history, my real name, my family's position and why I was pretending to be a samurai. I told them how I loved the power I got from being male and the respect I received even as just a boy – much more than we women ever get – and they appreciated that. They liked it.'

'So, it was a woman's pact.'

'Yes, I suppose it was.'

'So that was why they often stopped talking when I walked near them and why my sister's animosity towards you changed.' He laughed, 'I have to hand it to you women … I'm glad you're

all on my side.'

'We are all on the same side Kai, if only we all knew it. Men and women, we're all in this together.'

He laughed again, 'You're so wise.'

'Now you're teasing me,' I laughed back. 'But I have something more to tell you Kai, and maybe this will change your mind. Your mother asked me to tell you, when the time was right, that she admires and respects you more than you will ever know.'

He stared at me with his mouth open, as if he couldn't believe what I was saying. 'Really? She said that?'

'She did, let me see if I can remember her exact words,' I closed my eyes for a moment, 'She said, "I cannot go against my husband, I have to follow his lead, but I ask you to please look after Kai as best you can and tell him how much I love, admire and respect him."'

'Oh, Yoshi, did she *really* say that?'

'She did. Those are her exact words as I remember them. She loves you a lot. She was in a difficult position.'

'Yes. I can see that: a very difficult position. My poor mother … in that case, then yes, we must go back and tell them of our marriage and tell them our story.'

I hadn't known I was going to say the next thing until I had already said it, but I realised it was what I wanted. 'Shall we go back to Takarazuka to live Kai, when we are married?'

His eyes filled with tears. 'Oh, Yoshi. Yes. Yes please, let's go back to live in Takarazuka. I can help my family with the changes that must come, win or lose, for good or bad. It's going to be hard for them. Oh, thank you … thank you.'

We held hands in a silent confirmation and sat unmoving for a long time, neither of us wanting to break our new found intimacy.

I caressed his hands before letting them go and becoming businesslike. 'The time for fighting with swords is over for us. Now our battle is with words and deeds. It is time to be practical. We must think of life as it is now, not in the future.'

'I agree: our future depends on what we do now.'

'The first thing we must do is to make sure the teapot remains in its hiding place and when this is all over, we must take it with us and hide it from our children. We do not want them to find it by mistake.'

'Indeed, we don't want to run the risk of bringing its power back to life. Don't worry, it's still securely hiding in the space under my tatami mats in my room. I check it every night before retiring. And when we are settled, we will find a secure place where no one will find it – ever !'

'Yes, that's important. We must take it with us. Be in control of it.'

'But there is one important thing we have not talked about.'

'Oh !'

'Our children will call you *okazan*, but what will *I* call you? Not Yoshi, that's for sure.'

I suppressed a smile, 'No, I don't think you should call me mother, and as much as I love the name Yoshi, because you gave it to me, that would not be appropriate either. My real name is Asako ... Asako ... ', Oh, the Goddess help me, how do I tell him I have been married before?

I closed my eyes momentarily, and then took his hands in mine, 'I will say this quickly and please don't react to it because I'd like to forget this next part of my history but you must know about it ... no secrets ...' He raised his eyebrows and nodded, 'but ... well ... I have been married before. It was an arranged marriage and my husband and I did not love each other. There were no children and I assume he is dead. I want to be known by my family's name, I'm proud of that name ... 'I bowed my head to him, 'Makino Asako at your service.'

'I acknowledge your wishes ... Makino Asako ... Asako, it's beautiful ... I shall say your name every night before I sleep and first thing when I awake.'

'You look at me with such love Kai.'

'And you me Asako.'

I rose and held out my hands to him and as we stood and looked into each others' eyes, I said softly, 'Then let us seal our pact with a kiss which will be our one and only until our

country is travelling a safe path.'

We moved together slowly like feathers caught on a tiny breeze, and as our lips neared we hovered as if afraid to touch. But slowly, so slowly, as if the breeze had died and the feather started its elegant fall to earth, our lips came together and touched. We were content with the touching at first, and then slowly our passion inflamed and our lips opened of their own accord and we were deep into a kiss that I never knew was possible. I'd kissed my husband many times, but they were hard pebbles of kisses, this was one of hearts, minds, intimacy and most of all, deep, deep love. It went on for a long time, neither of us able to pull back. Finally, I was the one to break our contact and the loss of his lips on mine was a cruel blow.

We didn't move as we stood together, but neither of us tried to repeat the kiss. We had our pact. We would both keep it. We were as one.

We spent the next few hours devising a plan of how Kai could help me and how we could present it to Nakamura san. We arranged to go back to visit him the next day.

We both went down on our knees again with our foreheads touching the tatami.

'Rise my children,' he said. 'I am intrigued as to why you have returned.'

'Nakamura san,' I said in a strong voice as I knew I had to show strength or we would be lost, 'I have a confession to make.'

He raised his eyebrows but said nothing.

I forced myself to look into his eyes; he needed to know of my sincerity. 'Firstly, I apologise profusely for my unforgivable behaviour in running away from you ... and you will want to know why I said no to your exceptional offer. Kai has persuaded me to tell you our situation and offer a possible solution.'

He looked intrigued but remained silent. 'I want to say firstly that I would, under normal circumstances, have accepted your proposal with great joy and gratitude and worked hard with

you as my guide. I have so much to learn … so much I want to learn.'

He interrupted, 'And you Yoshi, also have so much to give. Please continue, I am intrigued as to what can be so awful that you refused me even though you feel this way. Please just tell me outright. Do not dwell on decorum.'

'Yes, sir, of course sir.' I looked at Kai and he nodded and smiled, encouraging me. It was now or never.

I kept my voice strong. 'The reason I said no, is because Kai and I love each other – love each other with total commitment and loyalty – we love … we love as man and woman. We cannot live without each other. I cannot function without Kai in my life.' I took a deep breath, 'I can only do this job if he is with me and helps me. There is no alternative for me.'

'I see,' he said, looking serious. 'And if Kai is with you, do you have any suggestions how to tell others as to why he is in such a position?'

'Yes, sir. Kai has suggested that he could be my servant, or assistant, or both. And if people are suspicious, we could put the rumour around that we are lovers and Kai is possessive of me and I him. But we don't confirm the rumours, as they are always believed more when not confirmed or denied. It is up to you my lord, I will be a willing student and work for you and our country to the very best of my abilities, but I cannot do it without Kai. It is both of us or neither.'

Nakamura san looked at us both, his mind working in that quick way he has. He cleared his throat, 'I trust you Yoshi. That is why I offered you this opportunity. I have confidence in your judgement and integrity and if you say that Kai is loyal and trustworthy and will do nothing to jeopardise our work, I see no reason why he cannot be included. I care nothing for your personal arrangements Yoshi, or yours Kai,' he said addressing him. 'I too, have a private life I wish to keep private. I guarantee that no one from my household or on my staff will bother you as long as you do your job well. But I warn you, if you do not, then that is a different matter.'

'I thank you sir,' I said. 'I will not give you cause to be

dissatisfied with me. I would die first.'

'Me too,' added Kai as he bowed low with his head touching the tatami and I followed his example.

'Nakamura san smiled. 'Before we take our leave there is one thing I need to ask you before we start on this great adventure. I don't want anything unknown raising its ugly head at inopportune moments. Do you have enemies I should know of?'

Kai and I looked at each other.

'I can see by your exchange that you do. It is better you tell me about him, or them, now. Maybe something can be done.'

'Kai and I do have such an enemy I'm afraid. Her name is Sato Masako of Nagoya.'

'A woman !'

'Yes sir and a very dangerous one too.'

'Tell me.'

We told him the story of Masako and Kai and how she tried to kill me and of the things she and Sato did to Kai in Nagoya. leaving out Bebe of course. When we'd finished he looked troubled. 'I'll make some enquiries about her. We don't want her causing trouble at a delicate moment – or even worse. I'll put one of my agents onto it, send him to Nagoya to find out what has happened or whether she has left. That would be the worst scenario. But let's wait and see what he discovers.'

He rose, 'This is all young sirs? You are not hiding anything else from me?'

'No, sir,' we said in unison.

'Please be assured,' I lied, 'that is all sir. Kai and I will await the results of your enquiries with interest.'

Later that evening, as Kai and I were finalising our discussions for starting work, I couldn't resist saying, 'I'm so excited to be part of all this. My life would have been so different if we hadn't met ...I'd probably be dead !

'Me too,' he cut in. 'The ordinary samurai and the aristocratic woman: who influenced each other.'

'And Bebe, don't forget her.'

He smiled, shaking his head slowly, 'Never ! He paused, thinking, 'I'd like to say something, it's a sort of confession I suppose, but, well, you and Bebe have changed me beyond recognition. To be honest Yoshi, now I know you are a woman, I can admit to my real feelings. Before, when I thought you were a male, I pandered to the way most men think about women, but now I can safely admit my admiration for Bebe to you. How she coped with everything – including me. I have a love for her and her honesty and her ability to adapt to what was happening to her, and to be able to help me in the way she so unselfishly did. It couldn't have been easy.'

I smiled, 'No Kai, I don't think it was.'

He smiled back, 'But I think I can confirm she's gone. Gone for good I mean.'

'How do you know?'

'I feel different. My mind is clear. I'm my own man again – albeit a changed one. I can't explain it, it's just a feeling but I have a certainty inside me that this has all finished now.'

He looked into the distance. 'My life has been altered by two women. And I thank Bebe, wherever she is, for changing my way of thinking and my attitudes and making me a man someone like you could fall in love with – could respect.'

'You underestimate your intelligence Kai, and the ability to accept new ideas. Not all men could have done that – even though it took you a while to accept it. Many would have let it overwhelm them and not learned the lessons she was teaching you. You're a special man.'

'Thank you Yoshi, but all three of us, are special and I hope Bebe is somewhere good and happy for we were all ordinary people before this happened to us. The ordinary Englishwoman, the ordinary samurai and the aristocratic woman, all powerless in the great scheme of things, but our coming together put us into positions undreamed of and taken us down unprecedented paths.'

'And this is just the beginning ...'

# CHAPTER TWENTY NINE

## KENJI

I sensed there was something deep inside Bebe that she was keeping to herself. I was unsure whether to bring it up or to leave well alone so I just gave her my support as best I could.

In the end, it came about naturally when, one evening, I came back late from work.

As I walked in she looked beautiful sitting on the sofa in her blue silk pyjamas, her hair freshly washed, her skin glowing. My whole being filled with pleasure and I went over and kissed her lightly on the cheek. 'You look great,' I said, but she looked down, avoiding my eyes. I lifted her chin gently with my finger and saw something in her eyes. Sorrow? Depression?

'What's the matter?'

'Oh, nothing,' she said too brightly.

I took off my jacket and hung it on the back of a kitchen chair wondering whether to say anything.

She noticed my hesitation. 'I'm sorry, I'm feeling low. I had a letter from my mother today. She's says she and my father are planning to come to Japan to visit me for a few weeks.'

'But you should feel happy, ne? Your parents …'

'Oh, Kenji,' she said jumping up and putting her arms around me. 'I'm so very sorry. How insensitive of me. Forgive me.'

I swallowed hard, 'Nothing to forgive my love. I would love to meet your parents.'

'Would you? Really?'

'Of course … but you do not want them to come?'

'It's not that I don't want to see them, but well, you know,

227

with all the things that have happened … the Nobu thing … I'm still not over that. They'd see something was wrong and try to persuade me to go back to England with them.'

Her words pierced me and I cursed myself for not having thought of that possibility before. What would I do if she returned home?

'Too be honest Kenji, I'm not coping as well as I thought. It's much harder … *the bastard.*' She moved away from me. 'There see, my anger is still there, but it's more than that. Oh, I don't know exactly, that's just it. I … I was a victim, and the thing I've discovered it is easy to continue to play the victim. It's like something stuck in your head that goes round and round and I suppose convincing yourself you are a victim takes away the responsibility. For I can't help thinking that I was to blame in some way for Nobu's attitude to me. Something I did or said, it all goes round and round. I feel so helpless. I've never hated anyone so much and its eating me away. I need to be strong Kenji. I can't live if I'm not strong.'

She broke down then with huge sobs and I took her in my arms, 'Cry my darling. Cry as much as you like. Get it all out. You are in shock and it takes a long time to recover from … I know.' I hugged her tighter. 'And it's not your fault. It's nothing to do with you. It's that bastard's doing – only his. Never forget that. He picked on you because he could. Because you were there. He could buy your time for lessons and that was his way in to your life. He had it all planned, I'm sure of it. *It was not your fault.*'

Time ceased to exist as I stroked her hair away and wiped her tears. My heart had never been so full of love and the threat that I may lose her altogether galvanised my intention. I had to make her understand there was nothing that would stop me loving her. It was time for me to speak.

We stood holding each other and I spoke softly. 'I've been doing a lot of thinking over the past few days and I've come to a decision. First of all, we have to throw that bastard out of our lives. We cannot let him rule us – ruin what we have together.'

She pushed her head deeper into my shoulder and sniffed, 'I agree.'

I felt her tears wet my shirt, 'I will not let him. It's what he wants. He wants to ruin what we have together. He's jealous, like a child. What he cannot have he will destroy. I will not let him Bebe. *I will not.*'

I kissed her on the cheek, a long kiss full of emotion and I held her close. I had to stay strong, to tell her what I'd decided.

'All the things that have happened have been extraordinary. Unbelievable: Kai and your life with him, but more than that, the danger you have been put in – in my world – in *my* Japan. I feel ashamed that my country could not keep you safe … that *I* could not keep you safe.'

She hugged me tighter, 'Oh Kenji …'

'No, my love please let me finish,' I interrupted.

She nodded into my shoulder and I could feel more tears soaking into my shirt. 'I am angry. I am angry about how you have been treated in my country: men stalking you, that bastard trying to ruin our lives, but I have the power to change that.'

She pushed herself away from me a little so that she could look into my eyes. 'Power … I don't understand … what power?'

Now was the time, I had to keep my confidence. I pulled away from her, 'Sit down,' I said softly as I led her to the sofa. I sat in front of her on my knees and kept my voice soft and low. 'We can deal with these things in two ways.' I held up a finger, 'One, we can let it destroy us, slowly break up our relationship, sap our confidence in our abilities. Two,' I held up a second finger, 'we can refuse to let it.'

I took hold of her hands and looked deeply into her eyes. 'We must not give the power of our lives to others.'

'Kenji …'

'Please let me finish … this is so difficult for me to say … all the things that have happened … to you … to me … has rocked me but also made me realise something very important … the fact is … I've been too Japanese.'

'Too Japanese?'

'Yes, you heard right. I've been thinking about my attitude to my family's illness and what it means to me and to other people. You have opened up my eyes to new ways and I have finally realised that I have given power to others to control the way I live my life and that can never be a good thing.'

The time had come. 'I'm alone now. My family are gone and I realise now how much I loved them. Nothing is more important than family. But I have to move on with my life. I have to learn from it all. I want a new life Bebe … a life with you.'

My heart was beating so fast I had difficulty breathing, but I was determined to do this properly. I dragged up some inner strength from somewhere and went on one knee in front of her and took her hand. 'Bebe, will you marry me? Could you accept me after … after I rejected your proposal?' I fought down my emotions, 'If you could find it in your heart to forgive my stupidity, you would make me the happiest man there has ever been.'

She looked at me with such confusion my heart sank.

'Kenji … I …I …'

I jumped in before she could refuse me, feeling I had to justify myself. 'I'm sorry if this is too soon – and I don't mean we should marry immediately, we will wait until you are ready. Recovered your mental harmony and confidence and … can look at me in the old way. Time is not important, intention is. I know my countrymen; they would not do this to you if you were a married woman. You would be under your husband's protection – my protection – and unless you broke the law, the authorities could not touch you for immigration matters. *And* Japanese men do not usually abuse other men's wives.'

Her look changed to love and my heart soared with hope. She took my hands in hers and kissed me on the lips. It was a kiss of intention – gentle but passionate – long with meaning, a deep, deep kiss that was the best kiss of my life.

'Are you sure?' She whispered.

'I've never been so sure of anything. You would make me the happiest man alive.'

Her laugh was soft and full of meaning and I caught a glimpse of my old Bebe. The one I wanted to get back.

'Then in that case, Kenji Yoshida, I accept because you've made me the happiest woman in the world.'

I stood up and pulled her gently to me and hugged her close. 'Then we are a couple in eternity,' I whispered. Re-birth after re-birth, we will be together. Every new life we have I will find you and marry you.'

'Do you really believe that Kenji?'

'Of course, I'm Japanese !'

'In that case, yes please … as one for all eternity.'

About a week later, Hiro and I were eating lunch together when he took a newspaper out of his pocket and said, 'I haven't had the opportunity to talk to you this morning, but there's something in today's paper.' He looked around suspiciously, as if we were spies. 'It's about that mad bear who tried to rape Bebe and complained about you to the boss.'

The hackles on my back rose like thorns and my heart pumped so hard I hardly had the breath to say, 'Nobu?'

'Yeh, the strange bod with the big chin … well,' he looked around and bent towards me as if sharing a great secret. 'He's only been charged with ten rapes and two murders.' He looked at me with such satisfaction one would have thought that he'd caught him himself.

'Ten rapes and two murders?' I repeated stupidly.

'How do you know it's him?'

'Here, look there's a picture of him.' He turned the newspaper towards me and sure enough, there was a picture of Nobu. It was unmistakable. 'Look, it says, "Inoue Nobutomo was charged yesterday. A police spokesman told us that they have been looking for this man for a long time. Many women came forward saying they had been brutally raped but the perpetrator always wore a balaclava and we could not get a full enough description. Recently, Inoue was found in Takarazuka unconscious in a restaurant which was being refurbished. A message was written in lipstick on his shirt that said 'rapist'. We

are still looking for the victim. These two messages prompted us to take his DNA and match them to other rapes. They matched ten of them and also the two rapes that ended in the murder of the women. The man is in custody. We would urge the latest victim to come forward and identify him".'

My emotions threatened to overflow right there in the middle of the restaurant and I tried to get control of myself by eating my noodles. I put my head down to the bowl and shovelled them into my mouth, but they stuck in my throat and I couldn't swallow them and was forced to spit them all out.

'You okay?' Hiro asked.

'Please wait here,' I said as I got up and ran outside. I called Bebe and told her the news. She couldn't believe it at first either. 'How? How did they find him?'

I told her about the article and filled her in on the details and said I would pick up a copy of the paper tonight after leaving work.

'But he might tell them it was you who beat him up, and me he tried to rape.'

'Let him. We just deny it. He cannot prove it.'

'Oh, Kenji ... is it really over? Really, really over?'

'Yes my love, it's really, really over. No doubt about it. He's gone from our lives.'

'Yes. Yes. YES.'

# CHAPTER THIRTY

## KAI

Edo was cold that winter of 1867. The ice of January had built up through the month, covering the ground in frost but it couldn't dampen the fervour of excitement that was circulating through the city. People were more defiant, expressing their views more openly, rumour was rife. It was a hotchpotch of confused thinking, radical thoughts, and reactionary stand-offs.

Yoshi and I had been part of this for the past year and a half, working for Nakamura san. Officially, Yoshi worked as one of his assistants and he spent some of his time doing clerical things, but his real job was kept confidential. He was to take every opportunity to go out into the streets and find a way to infiltrate secret meetings, promote the ideas and policies that Nakamura san wanted, then look for possible leaders: encourage their radicalisation. They were the same policies that Yoshi and I had been advocating in the past, so he was well placed to do this.

Yoshi and I decided I would always continue to refer to him as a male regardless of circumstances, just in case I slipped up inadvertently.

Also, our life had been easier for us since we'd heard the news about Masako. Nakamura san's agent had discovered that after Sato's death, she had been taken in by some of his

relatives as she was pregnant with his child. She died giving birth to a daughter who was called Masako in honour of her mother. Sato Masako – we hoped and prayed to the Goddess that she had not inherited her parents' cruel characters. That was all we could do. Let the child live her life. She would know little of her parents and nothing of us.

Yoshi concentrated on citizens below the rank of samurai. The ones who needed help in deciding who to support. The people we needed for the revolution that Nakamura san, Yoshi and I wanted to happen. Without the support of the masses, it would be difficult to implement the changes and the bloodbath would continue for the Goddess knows how long.

It was vital, dangerous work and Nakamura san had made it clear that if Yoshi was discovered, he would disown him. Yoshi would be executed as a traitor to the shōgun. That execution of course, included me, but it was a risk we were willing to take.

Yoshi needed to keep abreast of the latest ideas or rumours and bring regular reports to Nakamura san who would decide which ones he wanted to encourage.

The Sakura Inn was one of the secret places used by radicals. It was down-market, on the edge of a poor quarter, and its small, shabby rooms had been hired by the hour for nefarious practices. Situated at the edge of a stream, it was dank with the vague smell of sewage pervading everything. It was on the verge of closing down until the owner realised he could encourage the radicals to use his grubby rooms for secret meetings. He provided food and drink and started to thrive as more men got to hear of it. It was one of many similar places Yoshi and I visited on a regular basis.

Yoshi's natural oratory and charisma never failed to charm, even when some were hostile to him, but as soon as he stood up to speak the light and fire in his belly, his common sense and courage in expressing views that were treasonous, won him many supporters.

One evening, half-way through an overcrowded meeting in

a cold stuffy room at the Sakura Inn, a man we hadn't seen before was antagonistic to Yoshi. 'What do you know about anything? You are just a boy,' he sneered. 'Boys can't rule or change things, that's a job for men.' Others noisily agreed and the meeting was in danger of collapsing but Yoshi knew how to handle them.

He turned things around saying, 'That's part of the problem we have. Men, especially old men, are ruling the country from their fetid castles using their fetid minds while the country needs men – and boys – with courage. New ideas and ways of thinking are the only way to save our country and boys and young men are the best people to do that. We are not bogged down by tradition – or by favours owed to people – or by fear of failure – or of loss of face or fortune. We have vision.'

There was a roar of approval from some quarters and still dissent from others. He said, 'Young men and boys will not flinch from their beliefs or make compromises. The foreigners have come into our land and shown us a new way – a way full of possibilities: trains, good roads, industry, new building and farming techniques, new ways of thinking. It is my own belief that we must have education for all – for both men *and* women. Women are half our population and have brains to equal men.' Uproar broke out then and even Yoshi's supporters balked.

'Nonsense,' many called out.

'Stupid idea, I can just see my sister as shōgun,' someone shouted and everyone laughed with gusto.

Yoshi laughed too, joining in the banter. 'That's just what I want you to do my friends,' he said smiling, 'laugh at the preposterous new ideas, ridicule them, but then, on quiet reflection, maybe when you lay your head down to sleep, think about that idea. Think what it would mean to our society – for make no mistake, if we decide to change there will be *many* changes – not just the ones you want. And that is how new ideas are born: men thinking the impossible and accepting it as a possibility.'

A murmur went around the room and Yoshi cut it off by saying loudly, emphasising his words, 'Our country is fighting

for its life and I believe a new world is coming. The old against the new. Old men struggle to control the spiralling influence of foreigners and young men's ideas.'

He looked around the room ensuring everyone's attention was on him, 'The new world is ours if we hold our nerve. It's up to us to stay strong and to encourage and convert as many people as possible to our cause.' Peering through the dim light of the lamps, he made eye contact with the people he wanted to impress the most. 'We have to be organised. It is no good doing things individually for those efforts will disappear like specks of dust. What we need is a dust storm and to bring all our individual dust to rise at the same time. To gain the momentum that leads to power. There's power in numbers and once that momentum starts it will be very hard to stop it. We need to crush the confidence of the old leaders, but do it in a way that results in success for us. We cannot disintegrate and fall to earth when the storm abates. We must consolidate our dust until we have a solid base.'

He waited while they absorbed that information and added, 'Think on my words until the next meeting. We have little time to waste. Events will not wait for us to make up our minds. When change comes you must all be certain in your beliefs and be prepared to fight for them. Train your minds to be open to new and strange ideas. Every idea is strange at first: it is our familiarity with them that makes them acceptable.'

He looked around the room as his voice rang out, full of confidence, 'Who is willing to go into the world and talk to others of what we believe in? Who is willing to be a leader in this new world?'

The men had fallen silent, jolted by his challenge.

Yoshi finished his speech there: that was his genius. He had put the ideas into their minds and now he would leave them to ponder how far they would go.

As he turned to leave a cheer started and picked up momentum until it filled the room as we took our leave. Yoshi's mantra was to leave either on a high note or a controversial one.

'It adds to the mystique,' he had said to me, 'and mystique is

as important as policy. If you want to take men with you, you have to have that.'

As we made our way to our next meeting, there was something I needed to say. It was delicate, so I tried to be as diplomatic as I could and whispered in the darkness. 'There is something I feel I must speak about.'

He turned his head and peered at me, 'Oh yes?'

'It's a bit delicate, but I feel I am right in this matter.'

'Well, tell me. I am intrigued,' he said good naturedly which made it easier for me to speak. He was becoming more considerate like that.

'Well, I think it would be better not to mention the bit about equal education for women just at this time. It's too contentious. You might lose some followers, they'll think you are too odd, have gone too far.'

He nodded in the darkness, 'Mmm, you are still astute Kai, I agree. The reaction to it was not good tonight. I will leave that as a separate fight for another time. One battle at a time is good policy.'

That's one of the reasons I admired him so much, he never gave up.

I went everywhere with Yoshi. I was his protector and two long swords were better than one. I never forgot Sato and Nagoya. For the first time in my life I was also carrying a gun. I liked it, it was part of our new future and it put a lot of men off messing with us. My job was to protect Yoshi. I knew about the trouble he'd had when he visited Edo alone and my presence now deterred any similar behaviour.

It wasn't so easy in the palace though. The ploy we had adopted as male lovers worked to a certain extent, but it also caused a few men to come looking for Yoshi with propositions of their own. It made me realise again just how handsome and desirable he was. Too much for his own good really. I had to make sure they understood that I would kill them rather than let them have a dalliance with him. They soon got the message and left him alone.

At our meetings, when Yoshi was satisfied he had identified

237

potential leaders, he would gather them in special get togethers so they would encourage and take strength from each other. The atmosphere in Edo was young, modern, vibrant, while in Kyōto it was stagnating in its own festering history. He'd emphasise again and again how new thoughts and ideas must be promoted to as many people as possible.

It was a time of unlikely friendships and people gravitated to each other because of their beliefs rather than in more traditional ways of family and work status. People looked at each other differently and saw possibility whereas before they only saw rank, or lack of it. They saw usefulness rather than a person's wealth: hope, ambition, the desire to think – and say – the impossible. A modern Japan where a poor man could become a leader; possibilities were opening up that would have been unthinkable before the foreigners came with their new world. The rich man, the despised merchants and the poor farmer could be friends if they believed in the same values and progress.

He talked of the reactionary Shishi, who had taken control of the emperor in Kyōto. But he also told them that even some Shishi were beginning to realise that we could not win against the foreigners. If we could persuade them to modernise, to take an open and enlightened viewpoint, then there was hope that all this could be brought to pass. He encouraged men to travel to Kyōto and other areas and spread those views; he taught them how to do it effectively and keep their heads on their shoulders, for it was dangerous work. That was Yoshi's job and he excelled at it.

It was a time of hope, exploration and daring and Yoshi loved it all; ate up the challenge and excitement. His natural eloquence and charm drew people to him like a swarm of homeless bees following their queen. They seemed to need his certainty and confidence and I couldn't help thinking how angry those men would have been to find they had been influenced and moulded by a woman.

Nakamura san had given Yoshi and I two small rooms in his

household to use as our living and working quarters. When the end of January came with the promise of spring in the tight buds of the plum trees and Yoshi and I were working in our rooms, trying to keep warm as the cold penetrated the walls and seeped into our bones, Nakamura san walked in and gave us some news that changed everything.

He said, with an intensity that thrilled me, 'It has started.'

We didn't take our eyes off him.

'The emperor is dead.'

My heart and stomach lurched and Yoshi gasped.

'But our last report said he was recovering,' I said.

'It seems not,' he replied looking at each of us and then keeping his eyes on Yoshi. 'The smallpox had abated as we were told by our spies, and his people thought he would recover, but he was overtaken by violent vomiting and diarrhoea which resulted in his death a couple of days ago. I have had it confirmed that no one else in the emperor's court has caught the disease.'

That statement hung in the air, thick with meaning.

'You think it is true then? He was *deliberately* infected with smallpox?' Yoshi asked.

'The sudden worsening of his condition confirms to me that the rumour is true. I have no doubt the Shishi infected him with smallpox – more than once. Someone at his court passed him a handkerchief, or something similar, with the disease steeped into it.'

His eyes took on an added excitement, 'And now it begins. The past is the past and this news is the confirmation we needed that the tide has turned so far it cannot be turned back. The Shishi are committed and they now have the emperor's son, an easily moulded fourteen-year-old to lead them as a figurehead. One who will do as he's told and not interfere in politics like his reactionary father did.'

'So, we have succeeded,' Yoshi said grinning broadly. 'The Shishi have finally admitted they could not win against the foreigners.'

'That is correct. The emperor has not survived this and it

is my view the shōgun will not either. His government will flounder, and we,' he said looking at us both in turn, 'are going to be part of history.'

Yoshi and I glanced at each other I knew the excitement in Yoshi's eyes was also in my own.

'Now,' Nakamura san said, controlling his own excitement, 'the hard work really begins. The Shishi leaders have taken the initiative and the rest will follow as sure as night follows day. We must be in the vanguard of control. It is time for us to consolidate our friends. It's been clear to me for some time that the shōgun has lost his stomach for the fight. I see the new emperor taking over control as figurehead and opportunities for men like us to gain power if we are clever – and make no mistake – I intend us to be part of the new power base. We must distance ourselves from the shōgun. Our time has come and our struggle has started in earnest.'

He looked at each of us in turn. 'Are you ready Yoshi? Kai?'

'Yes, I am ready sir,' said Yoshi.

'Yes, me too sir.'

'Yoshi,' he said in a loud voice, the one he used when he wanted to confirm his authority, 'This is something we could never have anticipated. To kill your emperor to promote your own gains is the way of determined, ruthless, power-hungry men – but mark my words – they are also courageous men. Men to be careful of. Men we will have to work with for the benefit of all. There is no turning back for them now, we have to catch the moment and strengthen our position. We will be very, very, busy.'

He walked over to the window and looked out as if pondering a problem and the light, delicate, woody perfume of the rare incense he liked to burn in his office wafted from his clothes into the air. A fragrance I always associate with power.

He turned, 'The time has come to make our moves. Yoshi, you have been here long enough now for people to know you and understand the confidence I have in you. I am promoting you to be a senior in my office. You will sit in on all my meetings, even at the highest level. You will be my confidante

and representative whenever needed.' He lowered his voice, 'and of course, you will continue to be my eyes and ears out in the streets. Continue your work there, but things will move so quickly now, I need you near me too. It will be a time of hard work, there will be nothing else in our lives until this is done.' Yoshi bowed low to disguise the look of absolute pleasure I saw cross it.

'Kai, you too have been promoted. You are now Yoshi's assistant and will help him in any way he needs.'

'Yes sir, thank you sir, but I have already been doing this.'

'But now it is official. You will be endorsed as Yoshi's assistant with a monetary remuneration of your own, rather than sharing Yoshi's. I will make sure people know I have the utmost confidence and trust in you.'

I bowed low to him. 'Yes, I understand, thank you sir,' I said, unable to hide my own excitement.

He nodded. 'We will need to discuss how we proceed. Be in my office after lunch and use the time to think deeply.'

He left the room as quietly and unobtrusively as he had entered. That was his strength, people underestimated him.

The thrill of the moment was written on Yoshi's face and his eyes shone, as I knew did mine.

'We are to become part of history Yoshi.' I said my voice full of awe. He looked at me with such exhilaration he was bursting with it. A man of influence in the making and I had to wonder whether he would be able to give all this up when the time came. Power brings ambition. What would Yoshi's ambition be once all this was over?

He initiated a rare contact between us as he took my hands in his. 'Kai, our time has come at last. All our hard work is coming to fruition. The old man's prophesy has come true.'

I squeezed his hands gently in confirmation but he saw in my eyes that I was troubled.

'What's wrong Kai?'

I was spoiling his pleasure of the moment, and cursed myself for letting my thoughts show, but the damage had been done. All I could do was to take my hands from the comfort of his.

'This is not easy for me to say, but I worry that … well …'

'Please say what's on your mind Kai, we must keep complete honesty between us.'

'Yes, you are right.' I rubbed my hands over my face to give myself time to compose the words I needed to say. 'I worry that when our work is done you will not be able to give this up. Power can be addictive to people who thrive on it – as you so clearly do.'

He looked at me for a long time. 'You are astute again, Kai. I have thought about this but you have forgotten one very important thing – the luxury of power is not mine to attain.'

'What do you mean? You have power now?'

He raised his eyebrows and sighed, 'But my power is only a reflection of Nakamura san's power. I cannot hold power on my own. I am a woman who is accepted here in the disguise of a young man of promise, making his mark and way in the world. But I cannot stay young forever. As time goes on I will age but never turn into a mature man. My face will stay feminine – and although that's acceptable for a young man – it is not acceptable for an older one.'

He smiled, 'I will be discovered and then many of the men I now work with, maybe even Nakamura san himself, will turn on me for the deception. They will think how dare a mere woman impersonate a man and gain power and influence and be our equal. They will destroy me. I have no illusions about that.'

'But surely there is something you can do? You cannot just give up.'

'I cannot beat nature, as much as I'd like to – but you know, sometimes I wonder whether I am not alone in this.'

'What do you mean?'

'I often wonder if other women have done this before me … you know … disguised themselves as a man to attain power and influence and to live the kind of life they wanted.' His look was challenging. 'As you know Kai, it can be done. I fooled you and continue to fool other men … and the more I think about it, the more convinced I am that I am not alone. I will never

know though, how many women have done this in the past and will need to do so in the future.'

I shrugged, 'I cannot answer that Yoshi, but what will *you* do? What can *we* do?'

'Don't worry, when the time comes I will not be "giving up" as you put it. I've been thinking about this for some time and as soon as the time is right, when I have done all I can and there are others who can take over, I will go quietly away and put out a rumour that I have died. That would stop anyone looking for me or finding out my secret.'

He smiled in that knowing way of his that always sends shivers of anticipation through me. 'A new life will then start for me. I will become not Makino Asako as before, but Matsuda Asako, wife of Matsuda Kai, the best, the most generous, kind hearted, forward thinking samurai there has ever been.'

I felt so proud as I put my hand up and ran a finger down his scar, gently, from top to bottom. 'Your scar,' I said, keeping my voice as gentle as my touch, 'will affect your good looks when you are a woman. People will stare. Can you cope with that?'

I went to take my hand away, but he stopped me and held it lightly to his scar and smiled. 'I have no problem being a woman with a scar. Yes, people will stare and maybe not like it, but for me, man or woman, I am proud of this. You are the one who will have to look at me Kai; can you cope with it – when I am a woman?'

I caressed his scar with feather-like finger tips, 'If only you knew how proud I've become of this. It means I rescued you from that bastard Sato. Saved your life, for I have no doubt he would have killed you after he'd raped you. So no, I have no problem with it – now or in the future.'

Our eyes held and confirmed our words. He said, 'When I am old and my memories fade, this scar will be my proof that I really did these things.' He took the photograph he had taken in Edo out of his sleeve and looked at himself standing as the proud samurai with his scar easily visible. 'I will have another photo taken as a wife and mother, showing my scar clearly and our descendants will be able to see I am the same person: the

samurai and the mother.'

'I'll never forget,' I said gently. 'I want our children to know what an extraordinary mother they have.'

'And an equally extraordinary father; I could not have done this alone. You are as vital to my story as I am myself. Just think of our children Kai. With our blood mixed, our training and our new country, they can attain things we could only dream of. And maybe one of our distant female descendents may become a leader in her own right. A leader of this country and possibly beyond, for who knows what great things our new nation will achieve. What's waiting in the future – we will be part of that too. It is our destiny.'

I was awed again by Yoshi's intelligence and good sense as I took her hands in mine and saw, not Yoshi, the young samurai, but Asako, the woman I loved. The kind of woman our future needed. I knew she had great things still in her. I was in awe of her as always, and felt a deep gratitude that fate had brought us together.

And now, here I sit, writing my extraordinary story, wondering what the future will hold now this has all happened. Bebe entering my mind, changing me, educating me into different ways of thinking and being: letting me glimpse the future. It was because of her I met Yoshi, for without Bebe's influence I may not have had the courage to turn down Rintarō's offer of marriage to Masako. It was my destiny.

To my pride, I've managed to show Asako the possibilities of that new way. Acknowledge her superior mind and courage, her loyalty and ambition. Her ability to find solutions to problems I would have given up on. The thought of a woman like that being my wife and the mother of my children fills me with pride and there will never be a dull moment with her. I'm bursting with that same pride that she has chosen me to share her life and be the father of her children. It is our destiny.

In normal circumstances it would have been impossible for Yoshi and I to meet, let alone develop the deep feelings we have for each other so I also have to thank Bebe for that.

But now she is gone. I know deep inside me the force that connected us has been severed.

I am as certain as I can be that we will never meet again, and I thank all the gods that she came my way. I will not disappoint her, or Asako. I will be a new man for a new world and never forget that two women made this possible.

My world is altering more than anyone could imagine, and so quickly, it seems unreal. But it is real. I am real, Asako is real and Bebe is real. It is our destiny ... it is *my* destiny.

# CHAPTER THIRTY ONE

## BEBE

Kenji and I were eating dinner, sitting at my small table on our knees when he said, 'I know you haven't been into Kai's life for a while but is it really over do you think? Can we relax?' Our eyes met, 'I'm sorry Bebe, I didn't mean it to sound so harsh … I know you liked being in Kai's mind … the excitement of it and …'

'Don't worry,' I cut in as I put my hand over his, 'I understand and I'm as sure as I can be that it's over. I haven't felt his presence since the earthquake … perhaps the second chip has happened in Kai's time and it's broken the magic … I don't know, but something is different.'

'I see,' Kenji pondered, 'I'm not sure I understand what happened with the teapot – you know – in detail, how it worked … started?'

'I know it's hard to understand, maybe we should go through it together. Let me get my mind organised.' I took a sip of my wine, closed my eyes and concentrated. 'It all began when I rode on the Hankyu trains between Takarazuka and Nishinomiya Kitaguchi. I had these moments when I went out of myself and seemed to go into the past. I had visions I suppose you could say.'

'Visions of the past?'

'Yes: fighting, samurai, smells, sounds. It was scary. I didn't like it and wanted it to stop, but I couldn't control it. Then, I saw the little teapot in the Hankyu Department Store and fell in love with it. I knew I had to buy it – it felt like mine

in a strange, compelling way. It was after that I started to go further into the past, although I still had to be travelling on the Hankyu trains for anything to happen. But one time, when I was at the Takarazuka Theatre with you, I crossed over into Kai's life.'

'At the theatre? He asked, puzzled.

'Yes, it was that time where you thought I'd gone to sleep and you couldn't wake me up.'

'Ah !' He drank some wine, deep in thought. As he put his glass down he said, 'I thought it was strange … but … well, I liked you, I didn't want to cause trouble between us so I stayed silent.'

I put my hand over his. 'Thank you, my love. It was a bad moment for me, I thought you'd discovered me. But the thing is, I always crossed over whenever I was on Hankyu property, their trains, or theatre. But when I got the teapot well, the power became stronger the longer I had it and the more I used it. In the end, I didn't need the Hankyu connection to cross over.'

He frowned. 'So what is the connection with Hankyu? I don't understand.'

'Me neither, but Fumi thought maybe the railway was built over sacred ground, either because the railway company didn't care or, more likely, didn't know.'

'Mmm, impossible to tell now – everyone's dead.'

'Yes, but why me Kenji?'

He shrugged. 'You have a link with Kai maybe? Your sprits matched … and then you bought the teapot?'

'But others must have owned it before me – before Kai and Yoshi – I feel sure they did. Where had it been before the old woman gave it to Yoshi? And did they cross over too?'

Kenji looked startled. 'Mmm, good point. That teapot is very old – we don't know its history …'

'Or whether it could get the magic back again with someone else …'

'Or how many times this has happened?'

'Or maybe it had been kept somewhere … hidden away.'

'You mean someone hid it away because they were afraid of its magic?'

'Maybe ... and then, in our time, someone who didn't know anything about it found it and sold it and you bought it.'

'And that pushed everything that was happening to me to another level ... that's possible I suppose.'

We were silent, picking at our food, not tasting it, our minds elsewhere.

Eventually, with a helpless shrug, I said, 'It's beyond my ability to understand and analyse ... as you always say Kenji, the Goddess knows why.'

'Who could understand it? I would never have believed it if I hadn't experienced it with you. It's an incredible thing Bebe ... and I feel proud that my country could produce such a thing.'

He smiled and leaned over the table and kissed me gently on the lips. I caressed his face with my fingertips as I added, 'I feel proud that I was the chosen one – very proud – but I know it's over for me. I feel different. I'm myself again with no outside forces plaguing me. I'm back to being Bebe, in love with you, Kenji Yoshida, living in the twenty first century and loving every minute of it.'

'You don't want to go back ... just for a while to see what happened?'

I laughed. 'Oh Kenji, what a lovely thought – and yes, of course, I would love to go back just to see what happened. But it doesn't work like that and I might be stuck there forever. I feel lucky I was able to cross over again into my own life and I don't ever want to go back in time ever again.'

'Really? You really mean it?'

'Yes, I really mean it. It was fun and exciting and it changed me, and I grew to love Kai ... and Yoshi ... but now it's over and I'm glad. I want my life back.'

Smiling, he said, 'I'm glad too, very, very glad. And now, we have to make a decision, what shall we do about the teapot? If we keep it, it might use its magic again – we could never be sure.'

'Yes, I've been thinking the same. Should we get rid of it do

you think? But how?'

'Good question. If we smash it, the Goddess knows what would happen … if we use it … maybe the same … if we give it away we're out of control of it.'

'But now it's not doing anything,' I said. 'The ties have been severed, so let's just wrap it up very securely and find a box for it so that it can never get damaged again.'

'Great thinking: I agree, but let's get two boxes for it, one bigger than the other – and wrap it up carefully in thick cloths and put it in the smaller box and then put it in the bigger one.' He looked embarrassed. 'You know, just to be on the safe side in an earthquake … and put it in a cupboard under the work surface so that it cannot fall out and smash.'

'Yes, and cover it with cushions …'

We started to laugh. 'Maybe we don't need to go that far Bebe.'

I'd always thought arranging a wedding would be reasonably straight forward: guest list, civil or church, catering, reception, budget. Then I discovered it's even simpler in Japan – you just go to City Hall and ask to have your family register changed.

'Every family has a register,' Kenji said, as he wiped up the dishes I was washing. 'You ask the official to remove the woman's name from her family register and add it to the man's family register, then you stamp the alteration with your seal, and you are married.'

I stopped washing up and turned and looked at him. 'You're kidding !'

'There's more,' he said putting a cup away. 'You don't even have to go yourself. You can send anyone to do it for you – as long as they have your seal.'

'Now you *are* kidding … aren't you?'

He shook his head and laughed. 'It's true. I swear. That is how we get married in Japan.'

'But I've seen people getting married in hotels … expensive wedding dresses, top hats and tails, loads of guests – all very proper.'

He laughed again, 'Please believe me, it is true. The people you see at hotels are just having a fun party. They have been to City Hall and altered the registers and then they have a western style marriage service, with a priest, and party afterwards. But it is only a pretend marriage.'

I frowned. 'I'm sorry, but I'm confused, how can they have a marriage service if they are not real marriages?'

Kenji took hold of my hands and kissed the back of them, saying, sweetly, 'You are forgetting this is Japan. We embrace all sorts of things and turn it to our own ways. Religion is important, but we have never had any wars over it. We do not get ... hung up, I think you say, about it. Shinto and Buddhism exist side by side and we take something from one and something from the other and use it to help us live our lives as we want.'

I put my hands around his waist. 'Yes, I remember you telling me this when we went to Ise Shrine.'

'Well then, we do the same with a Christian marriage. We employ a western man to conduct the ceremony for us and go through the marriage service, western style, as if we were in England ... or America ...'

'But where do they get the foreign men from? There can't be many Christian priests in Japan.'

He laughed again. 'No, Bebe, you have not understood. They are not priests, they are ordinary men. They can come from any profession as long as they look decent and do a good imitation of a priest. Many of these men are English teachers who do this as an extra job on weekends.'

'What?' I stepped back in shock. 'English teachers moonlighting as priests ! Performing mock marriages ! Kenji, please tell me this is a joke.'

He looked concerned as he held my hands again. 'Sorry my love, that is what we do. It's just fun for us. Think about it - how would you like to get married by going to City Hall and seeing a straight faced official who cares nothing for you and probably resents the extra work you've brought him. It's horrible Bebe: really impersonal. We Japanese much prefer the

western way to get married, but we are stuck with our way and that's why we take the opportunity to have a wedding party. You know, like you see in magazines and on American movies. We want that, it's not our fault our system is different.'

My heart went out to him, this man, this good man, caught between two cultures. I pulled him close. 'Well, if you put it like that ... I do see how and why it happens ... but ... well, to be honest, I can't get enthusiastic about a pretend marriage. In my mind's eye, I see us in one of those luxury hotels, me in a white wedding dress, you in your top hat and tails – you know, like a posh Japanese wedding – all our guests dressed like royalty, romantic service, big reception afterwards – but I can't do it Kenji – not with a moonlighting English teacher taking the service. It's ... it's ...'

'It's part of our culture to make the best of things that are not perfect. You know this Bebe? Why is a marriage service different?'

I pulled away from him a little and looked into his eyes. 'I'm not sure ... I think it's because it's not part of my culture to do such a thing when it has no meaning ... we think differently that's all.'

I snapped my fingers, 'I've got it. Why don't we get married in Japan – at dreary City Hall – at least then we will be legally married which is what we want ... what we need. Then later on, we can go to London and get married again there – you know, a proper marriage with an authorised registrar, and all my family witnessing our vows. We can make vows Kenji, in front of everyone, I want us to make vows ... and have a big wedding – a real wedding – with wedding clothes and an English-style reception afterwards.'

The smile fell from my face when he didn't respond I realised how stupid I'd been. 'Oh Kenji, I'm so sorry. You may not want such a wedding ... your family ... please forgive me, I didn't think.'

I hugged him hard, burying my head in his shoulder. We stayed like that for a while, hugging each other, and then he looked into my eyes and I wiped away his tears, and he smiled

251

a kind smile.

'Please don't worry,' he said, caressing my face, 'I'd like a big wedding: I'll be creating a new family. Your family will become my family.'

I stroked his cheek. 'And they will love you as much as I do – I know they will.' I saw such hope in his eyes and my heart went out to him again.

'I like your way Bebe. I like it a lot. And we will truly be married – no problem anywhere in the world.'

I laughed with the joy of it. 'Also, being practical, it will solve the problem of my parents coming to Japan now, when it's not suitable. I'll just tell them to save their money for our big wedding in London.'

'And maybe your parents can come back to Japan with us for a few weeks. We can show them my country. I'd like that.'

'Great idea,' I said with mounting excitement. 'And we can invite Hiro and Fumi and her family … you could have Hiro as your best man.'

'What's a best man?'

He laughed when I explained it to him.

'Since Hiro went back to the coffee shop and asked Yoko san out, he has changed a lot. He's like a human being now – and very much in love. I think he would make a good best man.'

'I agree Kenji – we should invite Yoko san too. You know … push him in the right direction a bit.'

'That's a great idea. It's really serious between them. Since that evening when we got drunk together …'

'I'd loved to have been there.'

'Thank the Goddess you were not. It was not a pretty sight but it changed us both.'

'And I'm truly grateful Kenji, you know, Hiro isn't such a bad person when you get to know him.'

'I am glad you like him, he is my best friend now. We shared our deepest feelings with each other that night: we will always be special friends.' He shook his head slowly, 'I never thought I would hear myself say that. I have a special friend – the first one I have ever had – and I am about to get a wife and a new

family. Oh Bebe, I am the happiest man alive. I can't believe my good luck.'

'Thank you,' I smiled, hugging him close again. 'We are both the luckiest people in the world … my life with Kai and all that taught me … meeting you and my life in Japan. It's all so … wonderful ! If I ever write a book about it, I'll call it, Wonderful, Mysterious Japan !'

Laughing, Kenji led me to the middle of the room. He put on a CD of classic love songs. We held each other close and swayed to the soothing refrains of Patsy Cline singing, 'Crazy.' "… crazy for tryin', crazy for cryin' and crazy for lovin' you."

'We've had a crazy life together so far,' I whispered in his ear, 'but it's been fun hasn't it?'

'Now that we're all safe and everything is settled, yes my love, my darling, my soon to be wife, it has been fun … and will continue to be so.'

'Do you think so?'

'I do. The Sun Goddess is smiling down on us. I can see her when I close my eyes. She loves us as much as I … *we?* … love her.'

I caressed his back lightly, as he likes me to, and whispered, 'As *we* love her Kenji … as *we* love her.'

A few weeks later, after Kenji got all the official documents sorted out, we booked to go to City Hall to get married. That morning I went to the hairdressers. Well, it may be dour City Hall but I still wanted to look my best.

Sawako san had been doing my hair since I arrived in Japan and I liked her because she didn't chat all the time. It gave me time to think. I also liked the way each hair station had a three way mirror so that we could see the shop at all angles as we sat in the prison of the hairdressers' chair. The shop was a typical Japanese extravaganza and designed in the style of a Roman villa. The long room was divided up with faux pillars, large statues and flamboyant plants, creating light and dark areas with chair stations hidden from view.

As Sawako san cut my hair unbidden memories crowded

my mind – my boring life in England – my loving but unadventurous parents – coming to Japan – buying the little teapot – how my life started to intermingle with Kai's. Kai: I felt the power of him again and a shiver went down my spine. I remembered his handsome face, strong body and gentle eyes. And then, through a side mirror, I saw him standing beside a pillar in the distance, smiling, looking confidently at me. His kimono and brush topknot outlined in the shadows. My heart beat a tattoo until I realised it was a trick of the light, my mind getting fanciful, until, from the very spot I had seen Kai, a young man appeared, walking towards me: Yoshi?

I saw the same upright posture, the same long, black hair pulled into a tail with his softly flowing fringe and side locks framing his face. As he came nearer I realised it wasn't Yoshi. This boy didn't have his good looks or charisma; but the shock was just as strong.

He approached me and said, 'My name is Nao. You have booked to have your nails done today.' His high pitched voice startled me and as he sat down and took my left hand and examined my nails, I looked at his hands: soft, delicate hands, women's hands. And then it hit me. He wasn't a boy at all. He was female. How could I have been so stupid?

Sawako san noticed me staring at her and said, 'Nao san started working here last week. She's trained in nails and make-up. She's good, you'll like her.'

I laughed to cover my confusion. 'Sorry, Nao san. Sorry if I looked at you a bit strangely, I thought you were a boy at first.'

She smiled a knowing smile. 'I've met foreigners many times, you sometimes get confused by our … androgynous look … I think you say. Sometimes it is difficult to know – boy or girl, girl or boy.'

'You're right, we foreigners sometimes get confused. I think young Japanese men and women can look very alike – androgynous as you say.'

And then, calmly, without fuss, like the settling of a problem into peaceful waters, I saw it all. As understanding took root and developed inside me, my body started to tremble as the

shock sunk in. Yoshi was a woman !

Nao san said, 'Relax your hand please. You have tensed up.' I heard her from a great distance, but I only had thoughts of Yoshi in my mind. I was back in time, with Kai and Yoshi. It started to make sense. The way he'd kept himself aloof and private, the glimpses I'd get of a different Yoshi underneath ... my admiration for him – her.

Clever, clever Yoshi.

She'd fooled Kai ! And me ! And everyone else !

My admiration, which was considerable in the first place, soared. It must have been so difficult keeping up the pretence. How she had to prove her 'manhood' by fighting and killing. It would explain why she didn't kill Masako that time – could a woman kill another woman as easily as she could kill a man?

It would explain why everything got too much for her and she left Kai – and consequently, the little teapot. That thought sent waves of longing and regret through me. Was Yoshi meant to have been the one to come into my mind – and mine into hers?

Possibilities flooded my mind.

As much as I loved and had come to respect Kai, if it had been Yoshi – what a team we would have made. What could we have achieved together?

I had to swallow my disappointment. There was no point in it.

But would it have made any difference?

Could it have happened any other way?

My whole body pulsed with excitement and pleasure in the knowledge of what she had done and I had to wonder if this revelation had come from Kai. Had he discovered the truth? Was he proud of Yoshi, and that's why he'd come? Were we still connected in some way? Had I really seen him? I looked back at the pillar in hope, but there was just empty space.

Sawako san's voice pulled me back to the present. 'Are you all right Bebe san?' She looked worried.

I realised my hair was all finished and my nails looked beautiful as she and Nao looked at me strangely.

'I'm so sorry, yes I'm fine thank you both so much.' I paid them and tried to act normally as I left but I'm not sure how well I succeeded.

As I walked home, I realised the futility of dwelling on the past, but at the same time, I couldn't wait to tell Kenji what had happened.

Kenji.

There was a link there: Kenji, Kai, Yoshi.

Sacrifice.

That was it. They all sacrificed themselves for altruistic reasons: Kai and Yoshi for the good of their country and Kenji for the good of anyone who he might come to love.

Japan: the country of sacrifice.

I started to feel selfish and self-absorbed and then pulled myself together: I was English, not Japanese. I could never sacrifice myself as they had done. It just wasn't in me – in my culture. It had all happened the way it had happened. There was nothing any of us could do to alter it. It was our destiny.

But I couldn't stop my mind racing, had Kai declared his love to Yoshi?

Had they succeeded in their ambitions?

Did they change their country?

Kai and Yoshi would have been proud of today's Japan even though their vision has taken a long time to come to fruition and still has a way to go. The spirit of Kai and Yoshi still flows through the veins of many.

I would search the internet when I got back home. Try and find some reference to Yoshi, but then realised the futility of that. She would have been written out of history as nearly all women were. Or maybe she was never discovered. I wish I knew, but I felt it in my inner being that Kai would not come back. I knew about Yoshi and that was the end for us. I would just have to imagine the rest.

Kenji and I had found love through almost impossible odds and so had Kai and Yoshi. What each of us did with that love … and with our lives, would remain a mystery to the other … it was our destiny.

~~~

Later that day, I went to City Hall to marry Kenji. As I got out of the taxi and walked towards the building, the only thought in my mind was Kenji. Everything else disappeared. I saw only him as I put aside my past and walked into my future.

It was *my* destiny.

EPILOGUE

Yoshi was one of an army of women through the ages who had to disguise themselves as men to get any influence and take part in their society in any meaningful way.

We do not know what happened to Yoshi as, like all such women, she was written out of history. But we can guess she existed and survived because the little teapot re-surfaces in twenty-first century Japan and brings another, more modern woman, into her life to tell us her story.

This book is dedicated to all such women.

GLOSSARY

Bakufu – government of the shōgun
Daikon – large white radish
Edo – old name for Tokyo
Genkan – inner porch
Gobo – burdock root
Hakama – wide, skirt-like trousers worn just above the ankles
Han – feudal domain
Haori – a jacket with wide sleeves and fastened in front with a single tie
Juku – popular, private school for children of all ages attended after normal school hours.
Kura – fireproof stone storehouse used for protecting things from fire, mould and damp
Katana – long sword
Kitsune – fried tofu
Ne – a common tag ending to a sentence similar to: isn't it/ don't you etc.
Negi – vegetable like a cross between spring onion and leek
(O)bento – boxed lunch/dinner including rice, meat, fish, vegetables
Obi – a long belt made of silk, cotton or hemp, which wraps many times around the waist
Rōnin – a samurai who has no master because of the death of the master or the dishonour of the samurai
Ryokan – a traditional Japanese inn
Salaryman – a man who works in the office of a company but is not higher management.
San – polite way to address someone, equivalent to Mr, Mrs,

Ms, Sir or Madam.

Sama – extra polite version of san used for important people above you in authority and status

Shinsengumi – (Newly Selected Corps) were a band of vicious ruffians and criminals commissioned by the shōgun to counter the power of the Imperial Loyalist samurai in Kyōto.

Shōgun – military leader of the country

Wakizashi – short sword

Yukata – lightweight, casual kimono

OTHER BOOKS BY JILL RUTHERFORD

Secret Samurai Trilogy:
Book One, Tangled Lives

Two women samurai …
Two different centuries …
A story of secrets, lies, love, war and ambition
that has consequences for Japan itself

Modern Englishwoman, Bebe Bell, is working in Japan. Time-travel mixes her mind with male samurai, Kai Matsuda. Soon, she is living a double life – her own in modern Japan – and the other living as Kai, fighting in the civil war of the 1860's which changed Japan forever.

Yoshi is a young woman forced to disguise herself as a samurai in order to deliver an important message to the emperor's court. Living as a man gives her influence and respect – things she has never experienced as a woman of her time. She becomes intoxicated with the power of it – which takes her life down undreamed of paths.

Circumstances bring her into the world of Kai – and the attraction between them is immediate – but they are fighting on opposing sides and Yoshi can never disclose her true sex to anyone, especially Kai. But he has Bebe in his mind and events take an unexpected turn.

In her own life, Bebe falls in love with Kenji Yoshida, a man who hides his true self under a cloak of conventionality and is afraid to find joy in his life. He has a secret that is destroying him and he cannot allow himself to love Bebe.

When these four people's lives intermingle, it changes their perceptions, ambitions and reality.

Secret Samurai Trilogy:
Book Two, Snakes of Desire

The snakes of desire enter the blood of Bebe, Kai, Yoshi and Kenji as they seek out their cravings for trust, courage, ambition and love

Bebe has to cope with the growing pressures of a double life in different centuries and the restrictions imposed on women in old Japan. Prejudice affects her and her life with Kai.

Kenji suspects Bebe's secret as he fights his own demons. His past threatens his future.

Yoshi is trapped in Kyōto – "… a city whose streets run with rivers of blood". Alone and vulnerable, she has to deal with the Shinsengumi, the most vicious samurai force in Japanese history.

The civil war escalates and the country becomes more unstable.

Lives get more entangled and Bebe's presence in Kai's mind causes conflict and anger… secrets start to unfold.

Cherry Blossoms, Sushi and Takarazuka,
Seven Years in Japan

This memoir covers seven years in Japan and is Jill Rutherford's own true story of how she, with no influential friends in Japan, very little money, no job and no qualifications to get a job there, could realise her dream of living and working in Japan. How she survived and prospered in one of the world's most ancient cultures; where real life is hidden under a veil of good manners and everything takes on a different meaning.

This funny, interesting and informative book takes the reader into a different world, where the story revolves around the Japanese people themselves as their lives intermingle with Jill's as she endeavoured to succeed in this land of mystery, where incredible kindness goes hand in hand with institutionalised cruelty.

It also enables the reader to look behind the scenes of a unique theatre company, where over 420 female performers play both the male and female roles on stage and millions of Japanese housewives fall in love with the 'male' players; many devoting their lives to supporting and helping their chosen star. It's an intriguing world of entertainment in a fascinating, contradictory and unique country where nothing is as it seems and dreams really do come true.

The Day After I Won the Lottery ...
and other short stories

This book of nine prize winning short stories by Jill Rutherford covers diverse subjects such as: a tale of two cities; London and Tokyo, a puppy's struggle, the Japanese tsunami, colour, a faggots and peas café, an irritable old house, two ladies in kimono ... and of course, a tale about a lottery.

www.JillRutherford.co.uk

Lightning Source UK Ltd.
Milton Keynes UK
UKOW03f1602301216
291061UK00002B/2/P